EARTHCAM

D&C
David and Charles

EARTHCAM

TERRY HOPE

WATCHING THE WORLD FROM ORBIT

IN CO-OPERATION WITH

NASA

A DAVID & CHARLES BOOK
Copyright © David & Charles Limited 2006

David & Charles is an F+W Publications Inc. company
4700 East Galbraith Road
Cincinnati, OH 45236

First published in the UK in 2006

Text copyright © Terry Hope 2006

ISBN-13: 978-0-7153-2484-4 hardback
ISBN-10: 0-7153-2484-5 hardback

Printed in Singapore by KHL
for David & Charles
Brunel House Newton Abbot Devon

Commissioning Editor Neil Baber
Editor Ame Verso
Art Editor Mike Moule
Design Assistant Emma Sandquest
Production Controller Bev Richardson

Visit our website at www.davidandcharles.co.uk

David & Charles books are available from all
good bookshops; alternatively you can contact
our Orderline on 0870 9908222 or write to us at
FREEPOST EX2 110, D&C Direct, Newton Abbot,
TQ12 4ZZ (no stamp required UK only); US custom-
ers call 800-289-0963 and Canadian customers call
800-840-5220.

CONTENTS

INTRODUCTION 6

PART ONE: THE WORLD VIEWED 10
GEOGRAPHY 12
OCEANS AND SEAS 46
POLES, DESERTS AND REMOTE REGIONS 68
CITIES AND LANDMARKS 88
WEATHER AND NATURAL EVENTS 128

PART TWO: THE WORLD MODELLED 180
INTERPRETING THE EARTH 182
CLIMATE DATA 214
3D PROJECTIONS 234

INDEX 252
PICTURE CREDITS 255
ACKNOWLEDGMENTS 256

AN EYE ON THE WORLD

Satellite technology is in its relative infancy, and yet its capabilities are advancing at an amazing speed. The eye in the sky that was once pure science fiction is now a reality, and provides detailed data on our Earth that has a variety of uses.

We live in an age when technology is moving so fast that we have almost become immune to the staggering advances that are taking place all around us. The evolution of satellites is one of the examples of this: since 1946 the technology in this area has come from nothing to a point where it is now possible to identify objects as small as the family car from outer space. Other, more specialized satellites meanwhile are able to provide invaluable assistance with such tasks as weather prediction, mapping, the study of the effects of pollution and population growth and the provision of aid in the aftermath of natural disasters.

EARLY DAYS

While commercial applications for satellite information are growing rapidly, the key reason for the initial development of the technology, and the reason why huge funds were available to progress those early stages, was defence. The advantage of being able to see what the enemy was getting up to in areas difficult to access from the ground was realized long before the space age. The French, for example,

set up a company of balloonists in 1794 to carry out aerial surveillance during the French Revolution, and balloons were also employed during the American Civil War.

The first aerial photographs taken from an aeroplane date from January 1911 with the San Diego waterfront being the subject, and later that year the US Army Signal Corps put aerial photography into the curriculum at its flight training school. The realization quickly dawned that photographic reconnaissance missions could have great value, and the information obtained through this method became ever more extensive as aircraft and photographic technology became more refined.

At the start of the Cold War, the need for good quality intelligence increased, and the shortcomings of aeroplane-based reconnaissance became fully apparent, due to the risks of flying over potentially hostile territory. As early as 1946, satellite technology was seen as a way to get around this, when a report called 'Preliminary Design for an Experimental World Circling Spaceship' was published. Military uses such as missile guidance, weapons delivery, weather reconnaissance, communications and 'observation' were all foreseen and, by March 1955 the US Airforce had issued General Operational Requirement No 80, which officially established a high-level requirement for an advanced reconnaissance satellite.

The pressure for this to be developed heightened following the success of the Soviet Union's Sputnik I and II satellites in the autumn of 1957, and concern that it

would take too long for technology to be evolved that would allow a satellite to scan its exposed film and to return the image electronically led to President Eisenhower approving a CIA programme in 1958 to develop a satellite system that would physically return its images to Earth in a canister.

The programme, designated CORONA, became the mainstay of the US space reconnaissance programme for over a decade. Starting in 1959, it took a total of 14 launches before an operational CORONA spacecraft was placed in orbit, and nine of the first 12 launches carried a camera that was designed to photograph areas of the Soviet Union and other nations. The thirteenth mission was the first in which a dummy canister was successfully returned from space and recovered at sea, and on 18 August of that year a CORONA orbited the Earth for a day and the returning canister was snatched out of the air during its descent by a specially equipped aircraft. The images it acquired were very low resolution compared to what is now possible, but the mission did yield more images of the Soviet Union in its single day of operation than did the entire U2 spy plane programme.

The GAMBIT programme, which began in 1963 and continued until 1984, was a complement to CORONA, and was designed to produce high-resolution imagery of specific targets rather than area surveillance pictures that might cover thousands of square miles. The information from GAMBIT was obtained from high-resolution cameras that provided pictures with under six inch resolution. This allowed highly detailed intelligence to be carried out, which was particularly useful when the aim was to search for fairly small installations, such as foreign weapons systems.

There was a major advance in 1976, when the CIA launched a satellite carrying an advanced optical system that could transform images into electronic signals. These could then be relayed (through a relay satellite in a higher orbit) back to a ground station, where they were recorded on to tape and converted into an image. Now information could be received from space virtually instantaneously.

While information about current defence systems is understandably restricted, it is known that the US is presently operating at least two satellite imaging systems. The first has an infrared imaging capability, including thermal infrared, so that images can be obtained during darkness. The second system, known as VEGA, carries imaging radar as opposed to an electro-optical system, which allows the US intelligence community to obtain pictures even when targets are covered by clouds.

WATCHING THE EARTH

At the time that defence satellites were first being developed, experiments were also being undertaken to test television techniques designed to develop a worldwide meteorological satellite information system. The US launched TIROS-1 on

1 April 1960 with two television cameras in the craft, one offering high resolution, the other low, and magnetic tape recorders for storing photographs while the satellite was out of range of the ground station network. Throughout the mission's 78 days, these video systems relayed thousands of pictures of fairly hazy cloud-cover views of the Earth, that provided vital information concerning the structure of large-scale cloud regimes. They also helped to prove that in future it would be possible to predict the arrival of dramatic weather conditions, and provide early warning to areas that could be affected by, for example, an advancing hurricane.

The TIROS programme was deemed a success and, from 1962 onwards, provided continuous coverage of the Earth's weather to meteorologists worldwide. The technology that was utilized led to the development of vastly more sophisticated meteorological observation satellites, and this has gone on to become one of the primary uses for satellite technology, providing information about the weather on a global scale and helping to make predictions far more accurate.

THE PLANET'S HEALTH

As realization of the vulnerability of Earth has grown, so too has the requirement to monitor the changes, and the impact that man is having on his environment. Since its creation in 1958, NASA has been studying the Earth's changing environment by observing the atmosphere, oceans, land, ice and snow, and their influence on climate and weather. In 1991 NASA formalized this research by launching a comprehensive Earth Science programme, now called the Earth-Sun System Mission, whose aim has been to study the Earth as an environmental system. By using satellites and other tools to study the Earth, scientists are gaining a better understanding of how natural processes affect the planet, and how we might be affecting them in return. Such studies are yielding improved weather forecasts, tools for managing agriculture and forests, information for fishermen and local planners and, ultimately, the ability to predict how the climate will change in the future.

Phase one of the mission comprised of focused, free-flying satellites, Space Shuttle missions and various airborne and ground-based studies, and phase two began in December 1999 with the launch of the first Earth Observing satellite, Terra.

It was the start of what is intended to be the collection of a 15-year global data set, on which a number of scientific investigations will be based. Terra is being supported by a fleet of EOS spacecraft, which are providing valuable information on all aspects of life on Earth for the benefit of this and future generations.

Among the spacecraft currently gathering information to support this project are:
- Terra itself, which is providing comprehensive information about Earth's land,

oceans and atmosphere from its vantage point 438 miles above the planet. Terra orbits the Earth more than 14 times a day and observes nearly the entire globe, sending back roughly one million megabytes of data per day. One of the main instruments on board is the Moderate Resolution Imaging Spectroradiometer (MODIS), which produces a global map of where and how much carbon dioxide is drawn out of the air and fixed by vegetation during photosynthesis. Tracking plant growth is also an important function of Terra: scientists are using the satellite's Advanced Spaceborne Thermal Emission and Reflection Radiometer (ASTER) and MODIS instruments to monitor large agricultural regions and to assess the health of croplands. They produce pictures of the 'greenness' of the landscape, which scientists use as a measure of how much plant life is occurring. By comparing today's greenness maps to long-term averages, scientists can gauge when plants are under stress due to extreme heat or drought.
- Aqua, like Terra, carries a number of advanced scientific instruments, which are designed to aid the study of Earth's interrelated processes – the atmosphere, oceans and the land surface – and their relationship to Earth system changes.
- The Sea-viewing Wide Field-of-view Sensor (SeaWiFS/OrbView-2) studies the sea and looks for subtle changes in ocean colour which can signify various types and quantities of marine phytoplankton (microscopic marine plants), the knowledge of which has both scientific and practical applications. OrbView 2 is not provided or operated by NASA, and instead the data is purchased.
- The Tropical Rainfall Measuring Mission (TRMM) is a joint mission between NASA and the National Space Development Agency (NASDA) of Japan, and it's designed to monitor and study tropical rainfall and the associated release of energy that helps to power the global atmospheric circulation, shaping both weather and climate around the globe.
- Landsat 7 is the longest running enterprise for the acquisition of imagery of the Earth from space, the first Landsat satellite being launched in 1972.
- QuikSCAT carries a SeaWinds instrument, which is a specialized microwave radar that measures near-surface wind speed and direction under all weather and cloud conditions over the Earth's oceans.
- Jason 1, a joint US/French mission to monitor global ocean circulation, investigate the tie between the oceans and the atmosphere, improve global climate predictions and to monitor events such as El Nino, La Nina and ocean eddies.
- ICESat is a small satellite mission flying the Geoscience Laser Altimeter System (GLAS) in a near polar orbit. The purpose of GLAS is to measure accurately the elevation of the Earth's ice sheets, clouds and land.

INTRODUCTION

● The Advanced Earth Observation Satellite II (ADEOS II) is a joint mission with NASDA of Japan. The mission is taking an active part in the research of global climate changes and their effect on weather phenomena.

ASTRONAUT PHOTOGRAPHY

While the majority of images of Earth are taken remotely, a sizeable percentage have been produced by astronauts on various missions, and one of the chief functions of the International Space Station (ISS) is to act as a base from where observations of the Earth can be made.

Astronaut photography began with the first manned flights in 1961, and NASA has a database of astronaut images, which can be found at its 'Gateway to Astronaut Photography' website. Astronauts based on the ISS have fairly recently made the move to high resolution digital cameras, with the huge advantage that they produce digitized images that can be sent back to mission control immediately should the need arise, while film had to be brought back to Earth for conventional processing.

Surprisingly, pictures from the ISS are often taken hand held by astronauts, who shoot through a science window with an aperture 50.8cm in diameter that is perpendicular to the Earth's surface most of the time. The window's three panes of fused silica are of optical quality, and astronauts achieve images that have enough quality and detail to satisfy the requirements of scientists back on Earth.

'Photography plays a useful role on the ISS,' says Dr Kamlesh Lulla, NASA's chief scientist and astronaut training specialist. 'All flight crews are trained to conduct Earth observations, and they actually like it. They will be briefed in the basics of Earth remote sensing, space photography techniques, contents related to physical geography, geological formations, ecological issues, urban and human landscapes, oceans, wetlands and coral reefs. Other processes such as biomass burning, aerosols and dust storms are also included in the briefings. Thousands of pictures are taken on a typical ISS mission, and the astronaut database for Earth photography currently has over 500,000 images in its collection.'

COMMERCIAL APPLICATIONS

Commercial use of satellite imagery is growing quickly, with a select number of companies being set up from around 1984 onwards to provide data to both national government and corporate clients – who find a variety of uses for the information.

One of the biggest companies in this area is US-based DigitalGlobe. Founded in 1992 as WorldView, the company was granted the first licence allowing a private enterprise to build and operate a satellite system to gather digital imagery of the Earth for commercial sale in 1993. After a number of failed launches the Quickbird 2 satellite was successfully launched in September 2001 and has been performing perfectly ever since, collecting images with the highest resolution, largest footprint and highest accuracy of any other commercially available satellite imagery in the world. The 60-centimetre resolution of QuickBird images allows objects on the ground as small as 60cm (2 ft) to be seen. By May 2002 the images from this satellite were being made available to the global commercial marketplace and DigitalGlobe's products are used primarily for planning, mapping, monitoring, assessment and geographical information system (GIS) applications.

Emergency response and recovery applications have benefited greatly from satellite imagery in recent years, as the world has witnessed several devastating natural disasters. In the hours following the Southeast Asia tsunami in December 2004, DigitalGlobe collected satellite imagery showing the tsunami's initial impact, and made it available to emergency relief organizations, as well as journalists.

The wide availability of the imagery and the speed of the turnaround earned recognition about the value created by the understanding of events in remote areas, and for the support that good reconnaissance images could provide for those making damage assessments, relief, recovery and reconstruction efforts. Digital-Globe made similar imagery available following Hurricane Katrina in August 2005 and the Pakistan earthquake in October 2005.

Since 2002, the QuickBird satellite has collected and stored hundreds of thousands of Earth image scenes, covering more than 150 million square kilometres, and a million square kilometres are added every week. The company will be sending two new satellites, WorldView I and II, into space in the near future to provide even wider coverage and to prepare for the eventual decommissioning of QuickBird 2, and all the signs are that its services will continue to be in high demand.

THE FUTURE

It's impossible to say exactly how many satellites are orbiting Earth and recording data at any one time, but it's likely to be over 100, and extra missions are being flown all the time. As commercial uses for such data continues to expand, the numbers will rise, and there will be few corners of Earth that are not regularly photographed in great detail on virtually an everyday basis. For some this is a worrying thought, but there is undoubtedly much good coming out of this capability as well, particularly the message that pollution and the squandering of Earth's resources has to stop. One thing is for sure, satellite imagery is here to stay, and there will be few of us who aren't touched by it in some way in the years ahead.

Many of the satellites that orbit the Earth along with the manned International Space Station are sending back data that can be used in one way or another to help scientists to increase their understanding of the planet. Much of this data is returned in the form of imagery which is relatively 'straight' photography, utilizing natural colours to record the appearance of geographical features or some other aspect of life on the planet.

Even to the casual viewer much of this imagery is breathtaking, showing the world in a way that would have been inconceivable to previous generations. To the expert eye, however, pictures of the Earth from space are not just beautiful, they can also have a vital role to play both in the present and the future, allowing the planet to be seen in its entirety, and for events on the ground that would be on too large a scale to be properly assessed from Earth, to be seen in their true perspective from a vantage point out in space.

In the Introduction we've already looked at the military applications of satellite photography, reconnaissance of this kind will become ever more vital in the future, allowing those with a foothold in space to hold a potentially crucial advantage over those who do not have access to such data. But there are many other uses for satellite images, and the influence of satellite technology is increasingly making its presence felt in everyday life. Perhaps the most obvious way in which we are all

benefiting from imagery being sent back from space is the way that weather can now be more confidently predicted. While at times this might affect something as trivial as whether to plan a barbecue for the following evening, it can also make a much more important contribution, such as when a hurricane is brewing and is likely to hit an area of high population. Modern weather satellites can provide detailed information about the formation of dangerous storms and more accurately predict the path they might follow. Advance warning can be given and lives can be saved. This is exactly what happened with Hurricane Katrina and New Orleans in 2005: ultimately the devastation that occurred could not have been averted but, thanks to the eye in space, it was not entirely unexpected.

As concern for the health of the planet increases, images from space are able to accurately chart the speed with which such things as deforestation or the melting of the polar ice caps are taking place, and NASA now has an invaluable archive of material dating back over 40 years that can be compared with modern imagery to visually demonstrate changes over a substantial period of time. This could be used to show how a city has expanded, for example, or to record the startling disappearance of a major geographical feature, such as Lake Chad in Africa.

'NASA's Earth Observation data is turned over to the US Geological Survey, which is an official partner of NASA,' says Dr Kamlesh Lulla, chief scientist and

astronaut training specialist at NASA, 'and they hold a substantial library of images. They will undertake "data mining", which effectively means looking at certain areas of the Earth and comparing images that have been taken several years apart in some cases to see what changes have taken place.'

The growth of specialist commercial satellite companies, each of which has had to make a massive investment in order to get involved, has opened up all sorts of possibilities for major companies and even individuals to purchase satellite images for a variety of end uses. DigitalEarth's QuickBird satellite, for example, collects over 75 million square kilometres of image data annually, and this amount of image acquisition is likely to increase ten-fold in the coming years as two further satellites, WorldView I and II, are launched.

Satellite imagery can be viewed by members of the public through the Google Earth facility (www.earth.google.com), and DigitalGlobe has partnered with Google to provide a substantial amount of data for this. For those who simply want to enjoy the ability to check out an aerial view of their house or neighbourhood the service is free, but there is also a very serious commercial angle behind the operation, which is aimed at those who work in industries such as commercial and residential real estate, construction and engineering, mapping, insurance, the media and state and local government.

Those involved in real estate, for example, can use Google Earth to fly over and to zoom in and inspect a potential site for development, and they are able to check the locality in a way that conventional mapping would never allow. It is even possible to create a three-dimensional earth view to get some idea of the perspective of the location, and to see whether there are any undesirable or unsightly elements, such as an adjoining scrapyard or tip, that might influence the viability of a development.

The next generation will come to accept satellite imagery as commonplace, something that is being encouraged through schemes such as NASA's ISSEarthKAM scheme, which was originated by astronaut Sally Ride and gives American school-children the opportunity to get involved in ISS missions and to request specific pictures of the Earth from space. The first EarthKAM pictures were taken on a Space Shuttle mission in January 1998, and there are now more than 16,000 images that can be viewed in the online collection (http://datasystem.earthkam.ucsd.edu/). In many ways the future is here already, and satellite imagery will become ever more part of our everyday lives in the years ahead, offering huge potential benefits for the international community, while pointing out the effects of unsustainable development in such stark terms that huge pressure will be exerted to protect the delicate balance of the world that we all live in.

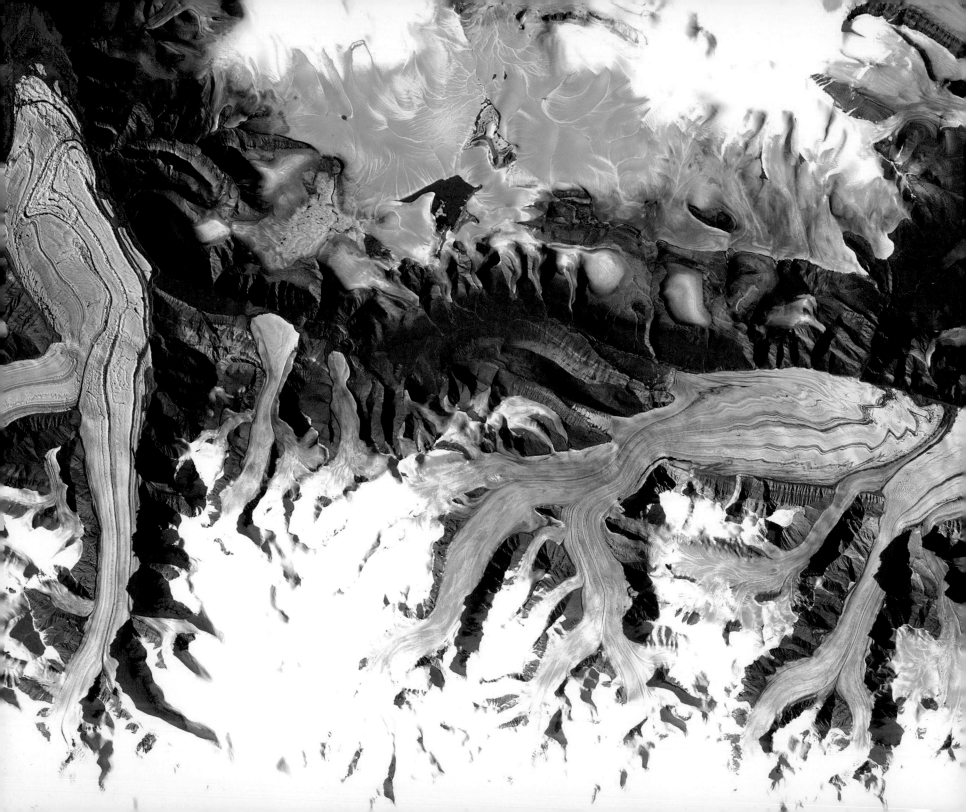

GEOGRAPHY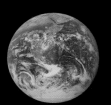

PREVIOUS PAGE:

The Chapman Glacier is located on Ellesmere Island, Nunavut Territory, Canada, near the North Pole. Formed by the merger of several smaller glaciers, rocky debris on top of the glacier clearly marks the edge of each individual glacier. In this Advanced Spaceborne Thermal Emission and Reflection Radiometer (ASTER) image, the debris allows the flow pattern, formed as the glacier moves downstream, to be clearly seen.

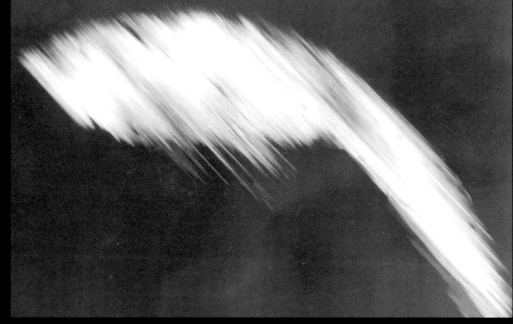

This is the first crude picture obtained from Explorer VI Earth satellite launched August 7, 1959. It shows a sunlit area of the Central Pacific ocean and its cloud cover. The picture was made when the satellite was about 17,000 miles above the surface of the earth on August 14, 1959 and, at the time, the satellite was crossing Mexico. The signals were received at the South Point, Hawaii, tracking station.

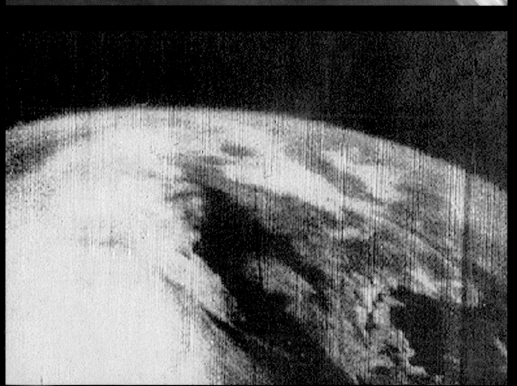

This was the first television picture received from space, which was obtained from the TIROS-I satellite on April 1, 1960. TIROS-I, which housed both high and low resolution TV cameras, was operational for only 78 days, but proved that satellites could be a useful tool for surveying global weather conditions from space.

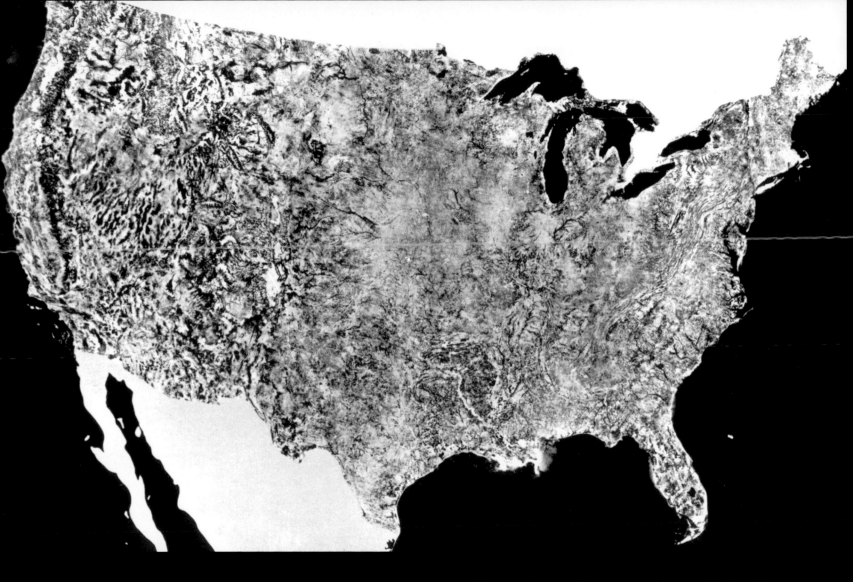

This giant photo map of the contiguous 48 states of the United States
was the first ever assembled from satellite images, and it was completed
for NASA by the US Department of Agriculture Soil Conservation Service
Cartographic Division. The map, which measures 3 x 4.8m (10 x 16ft), is
composed of 595 cloud-free black-and-white images returned from
NASA's first Earth Resources Technology Satellite (ERTS-1) during the

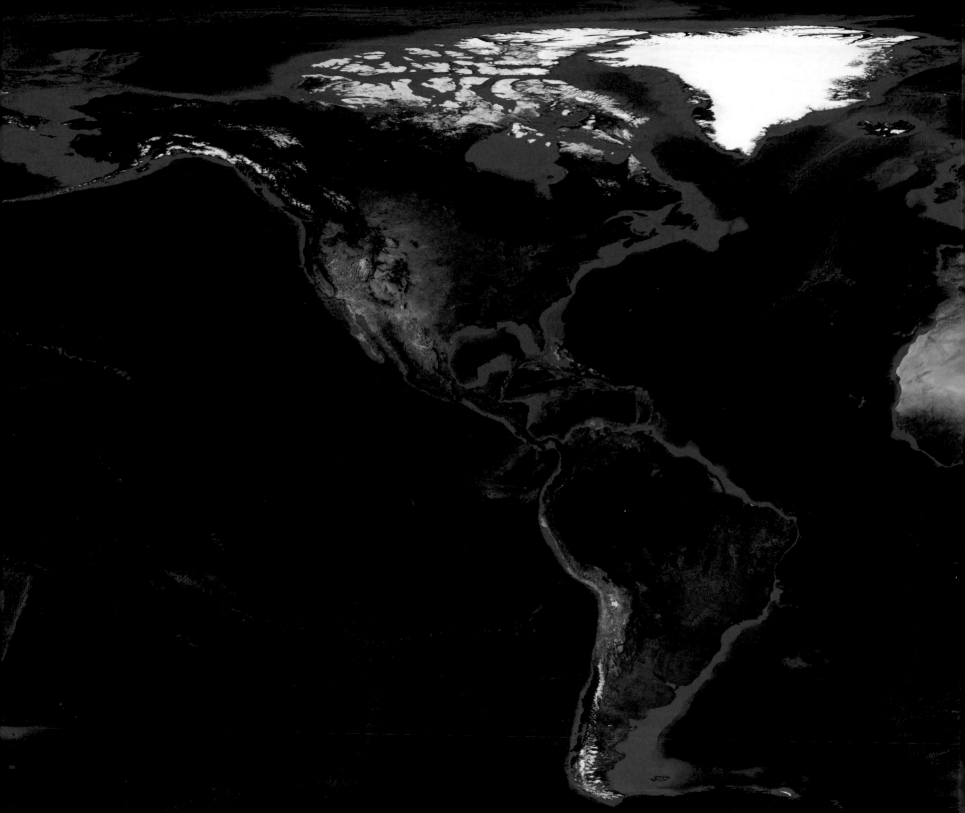

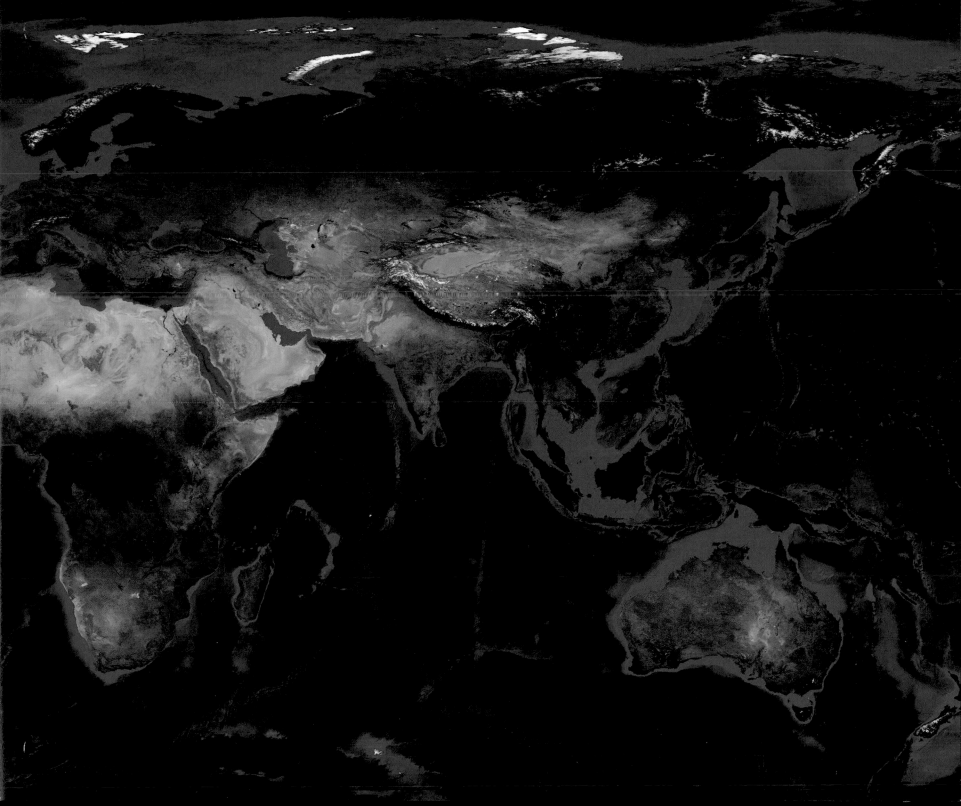

PREVIOUS PAGE:

The Blue Marble: Next Generation
project consists of a year's worth
of monthly composites taken
at a spatial resolution of 500m
(1,640ft). These monthly images
reveal seasonal changes to the
land surface: the green-up and
dying-back of vegetation in
temperate regions such as North
America and Europe, dry and
wet seasons in the tropics, and
advancing and retreating Northern
Hemisphere snow cover.

Much
of the
information
contained
in this image
came from a single
remote-sensing device –
NASA's Moderate Resolution
Imaging Spectroradiometer (MODIS).
Flying over 700km (435 miles) above the
Earth on board the Terra satellite, MODIS
provided an integrated tool for observing
a variety of terrestrial, oceanic, and
atmospheric features of the Earth.

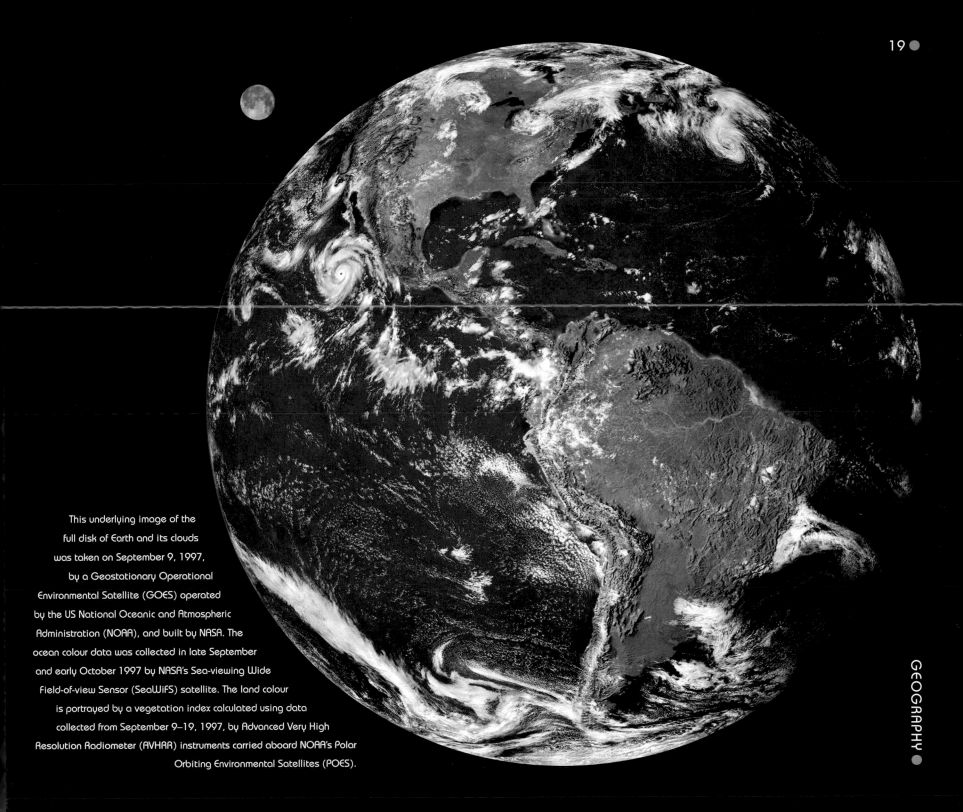

This underlying image of the full disk of Earth and its clouds was taken on September 9, 1997, by a Geostationary Operational Environmental Satellite (GOES) operated by the US National Oceanic and Atmospheric Administration (NOAA), and built by NASA. The ocean colour data was collected in late September and early October 1997 by NASA's Sea-viewing Wide field-of-view Sensor (SeaWiFS) satellite. The land colour is portrayed by a vegetation index calculated using data collected from September 9–19, 1997, by Advanced Very High Resolution Radiometer (AVHRR) instruments carried aboard NOAA's Polar Orbiting Environmental Satellites (POES).

GEOGRAPHY

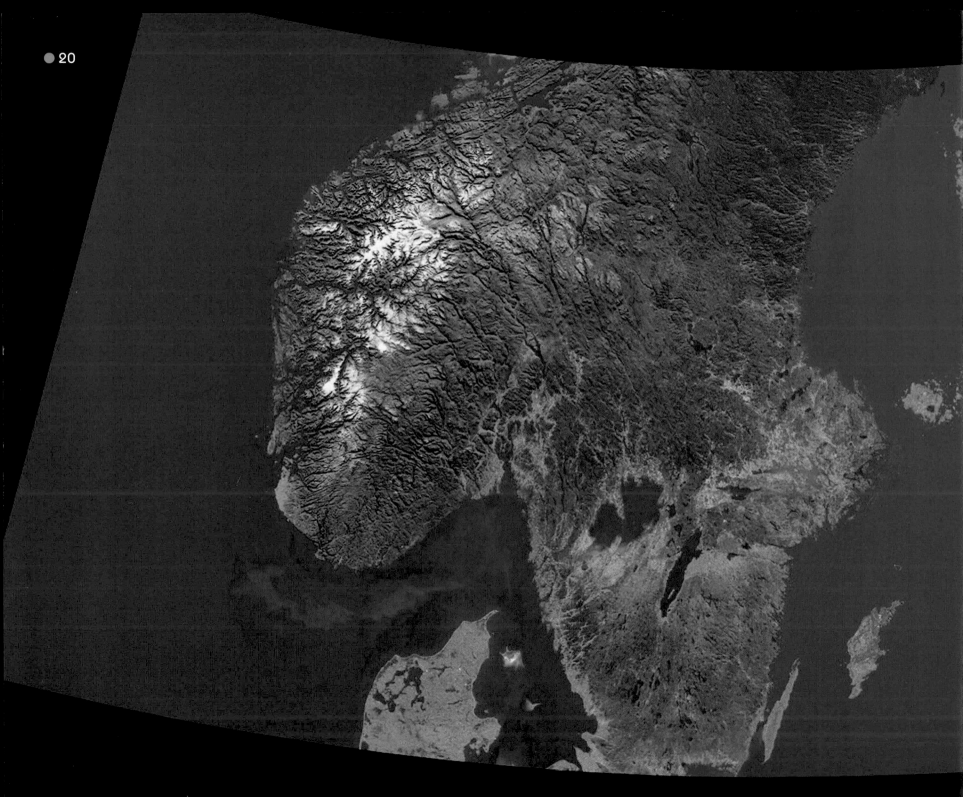

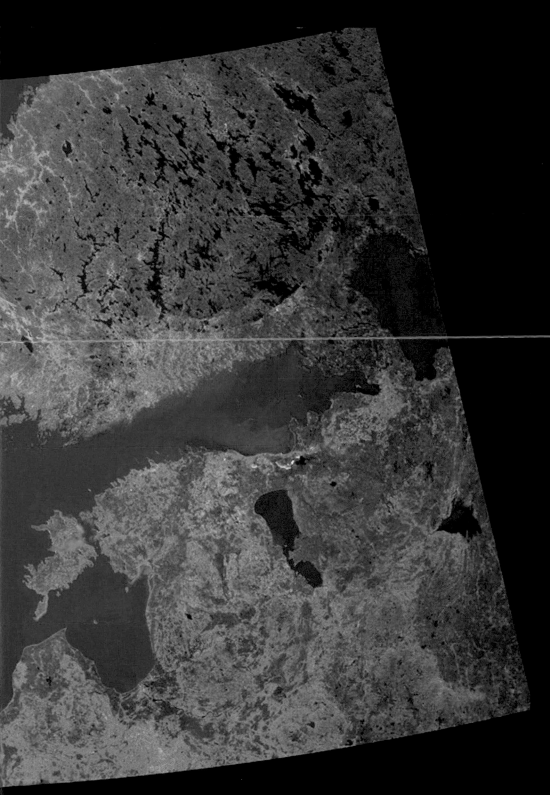

The Strait of Messina Bridge Project, if completed, would stand as one of the landmark bridges of the 21st century. The Strait of Messina divides the island of Sicily from Calabria in southern Italy, and is 3km (1¾ miles) wide. While the overall length is not a big problem, the economics, water depth, wind, and the possibility of earthquakes all have to be accounted for. To avoid the problem of the deep water, the solution being proposed is the longest suspension bridge ever. It will have a 3,300m (10,800ft) main span and 180m (590ft) side spans, giving it an overall length of 3.7km (2¼ miles). This image was taken by the ASTER instrument aboard NASA's Terra satellite.

Data from the Multi-angle Imaging SpectroRadiometer's (MISR) vertical-viewing (nadir) camera were combined to create this cloud-free natural-colour mosaic of Scandinavia and the Baltic region. The image has been draped over a shaded relief Digital Terrain Elevation Model from the United States Geological Survey. The image area includes southern Norway, Sweden and Finland, northern Denmark, Estonia, Latvia and part of western Russia. The MISR observes the day-lit Earth continuously from pole to pole, and every nine days views the entire globe between 82-degrees north and 82-degrees south latitude.

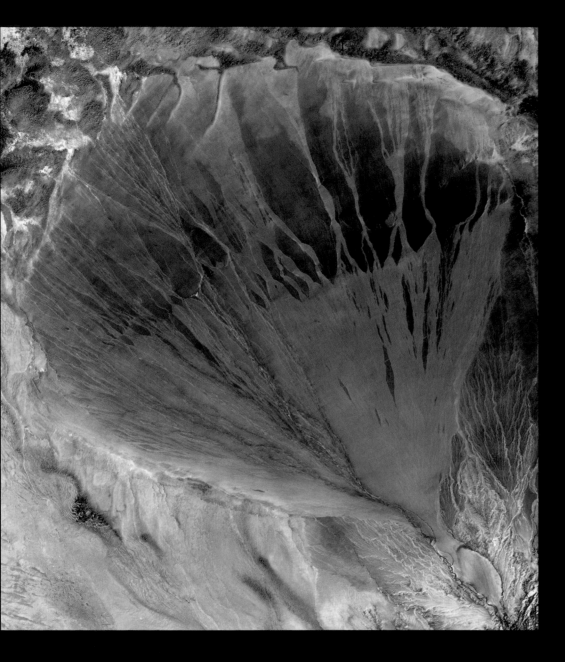

A vast alluvial fan blossoms across the desolate landscape between the Kunlun and Altun mountain ranges that form the southern border of the Taklimakan Desert in China's XinJiang Province. The left side is the active part of the fan, and appears blue from the water currently flowing in the many small streams.

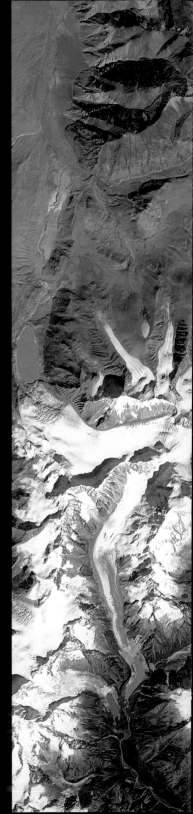

One of the highest mountain reliefs on Earth can be found in the tiny country of Bhutan. Sandwiched between eastern India and the Tibetan plateau, Bhutan hosts peaks that reach between 5,000 and 7,000m (16,000–23,000ft) in height. The impressive Bhutan Himalayas are permanently capped with snow, which extends down valleys in long glacier tongues. Because of weather patterns on each side of the Himalaya and differences in topography, the glaciers on each side of the mountain are distinctly different from one another and are likely to react very differently to climate change. This picture, taken by the ASTER instrument, is one of a series of images used to study the glaciers of the Bhutan Himalayas.

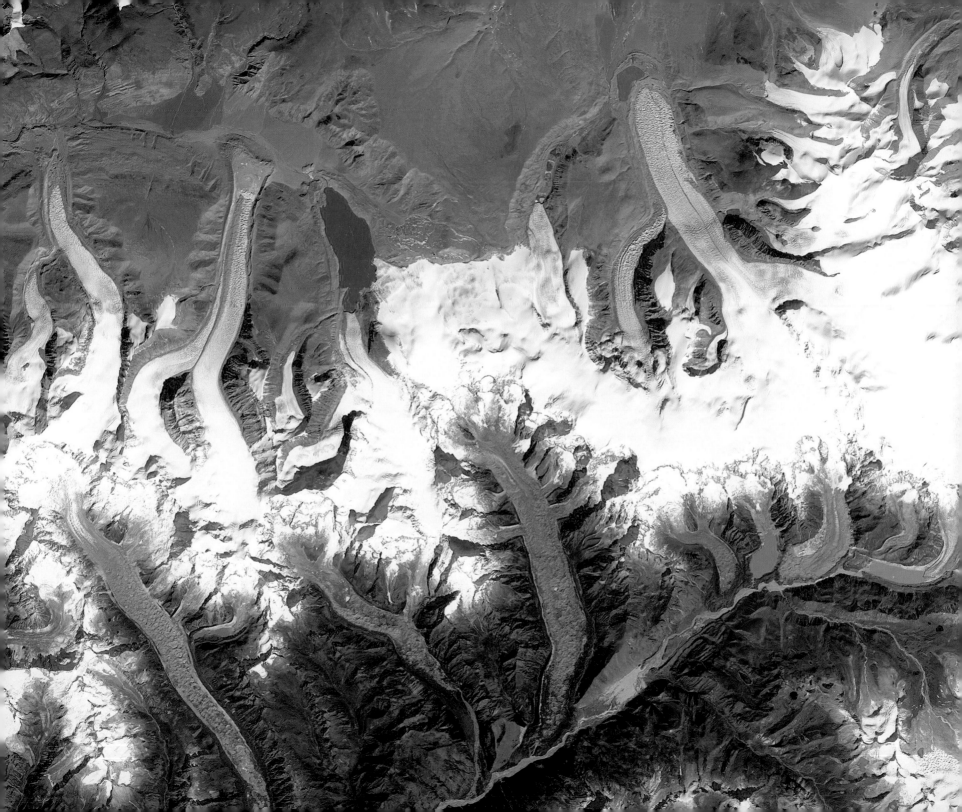

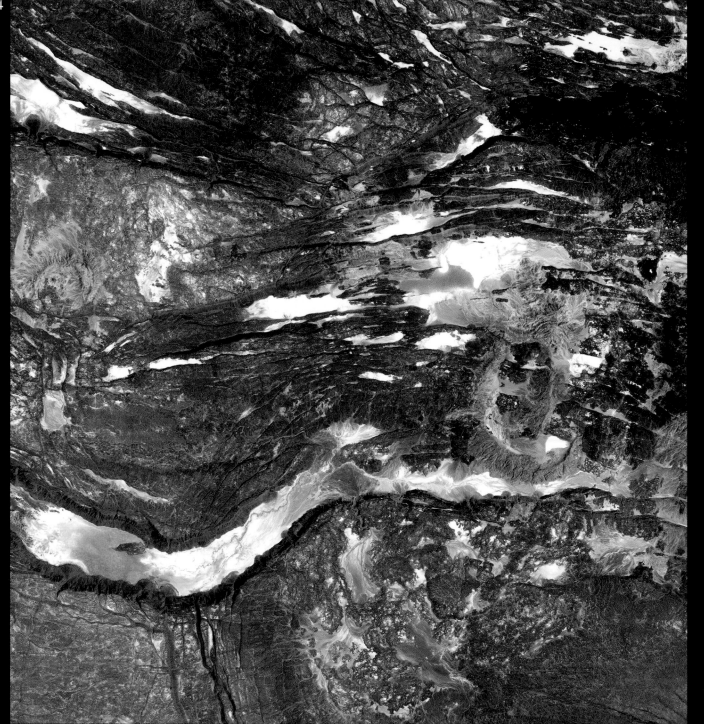

The Afar Depression is a plate tectonic triple junction where the spreading ridges that are forming the Red Sea and the Gulf of Aden emerge on land and meet the East African Rift. The Afar Depression is one of two places on Earth where a mid-ocean ridge can be studied on land, the other being Iceland. The Afar is slowly being pulled apart at a rate of 1–2cm (⅜–¾in) per year. The floor of the Afar Depression is composed mostly of basaltic lava. The Afar Depression and Triple Junction also mark the location of a mantle plume, a great uprising of mantle that melts to yield basalt (like Yellowstone and Hawaii).

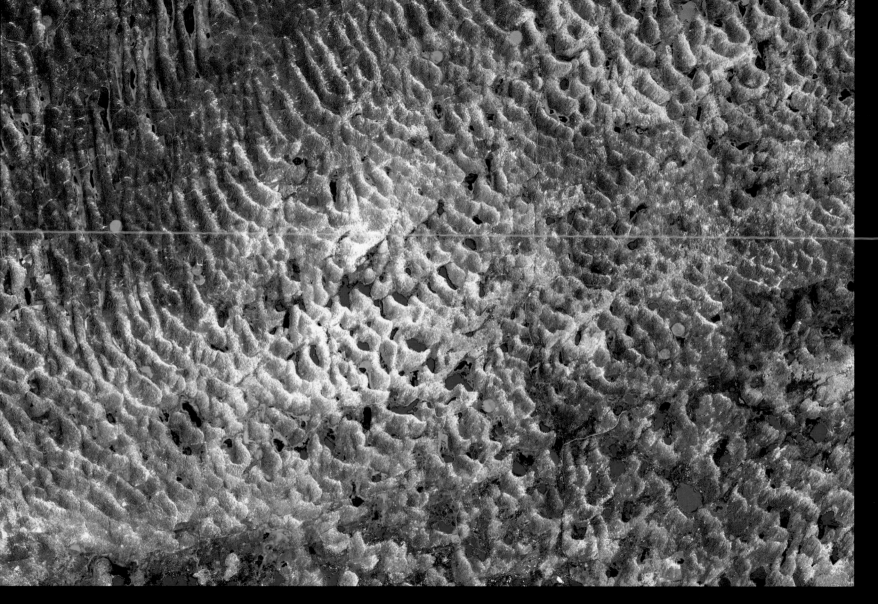

About a quarter of Nebraska is covered by the Sand Hills. These are Pleistocene (1.8–1.6 million to 10,000 years before the present) sand dunes derived from glacial outwash eroded from the Rocky Mountains, and now stabilized by vegetation. The hills are characterized by crowded barchan (crescent-shaped) dunes, general

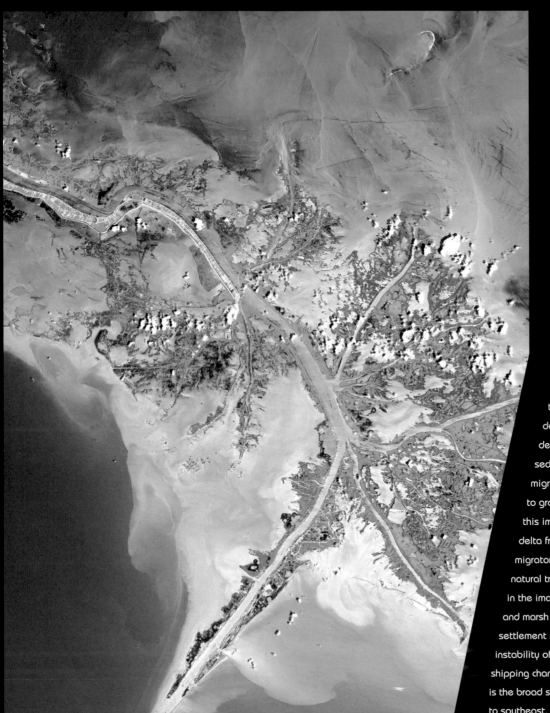

As the Mississippi River
enters the Gulf of Mexico,
it loses energy and dumps
its load of sediment that it
has carried on its journey
through the mid-continent.
This pile of sediment, or
mud, accumulates over
the years building up the
delta front. As one part of the
delta becomes clogged with
sediment, the delta front will
migrate in search of new areas
to grow. The area shown on
this image is the currently active
delta front of the Mississippi. The
migratory nature of the delta forms
natural traps for oil. Most of the land
in the image consists of mud flats
and marsh lands. There is little human
settlement in this area due to the
instability of the sediments. The main
shipping channel of the Mississippi River
is the broad stripe running northwest
to southeast.

Bombetoka Bay in northwestern
Madagascar is an inlet of
Mozambique Channel, and is at
the mouth of the Betsiboka River.
Just downstream is the second
largest port of Madagascar,
the town of Mahajanga, a road
terminus and trade centre that
exports sugar, coffee, spices,
cassava (manioc), vegetable
oils, timber, and vanilla. The
surrounding area abounds in
extensive coffee plantations. The
simulated natural-colour ASTER
image covers an area of 2.9 x
30.4km (1¾ x 18¾ miles).

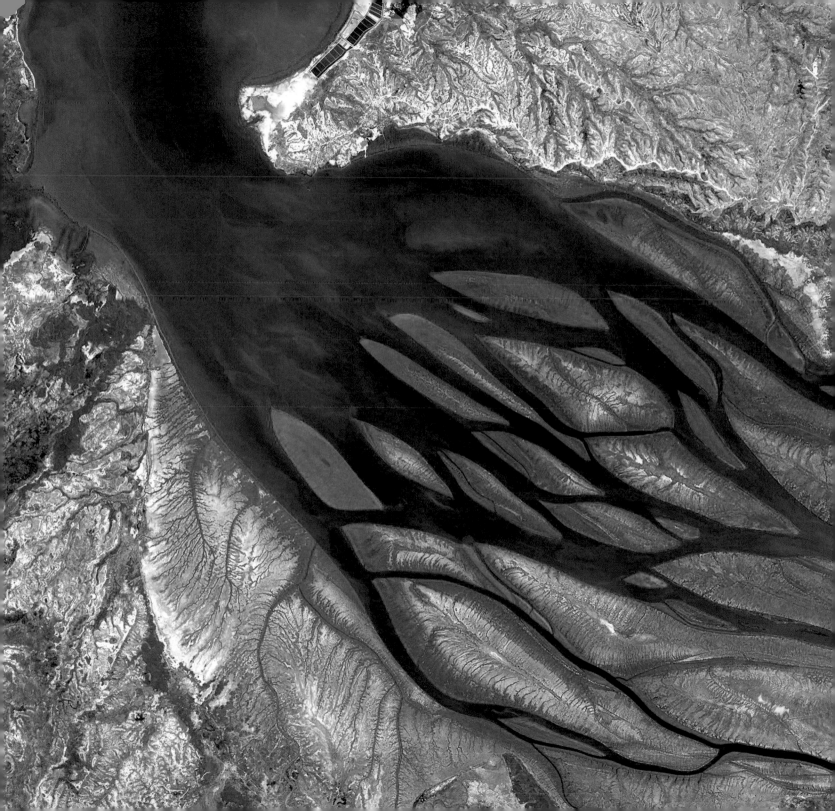

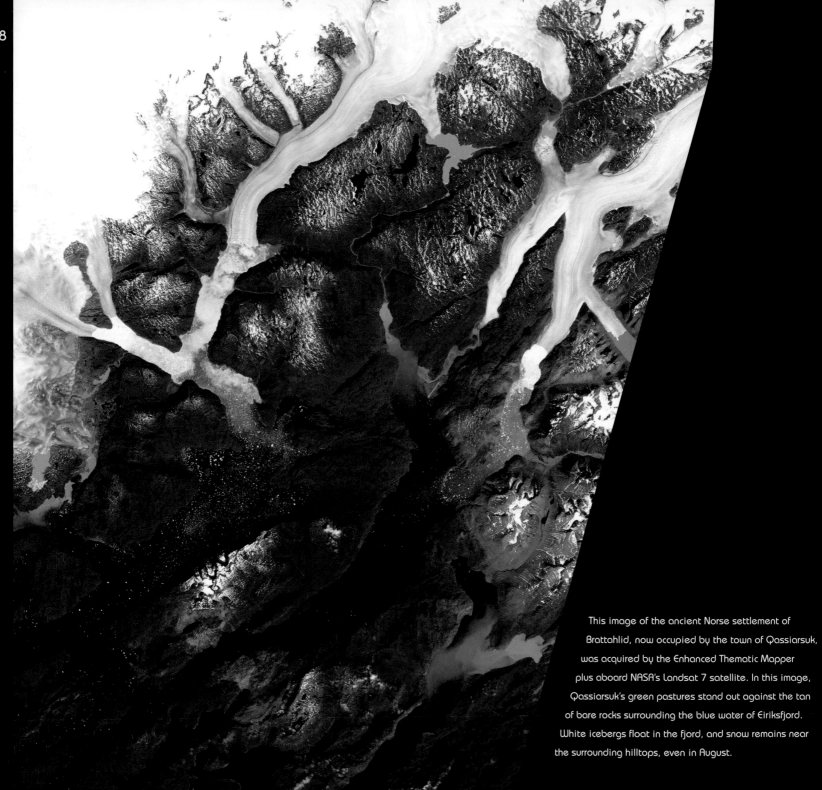

This image of the ancient Norse settlement of
Brattahlid, now occupied by the town of Qassiarsuk,
was acquired by the Enhanced Thematic Mapper
plus aboard NASA's Landsat 7 satellite. In this image,
Qassiarsuk's green pastures stand out against the tan
of bare rocks surrounding the blue water of Eiriksfjord.
White icebergs float in the fjord, and snow remains near
the surrounding hilltops, even in August.

Egmont National Park, in New Zealand, is dominated by the dormant volcano of Mount Taranaki. Since the area has a high rainfall rate and mild coastal climate there is a lush rainforest covering the foothills, changing to sub-alpine and alpine shrublands at high elevations, which are in stark contrast to the surrounding pasture farmlands. Mount Taranaki was first named Mount Egmont by Captain James Cook.

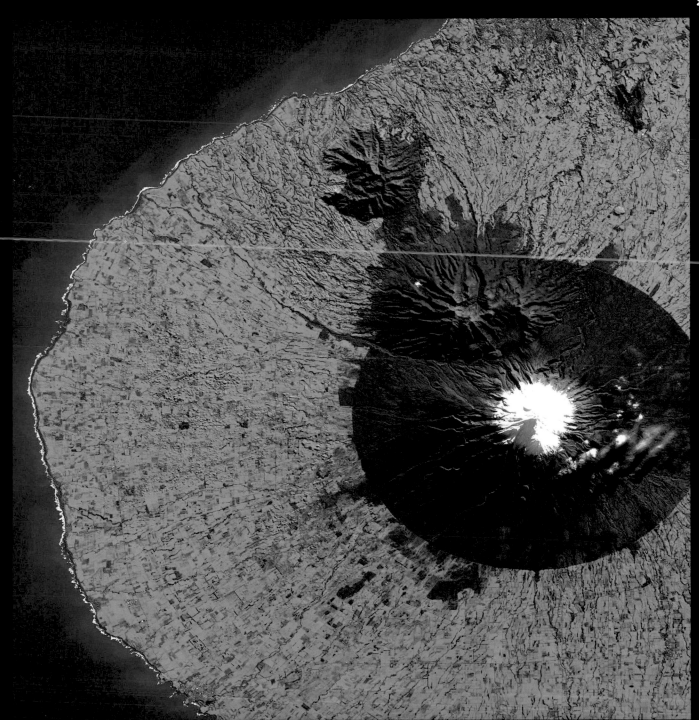

The island of Cozumel off the eastern coast of Mexico's Yucatan Peninsula is the largest of the islands in the Mesoamerican Reef system. The Mesoamerican Reef itself is the largest in the Atlantic Ocean, and it stretches about 724km (450 miles) southward from the tip of the Yucatan Peninsula to the coast of Honduras. Cozumel's white-sand beaches slope down into the transparent waters that surround the island's spectacular coral reefs. The interior of the island is relatively undeveloped, making it a refuge for endemic and endangered species of birds and other animals. This image of the island was captured by the Landsat satellite. The major resort area, San Miguel, makes a white spot on the western coastline, and roads can be seen crisscrossing the interior.

Nestled between the large Indonesian islands of Java and Sumatra is the Krakatau Volcano National Park. In August 1883 the volcano on Krakatau erupted with such violence that the sound was heard as far away as Madagascar and Alice Springs, thousands of kilometres away. Two-thirds of the island was destroyed and roughly 20 cubic km of rock was lofted into the atmosphere. It was one of the largest explosions on Earth in recorded history. The eruption also raised a tsunami 40m (130ft) high which resulted in an estimated 36,000 deaths when it washed ashore as much as 10km (6 miles) inland from the coast of nearby islands. Since 1927, continued eruptions and outflow material has formed the fourth island in the park, Anak Krakatau – 'Child of Krakatau.' This scene was acquired by the Landsat 5 Thematic Mapper instrument, and this natural-colour composite uses red, green and blue wavelengths.

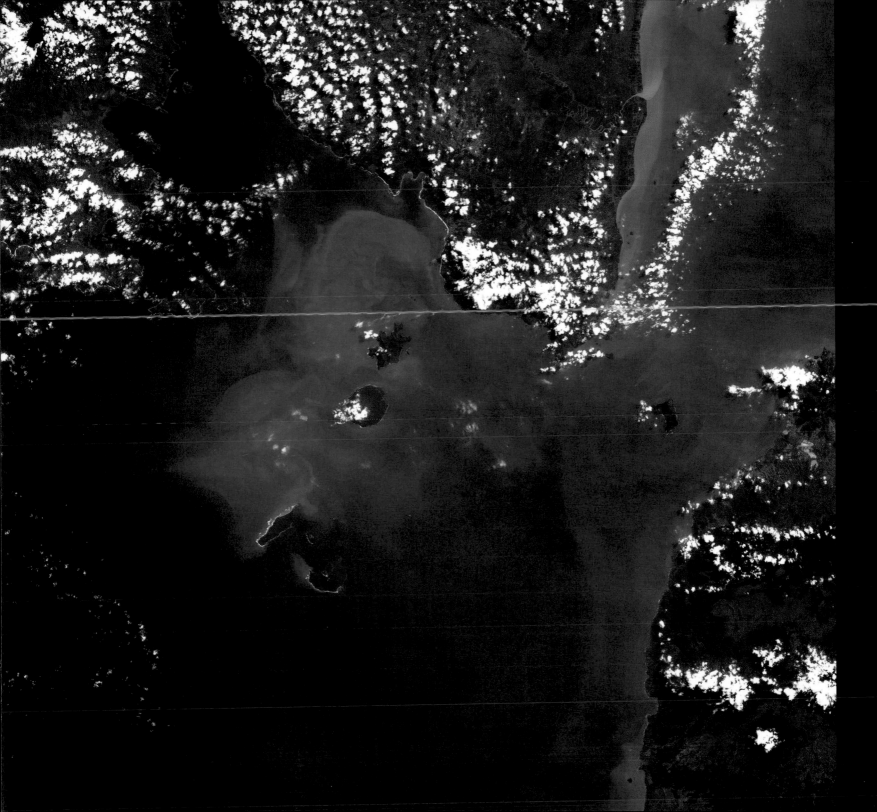

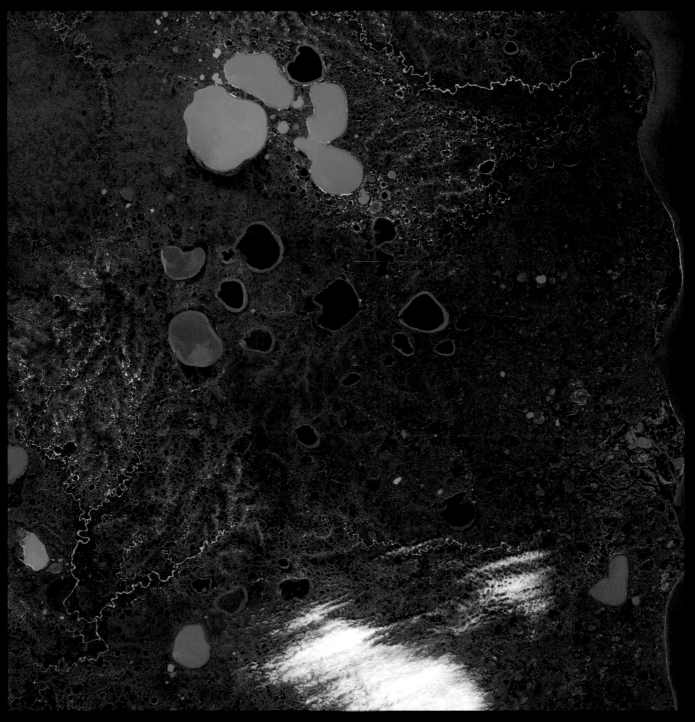

When the Pleistocene Ice Age reached its peak around 22,000 years ago, continent-spanning glaciers covered large sections of North America and Eurasia like a sheet. As the Ice Age waned, the glaciers retreated. Occasionally large chunks of ice broke off from the glacier and became surrounded or even buried by soil and rock debris deposited by the melting ice sheet. Eventually, the blocks of ice also melted, leaving behind a depression in the ground. These depressions are called kettles; when they are filled with water, they are called kettle lakes, or pothole lakes. This natural-colour Landsat 7 image shows blue and green pothole lakes in northern Siberia. The different colours of the lakes reflect different amounts of sediment or depth; the deeper or clearer the water, the bluer the lake. Scientists use satellite images of these glacial kettle lakes to measure water clarity, to make environmental assessments and to study climate change.

Lake Natron, in Africa's Great Rift Valley, practically sends a warning with its colour. This bright red lake is the world's most caustic body of water, but not to everything. An endemic species of fish, the alkaline tilapia, lives along the edges of the hotspring inlets, and the lake actually derives its colour from salt-loving micro-organisms that thrive in its alkaline waters. Spirulina, a blue-green algae with red pigments, passes its pigments along to the Lesser Flamingos that feed on the algae and raise their young here. The ASTER instrument on board the Terra satellite captured this image, which simulates natural colour to show where the salt-loving micro-organisms have coloured the lake's salt crust red or pink. The salt crust changes over time, giving the lake a slightly different appearance each time it is photographed by astronauts or imaged by satellites.

A simulated natural-colour ASTER image of Olduvai Gorge, an archaeological site located in the eastern Serengeti Plains, northern Tanzania within the Ngorongoro Conservation Area. The gorge is a very steep sided ravine roughly 50km (31 miles) long and 90m (295ft) deep. Exposed deposits show rich fossil fauna, many hominid remains and items belonging to one of the oldest stone tool technologies, called Olduwan. The time span of the objects recovered dates from 2,100,000 to 15,000 years ago.

This ASTER image shows the junctions of the Amazon and the Rio Negro Rivers at Manaus, Brazil. The Rio Negro flows 2,300km (1,429 miles) from Columbia, and is the dark current forming the north side of the river. It gets its colour from the high tannin content in the water. The Amazon is sediment laden, appearing brown in this simulated natural colour image. Manaus is the capital of Amazonas state, and has a population in excess of one million.

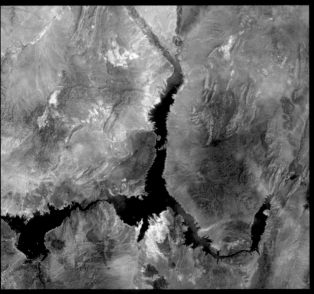

In the western United States, water is the most critical natural resource. In addition to drinking supplies, water sustains agriculture, provides hydroelectric power, and nourishes ecosystems. This Landsat 7 satellite image shows the artificial Lake Mead reservoir on the Colorado River, one of the most important water caches in the western states which, in recent years, has been brought to unusually low levels thanks to years of sustained drought.

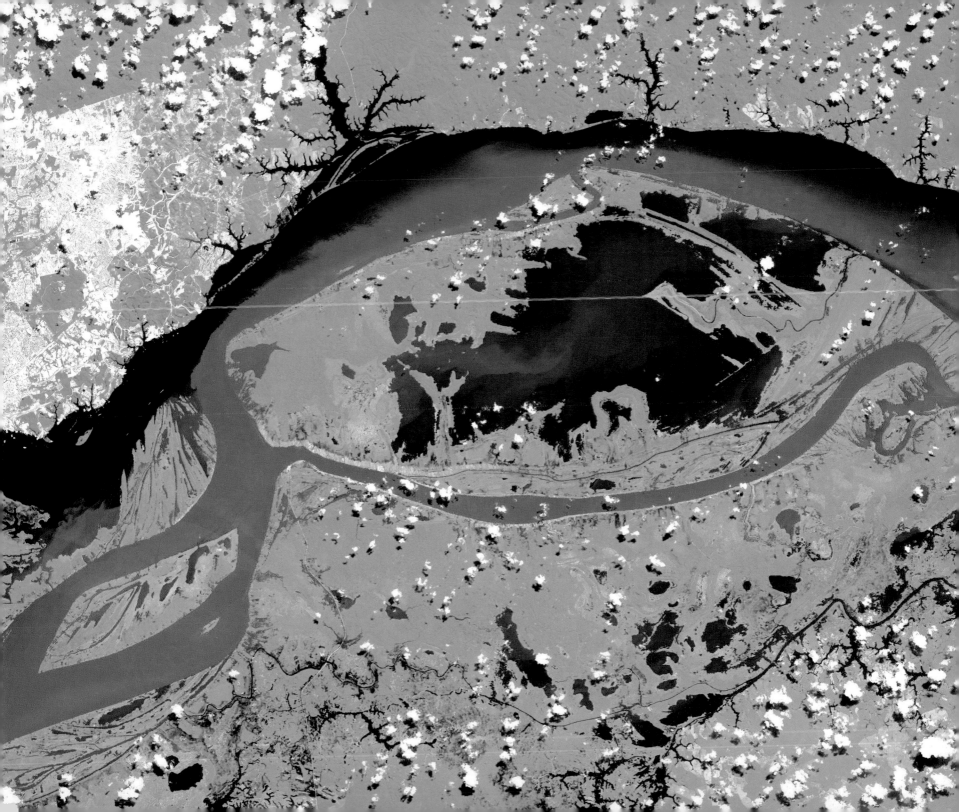

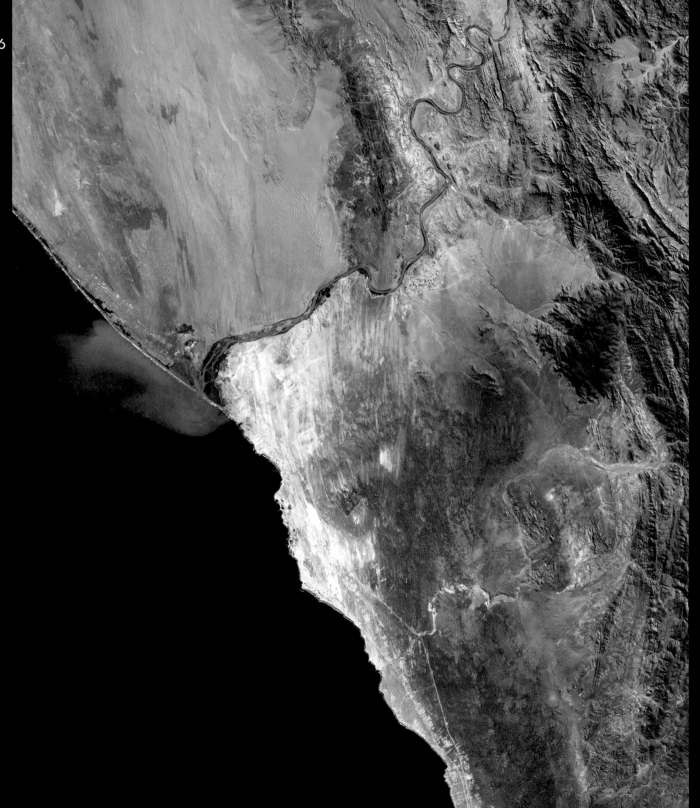

In southwestern Africa, the Orange River carves through a rugged, stark, and beautiful landscape before emptying its desert-sand-filled waters into the South Atlantic Ocean. The river is a political and geographical divide, separating Namibia from South Africa and the massive sand dunes of the lower Namib Desert from the swept-rock moonscape of northwestern Namaqualand. This image shows the last 100km (60 miles) of the Orange River, which is born in the Drakensberg Mountains on the eastern side of the continent and snakes more than 2,000km (1,200 miles) across South Africa. In this last stretch the gravel deposits in the river bed and the banks are rich with diamonds, with several mines operating along it. The Enhanced Thematic Mapper Plus (ETM+) instrument on Landsat 7 aquired this scene, and this natural-colour composite was created by combining red, green, and blue wavelength data.

The Stirling Range National Park in the southwestern corner of Australia forms a rare patch of deep green, wooded hillsides and parkland in an area dominated by checkerboard plains of agricultural land. The Stirling Range reaches as high as 1,095m (3,600ft) above sea level at Bluff

dramatic imprint of wide-scale agriculture in sharp contrast to the natural and essentially unaltered state of natural affairs within the park. The sharp, clearly defined boundaries on all sides of the national park show where agriculture immediately gives way to protected land. The

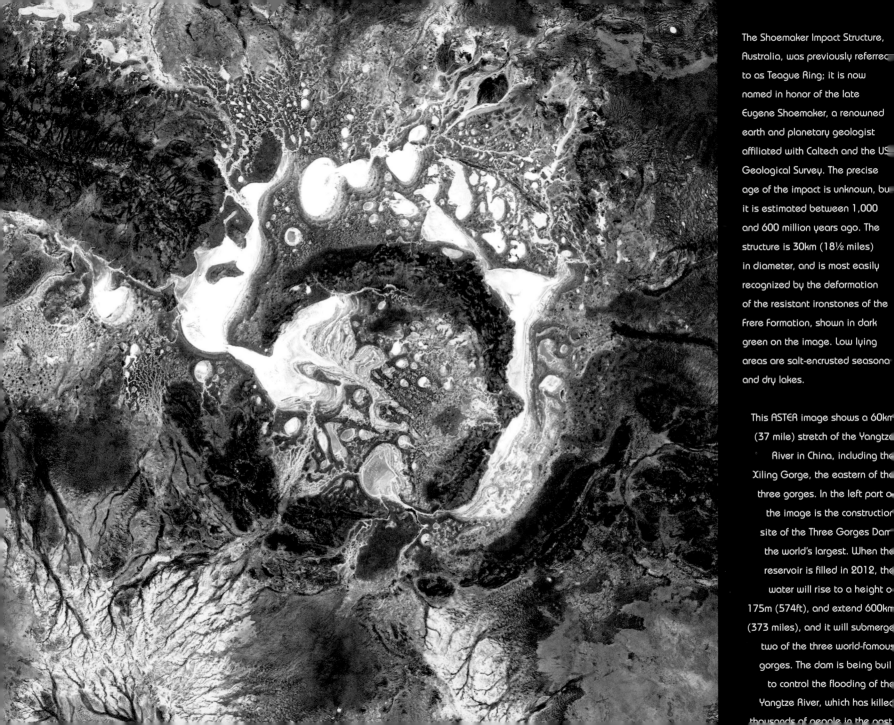

The Shoemaker Impact Structure, Australia, was previously referred to as Teague Ring; it is now named in honor of the late Eugene Shoemaker, a renowned earth and planetary geologist affiliated with Caltech and the US Geological Survey. The precise age of the impact is unknown, but it is estimated between 1,000 and 600 million years ago. The structure is 30km (18½ miles) in diameter, and is most easily recognized by the deformation of the resistant ironstones of the Frere Formation, shown in dark green on the image. Low lying areas are salt-encrusted seasonal and dry lakes.

This ASTER image shows a 60km (37 mile) stretch of the Yangtze River in China, including the Xiling Gorge, the eastern of the three gorges. In the left part of the image is the construction site of the Three Gorges Dam, the world's largest. When the reservoir is filled in 2012, the water will rise to a height of 175m (574ft), and extend 600km (373 miles), and it will submerge two of the three world-famous gorges. The dam is being built to control the flooding of the Yangtze River, which has killed thousands of people in the past.

Cutting across the Manchurian Plain of northern China, the Songhua River flows north out of the Changbai Mountains. As China's northernmost river system, the Songhua is an important artery for transporting agricultural products grown on the plain. On its way, the river flows past Harbin, the capital of China's Heilongjiang Province. The extreme flatness of the Manchurian Plain has caused the river to meander widely over time. Classic fluvial features are seen here, such as ox-bow lakes, formed when a meander is cut off. Meandering rivers shift their positions across the valley bottom by depositing sediment on the inside of bends while simultaneously eroding the outer banks of the meander.

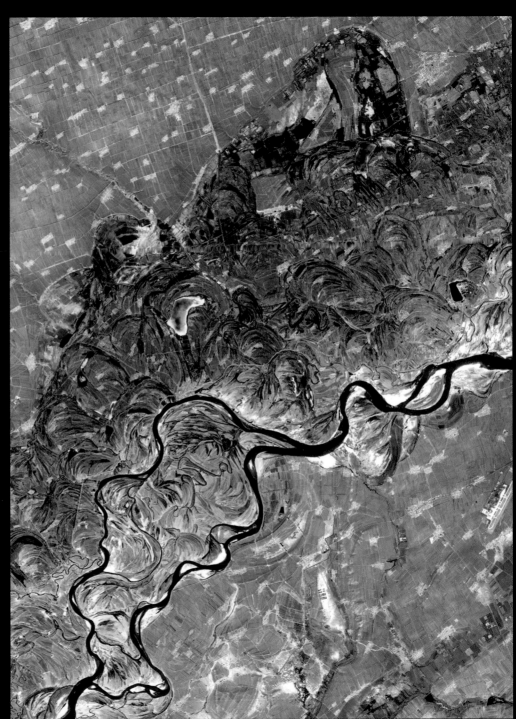

GEOGRAPHY

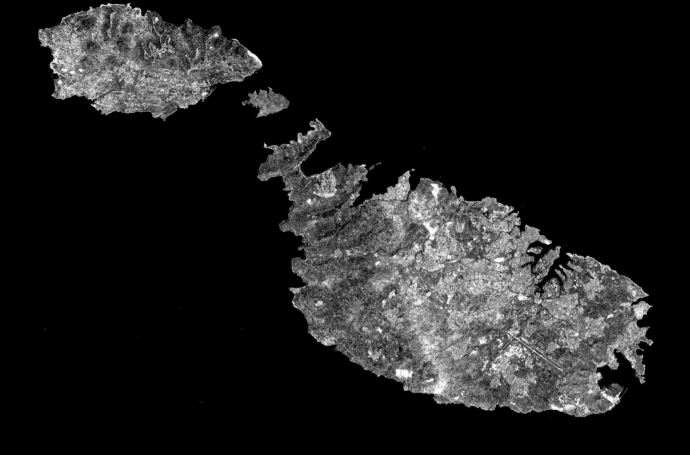

floodwaters and to hold water
to enable it to recharge the
underground aquifer. Five dams
in this ASTER scene, acquired on
January 23, 2005, can be seen
along the San Gabriel River:
Cogwell, San Gabriel, Morris,
Santa Fe, and Whittier Narrows.

● PART ONE: THE WORLD VIEWED

Malta, an independent republic, consists of a small group of islands – Malta, Gozo, Kemmuna,
Kemmunett, and Filfla – located in the Mediterranean Sea south of Sicily, with a total area of
316 sq km (122 sq miles). The islands of Malta consist of low-lying coralline limestone plateaus
surrounded by impermeable clay slopes, and the highest point is 239m (784ft) above sea level.

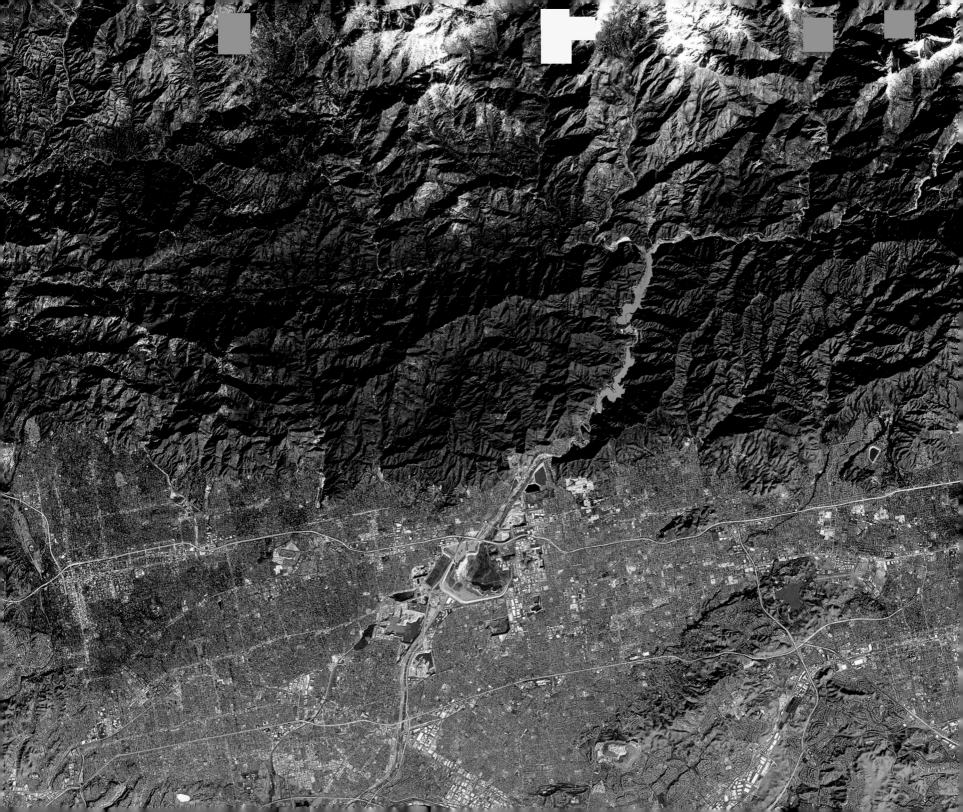

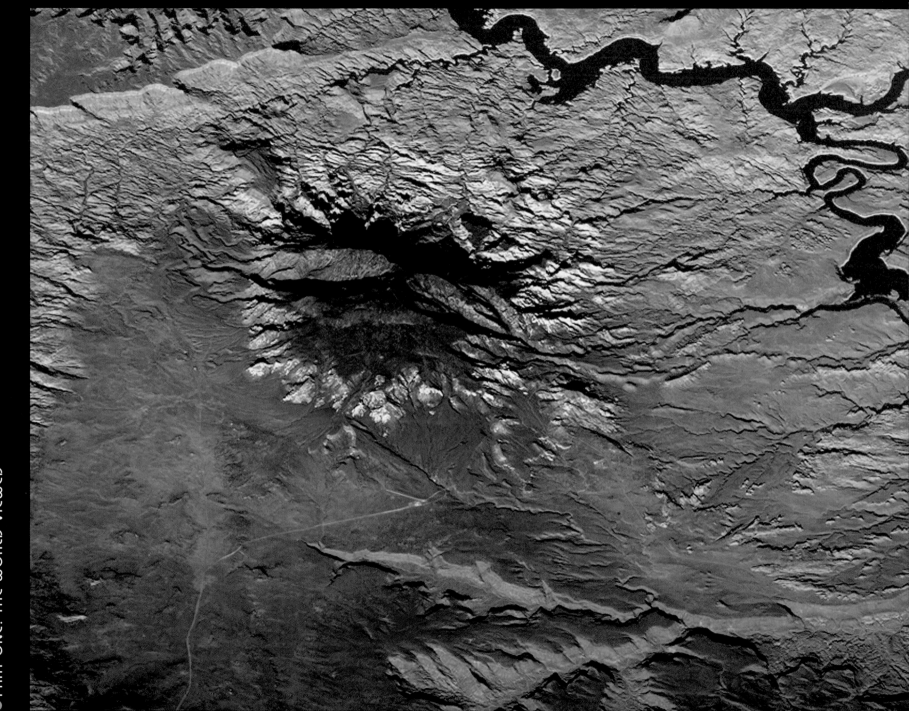

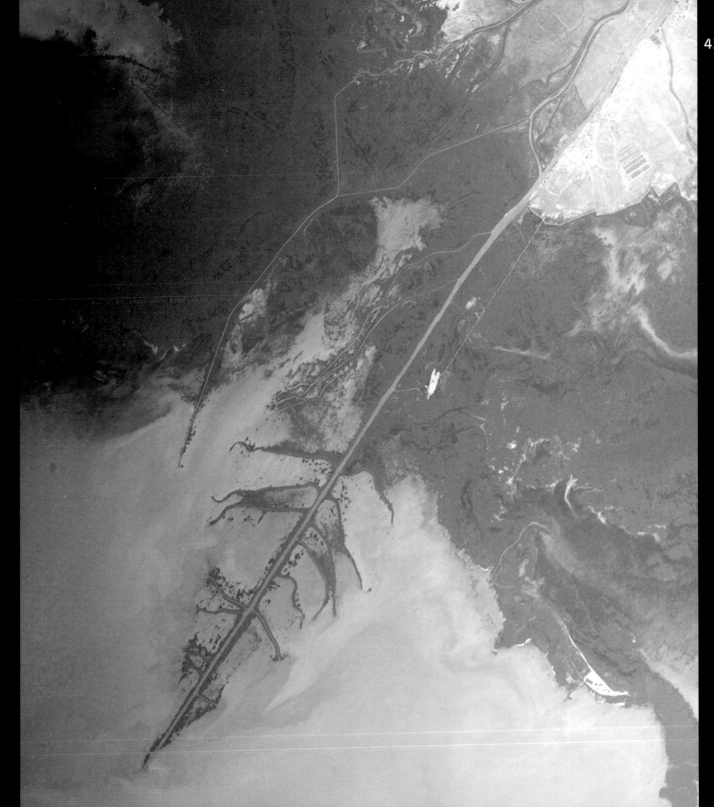

The Colorado Plateau is made of mostly flat-lying layers of sedimentary rock that record paleoclimate extremes ranging from oceans to deserts over the last 1.8 billion years. Navajo Mountain in southeastern Utah is a dome-shaped chunk of igneous rock that intruded into the sedimentary layers lifting up the overlying layer. This oblique astronaut photograph highlights the mountain surrounded by light red-brown Navajo Sandstone, while the igneous rock at the core is wrapped in sedimentary layers.

The Ural River empties into the northern coast of the Caspian Sea, creating extensive wetlands. This image shows details of the Ural's tree-like delta which forms naturally when wave action is low, and sediment content in the river is high. New distributary channels form in the delta when the river breaches natural levees formed by sediment deposition. The long main channel of the river and several of the distibutary channels are too regular to be entirely natural, however. Like the Mississippi River delta in the United States, the Ural River delta has been significantly modified to reduce flooding and divert water.

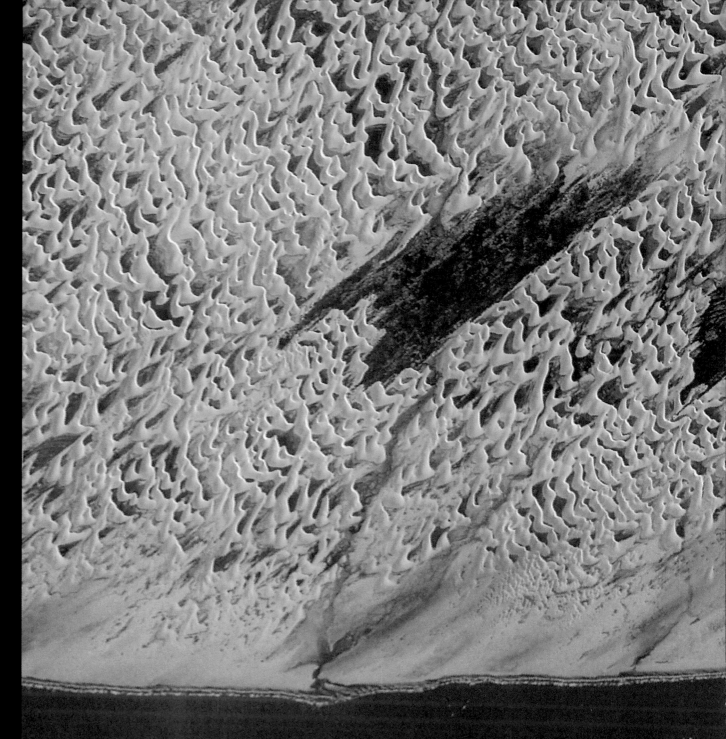

The area shown here, some 10km (6 miles) across, is a small part of the dune field which is now protected as the Lençóis Maranhenses National Park, on Brazil's north coast, about 700km (435 miles) east of the Amazon River mouth. Persistent winds blow off the equatorial Atlantic Ocean on to Brazil from the east, driving white sand inland from the 100km (62 mile) stretch of coast, to form a large field of dunes. The strongly regular pattern of these dunes is a common characteristic of dune fields. The basic shape of each sand mass, repeated throughout the view, is a crescent-shaped dune. The wind strength and supply of sand are sufficient to keep the dunes active, and thus free of vegetation, despite 150cm (60in) of rainfall annually. This image was taken by an astronaut aboard the International Space Station (ISS) using a Kodak

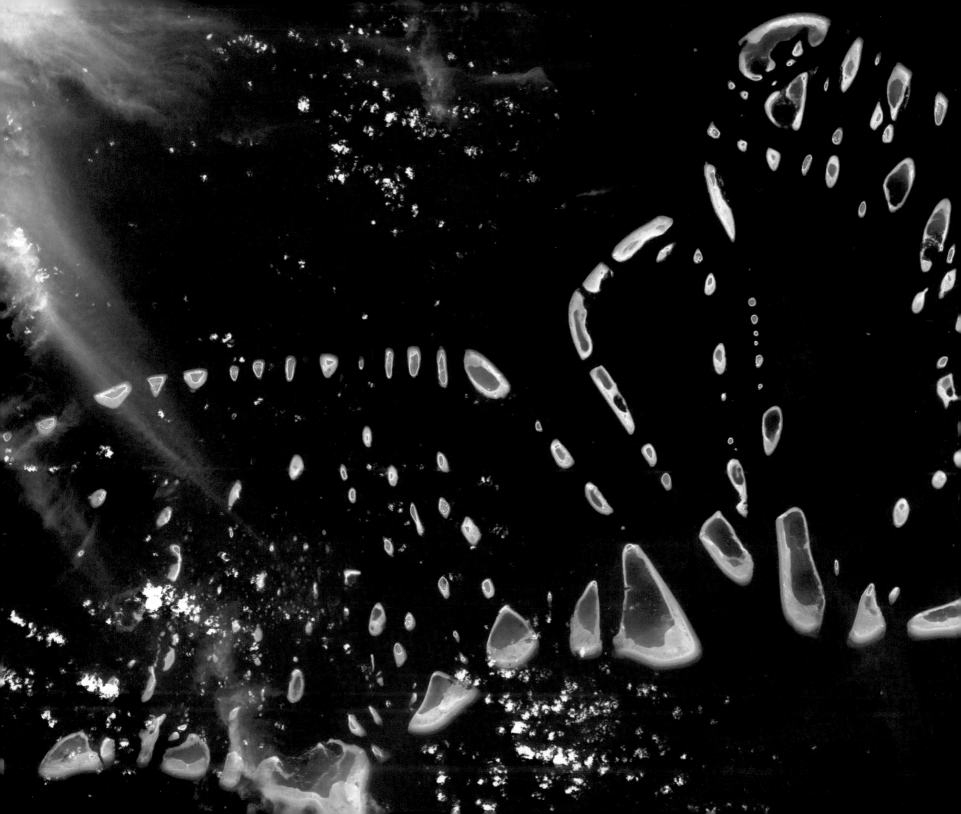

OCEANS & SEAS

PREVIOUS PAGE:
This is a simulated natural-colour ASTER image of North and South Malosmadulu Atolls in the Maldives, an island republic in the northern Indian Ocean, southwest of India. The Maldives is made up of a chain of 1,192 small coral islands that are grouped into clusters of atolls, and it has a total area of 298 sq km (115 sq miles) and a population of about 330,000. The capital and largest city is Male, with a population of about 80,000. Arguably the lowest-lying country in the world, the average elevation is just 1m (3ft) above sea level. Waves triggered by the great tsunami of December 2004 spilled over sea walls to flood Male with sand-clouded water and then swept out just as suddenly. Residents fear this was a forewarning of disasters to come from sea-level rise due to global warming.

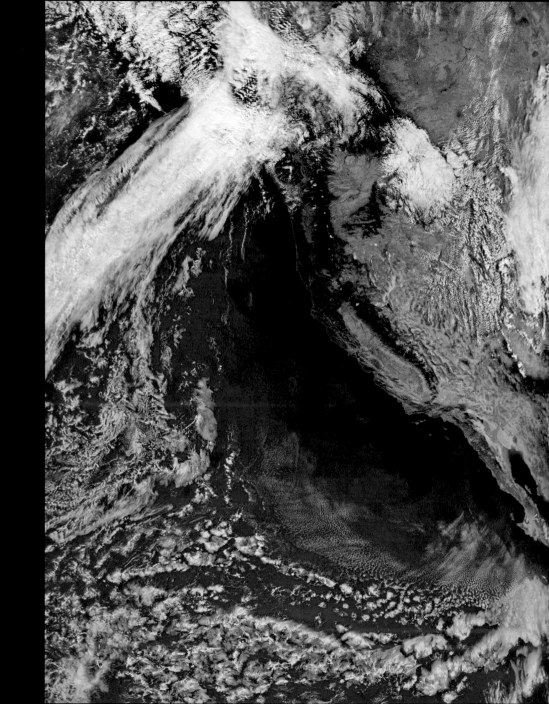

LEFT AND RIGHT:

The Pacific Coast of North America teams with life because of the rich plant life supported by cold ocean waters. The thriving ecosystem is driven by coastal upwelling where deep ocean water pushes to the surface near the coast. Upwelling is not constant: instead it is controlled by the wind, and when winds blow from the north the warm surface water of the ocean is pushed west. Cold ocean water then rushes up from the ocean depths to replace the surface water, carrying with it nutrients that had settled on the ocean floor. Called upwelling, the surge of nutrient-rich cold water nourishes tiny ocean plants called phytoplankton. These plants then become a source of food for other ocean life. On September 21, 2004, the SeaWifS detected high concentrations of chlorophyll along the California, Oregon, and Washington shorelines, an indication that coastal upwelling was strong. An abundance of phytoplankton have coloured the ocean waters dark green in the natural-colour image shown on the left. On the right, chlorophyll concentrations are shown, with the highest concentrations (dark red) near the shore.

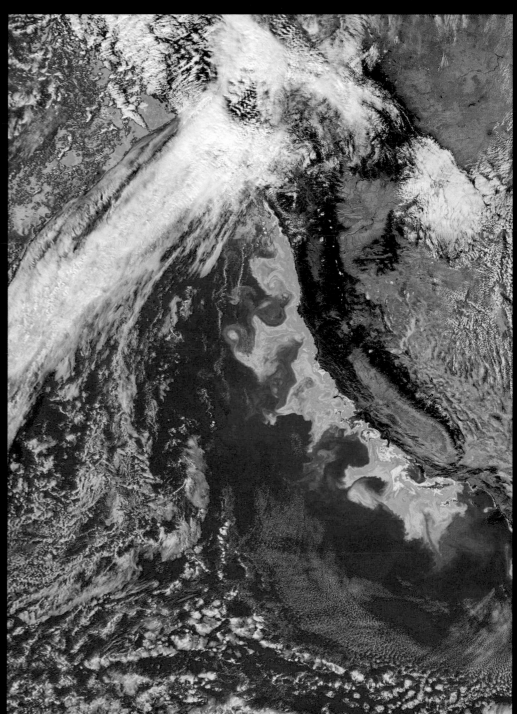

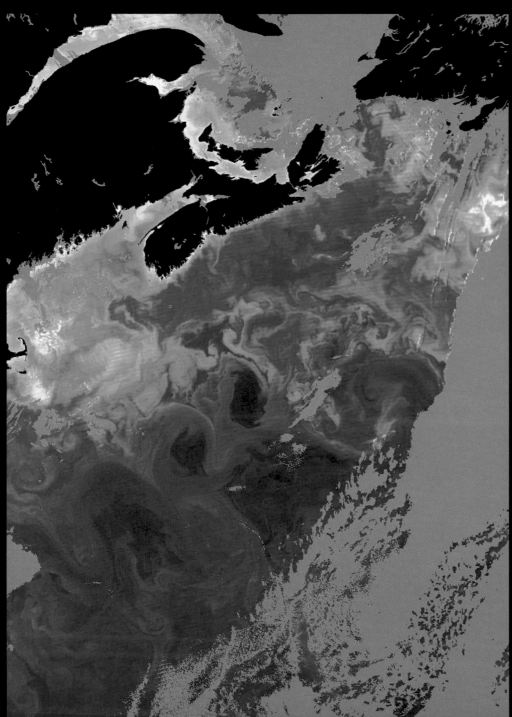

LEFT AND RIGHT:

The Gulf Stream Current is one of the strongest ocean currents on Earth. This river of water that ferries heat from the tropics far into the North Atlantic pulls away from the southeast coast of the United States, around Cape Hatteras, North Carolina, and there the current widens and heads northeastward. In this region, the current begins to meander more, forming curves and loops with swirling eddies on both the colder, northwestern side of the stream and the warmer, southeastern side. These images show the sea surface temperature (right) and chlorophyll concentration (left) of the Gulf Stream on April 18, 2005. In the sea surface temperature image, the warm waters (creamy yellow) of the Gulf Stream snake from bottom left to top right, showing several deep bends in the path. In fact, the northernmost of the two deep bends actually loops back on itself, creating a closed-off eddy. On the northern side of the current, cold waters (blue) dip southward into the Gulf Stream's warmth. Often chlorophyll, which indicates the presence of marine plant life, is higher (yellow) along boundaries between cool and warm waters, where currents are mixing up nutrient-rich water from deep in the ocean. Many of the temperature boundaries along the loops in the Gulf Stream are mirrored in the chlorophyll image with a stripe of lighter blue or yellow, indicating elevated chlorophyll. The grey areas in both of the images are clouds.

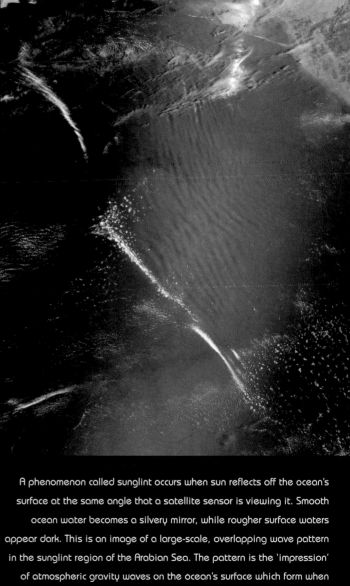

A phenomenon called sunglint occurs when sun reflects off the ocean's surface at the same angle that a satellite sensor is viewing it. Smooth ocean water becomes a silvery mirror, while rougher surface waters appear dark. This is an image of a large-scale, overlapping wave pattern in the sunglint region of the Arabian Sea. The pattern is the 'impression' of atmospheric gravity waves on the ocean's surface which form when buoyancy pushes air up, and gravity pulls it back down. On its descent, the air touches the surface of the ocean, roughening the water. The vertical dark lines show where troughs of gravity waves have roughened the surface. The brighter regions are the crests of the atmospheric waves.

OCEANS & SEAS

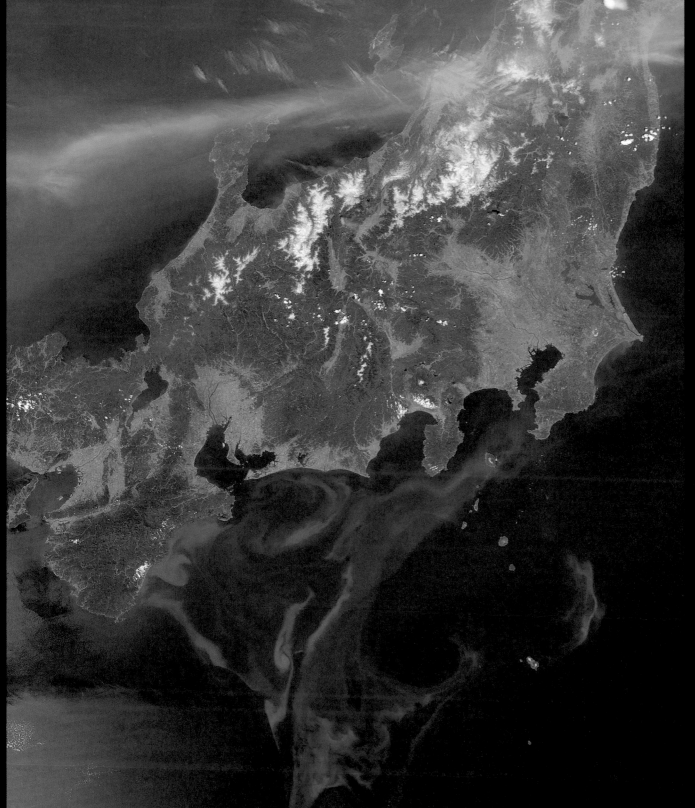

This view of Honshu, Japan's main island, was taken by the MODIS on NASA's Aqua satellite on May 4, 2005. The plume of smoke crossing the island is the result of fires burning in North Korea. To the south, the ocean is brightly coloured with phytoplankton, microscopic plants growing near the surface of the water. Its profusion here may be linked to dust, which settles in the water during springtime sand storms from China. The dust carries iron, a nutrient needed for phytoplankton growth.

The disturbance that islands cause in the flow of water currents in the ocean creates turbulence that mixes surface waters with deeper ocean layers. This mixing increases the amount of nutrients available in the warm surface waters where microscopic ocean plant life grows. Iron-rich sediments running off the islands also enhance plant productivity, particularly when the islands are steep and do not have shallow lagoons where the sediment can settle. This colourful image shows the concentration of chlorophyll in the waters

waters with less chlorophyll are coloured in blue, while progressively higher amounts of plant chlorophyll are yellow. Clouds are white, and the islands are dark grey. The largest of the three islands arranged in a triangle in the centre of the image is Nuku Hiva, and to its east is Ua Huka, and to the south Ua Pou. The highest chlorophyll levels in the region are south of this triangle of islands, while another strong plume is visible stretching northward from Hiva Oa, farther east. Although these islands appear as just a speck

OCEANS

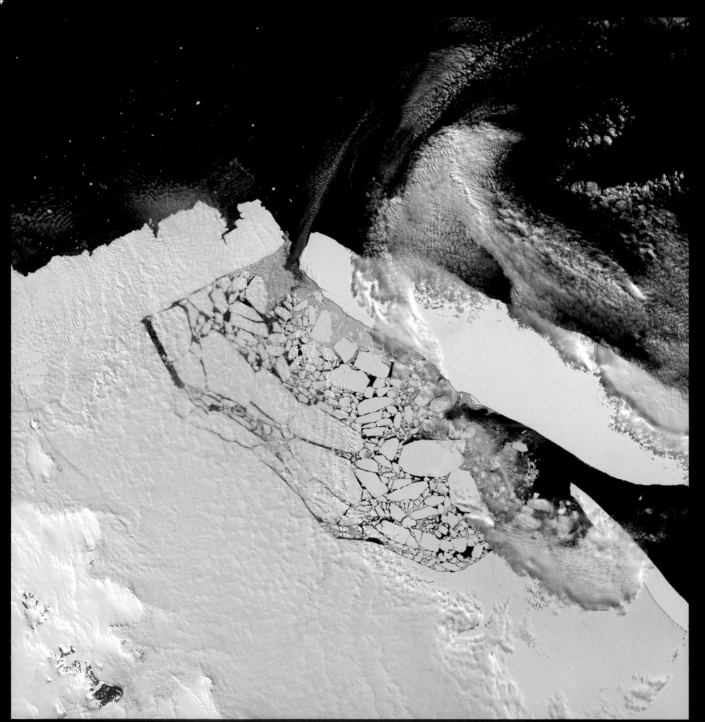

In early January 2005, it appeared that the B-15A iceberg was on a collision course with the Drygalski Ice Tongue, the floating portion of a glacier flowing off the Scott Coast of Antarctica into the Ross Sea. Scientists checked satellite images of the region daily to monitor the iceberg and to witness the impacts. In mid- to late January, however, the berg's forward progress was arrested, and it ran aground in the shallow coastal waters. This image shows at upper left the tip of the Ice Tongue, while at bottom is the northernmost portion of the iceberg. The distance between them on January 21 was less than 5km (3 miles).

As summer wanes, snowmelt and glacial runoff swell the rivers along Alaska's southern coast. Here the Copper River (upper centre) spills light grey sediments into the Gulf of Alaska. Upstream, glaciers grind bedrock into powder as they slowly move along mountain valleys. This fine sediment is easily carried by water, even if it is slow moving. Where the river meets the ocean, the sediment gradually disperses, and the water fades from bright turquoise to dark blue.

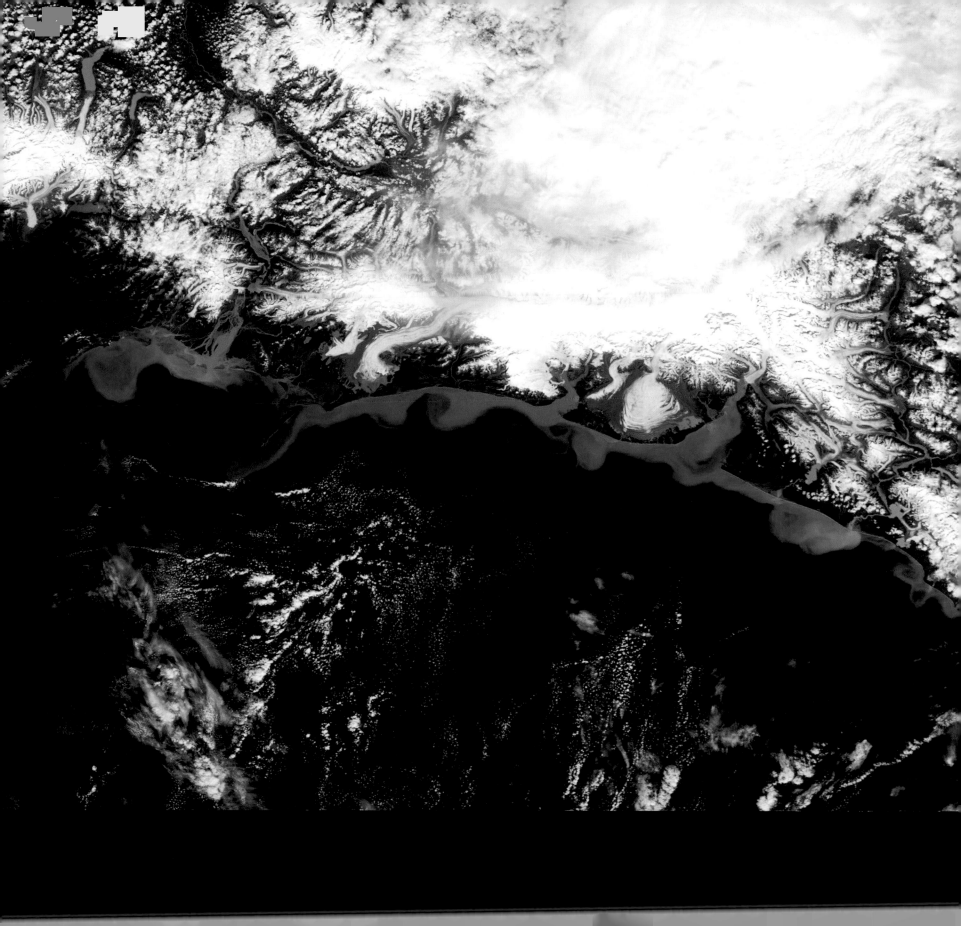

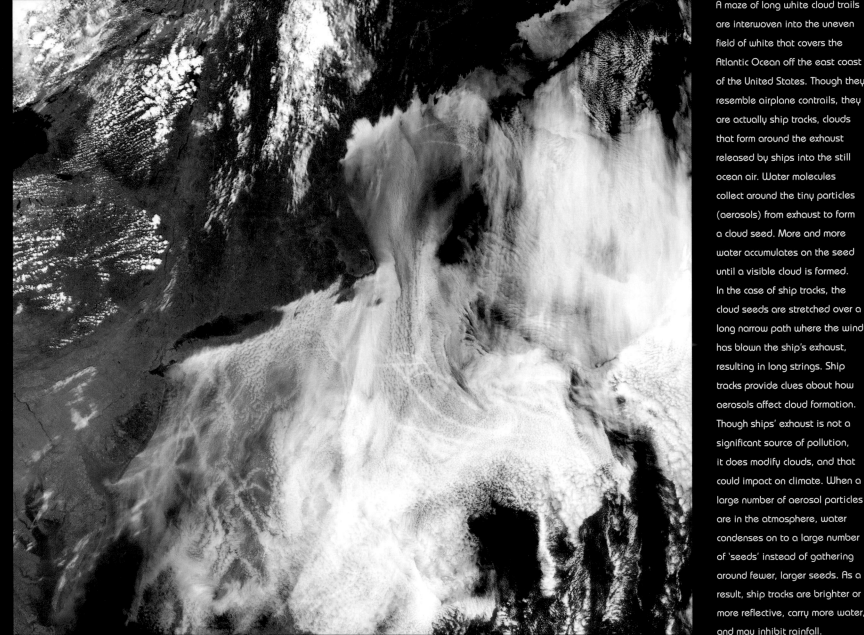

A maze of long white cloud trails are interwoven into the uneven field of white that covers the Atlantic Ocean off the east coast of the United States. Though they resemble airplane contrails, they are actually ship tracks, clouds that form around the exhaust released by ships into the still ocean air. Water molecules collect around the tiny particles (aerosols) from exhaust to form a cloud seed. More and more water accumulates on the seed until a visible cloud is formed. In the case of ship tracks, the cloud seeds are stretched over a long narrow path where the wind has blown the ship's exhaust, resulting in long strings. Ship tracks provide clues about how aerosols affect cloud formation. Though ships' exhaust is not a significant source of pollution, it does modify clouds, and that could impact on climate. When a large number of aerosol particles are in the atmosphere, water condenses on to a large number of 'seeds' instead of gathering around fewer, larger seeds. As a result, ship tracks are brighter or more reflective, carry more water, and may inhibit rainfall.

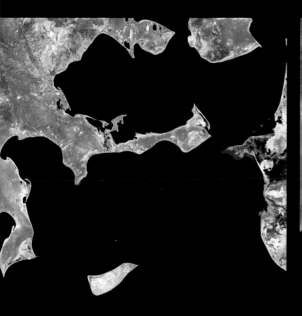 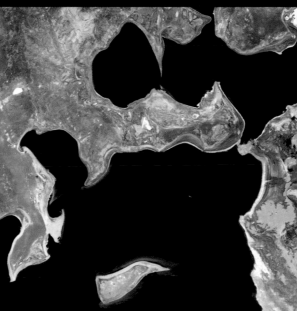 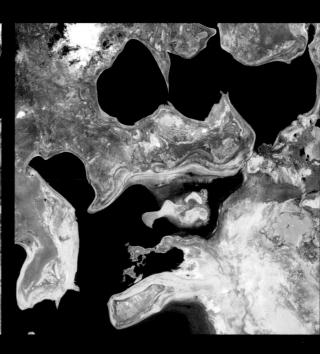

The Aral Sea is actually not a sea at all. It is an immense lake, a body of fresh water, although that description might now be more a figure of speech. In the last 30 years, more than 60 per cent of the lake has disappeared. The sequence of images above, acquired by Landsat satellites, shows the dramatic changes to the Aral Sea between 1973 and 2000. Beginning in the 1960s, farmers and state offices in Uzbekistan, Kazakhstan, and Central Asian states opened significant diversions from the rivers that supply water to the lake, siphoning off millions of gallons to irrigate cotton fields and rice paddies. As recently as 1965, the Aral Sea received about 50 cubic km of fresh water per year – a number that fell to zero by the early 1980s. Consequently, concentrations of salts and minerals began to rise in the shrinking body of water. That change in chemistry has led to staggering alterations in the lake's ecology, causing precipitous drops in

the Aral Sea's fish population. The sea supported a thriving commercial fishing industry employing roughly 60,000 people in the early 1960s. By 1977, the fish harvest was reduced by 75 per cent, and by the early 1980s the commercial fishing industry ended. The shrinking Aral Sea has also had a noticeable effect on the region's climate. The growing season is now shorter, causing many farmers to switch from cotton to rice, which demands even more diverted water. A secondary effect of the reduction in the Aral Sea's overall size is the rapid exposure of the lake bed. Strong winds that blow across this part of Asia routinely pick up and deposit tens of thousands of tons of now exposed soil every year. This process has not only contributed to significant reduction in breathable air quality for nearby residents, but has also appreciably affected crop yields due to heavily salt-laden particles falling on arable land.

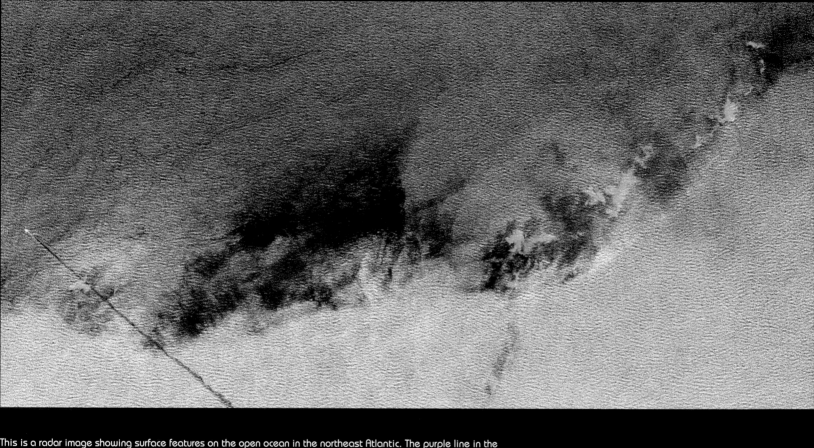

This is a radar image showing surface features on the open ocean in the northeast Atlantic. The purple line in the lower left of the image is the stern wake of a ship. The ship creating the wake is the bright white spot on the middle, left side of the image. The ship's wake is about 28km (17 miles) long in this image, possibly because the ship was discharging oil. A fairly distinct boundary or front extends from the lower left to the upper right corner of the image and separates two water masses at different temperatures. The varying ocean temperature affects winds, the light green area depicts rougher water with more wind, while the purple area is calmer water with less wind. The dark patches are smooth areas of low wind, probably related to clouds along the front, and the bright green patches are likely to be ice crystals in the clouds that scatter the radar waves. The overall fuzzy look of this image is caused by ocean swell.

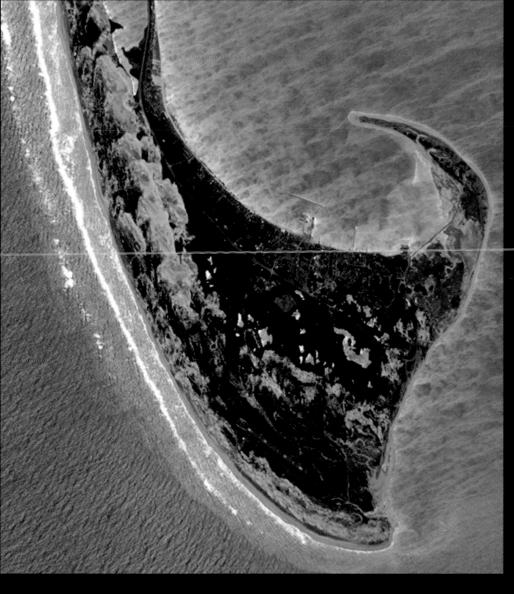

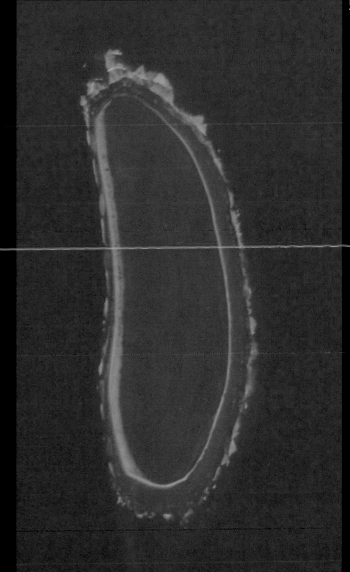

This astronaut photograph, taken from the ISS, shows the northernmost parts of the Cape Cod National Seashore in the United States. Most of Cape Cod's geological history involves the advance and retreat of the last continental ice sheet and the subsequent change in sea level. When much of Earth's water was locked up in massive ice sheets, the sea level was lower, but as the ice began to melt, the sea began to rise. By 6,000 years ago, the sea level was high enough to start eroding the glacial deposits that the vanished continental ice sheet had left on Cape Cod. The water carried the eroded deposits along the shoreline to a new home on the tip. Provincetown Spit, shown here, consists largely of marine deposits, transported from farther up the shore.

Howland Island is a United States possession located in the north Pacific between Australia and the Hawaiian Islands. It is composed of coral fragments surrounded by an active fringing reef, which is indicated by the white breakers encircling the island. Astronauts photograph numerous reefs as part of a global mapping and monitoring programme. High-resolution images are used to update maps, assess the health of reef ecosystems, and calculate bathymetry of the surrounding ocean bottom.

The Republic of Kiribati is an island nation consisting of some 33 atolls near the equator in the central Pacific. Two of Kiribati's atolls, Tarawa and Maiana, appear in this image. Tarawa – remembered as the site of a brutal World War II battle – is the larger island. Each island consists of a ring of coral around a central lagoon, and this photo shows calm conditions, with clear, still water in each central lagoon, and a light spray of clouds overhead. This astronaut image was acquired from the ISS using a Kodak Elite 100S camera fitted with a 250mm lens.

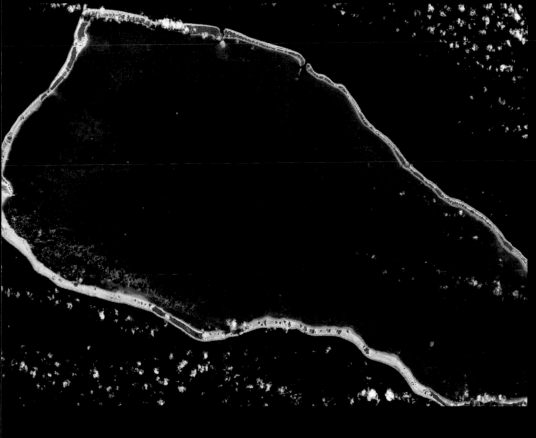

This remarkable SeaWifS image shows the northern edge of the Gulf Stream as it separates from the coast at Cape Hatteras, North Carolina.

In recent times large numbers of coral reefs have died suddenly, leaving once thriving marine communities barren. This phenomenon, known as coral bleaching, occurs throughout the tropical oceans of the world. In 1998 a particularly severe bleaching event struck the corals of the Rangiroa Atoll in French Polynesia. Not only did large numbers (more than 99 per cent of the pre-bleaching cover) of fast-growing Pocillopora corals die, but colonies of slow-growing and resilient Porites coral also died (more than 40 per cent of the pre-bleaching cover). Extreme temperatures and increased solar irradiation are thought to be the main causes. In 1998 a record-breaking El Niño raised the sea surface temperature in the region almost 1°C (34°F) higher than the normal highs and held it there for three months. This suggests that the coral were killed by the high temperatures. If conditions in Rangiroa returned to normal, it would take about 100 years for the Porites coral to re-grow. However, rising global temperatures and the possibility of more frequent El Niños may prevent the reefs from ever recovering. The true-colour image was acquired by the ETM+ aboard NASA's Landsat 7 satellite in 1999.

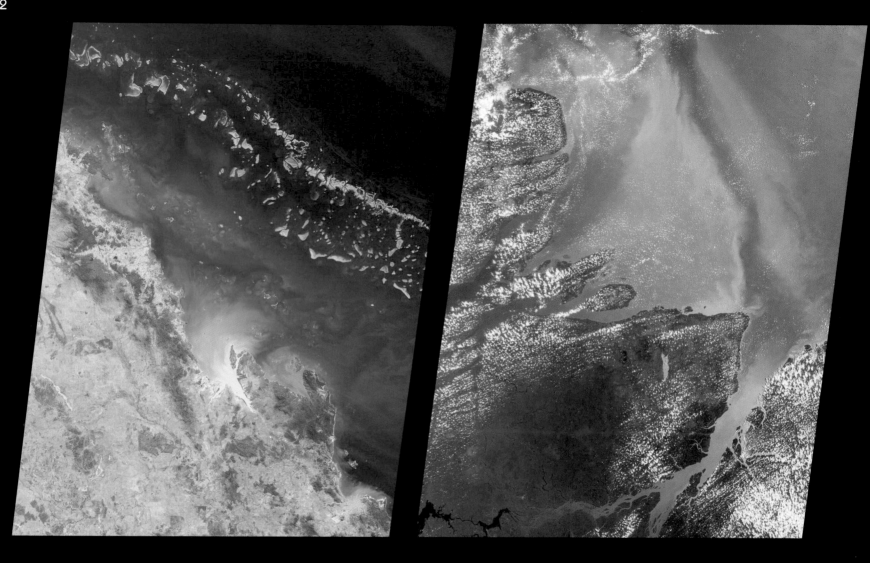

The Great Barrier Reef extends for 2,000km (1,250 miles) along the north eastern coast of Australia. It is not a single reef, but a vast maze of reefs, passages, and coral cays (islands that are part of the reef). This nadir true-colour image was acquired by the MISR instrument on August 26, 2000, and shows part of the southern portion of the reef adjacent to the central Queensland coast. The width of the MISR swathe is approximately 380km (236 miles), with the reef clearly visible up to approximately 200km (125 miles) from the coast.

Flowing for more than 6,450km (4,000 miles) eastward across Brazil, the Amazon River originates in the Peruvian Andes as tiny mountain streams that eventually combine to form one of the world's mightiest rivers. Showing an area of 380km (235 miles) across. this image of the Amazon's mouth was captured by the MISR's vertical-viewing (nadir) camera on September 8, 2000. Although surpassed in length by the Nile, the Amazon carries the largest volume of freshwater in the world, accounting for nearly 90 per cent of the Earth's discharge into the oceans.

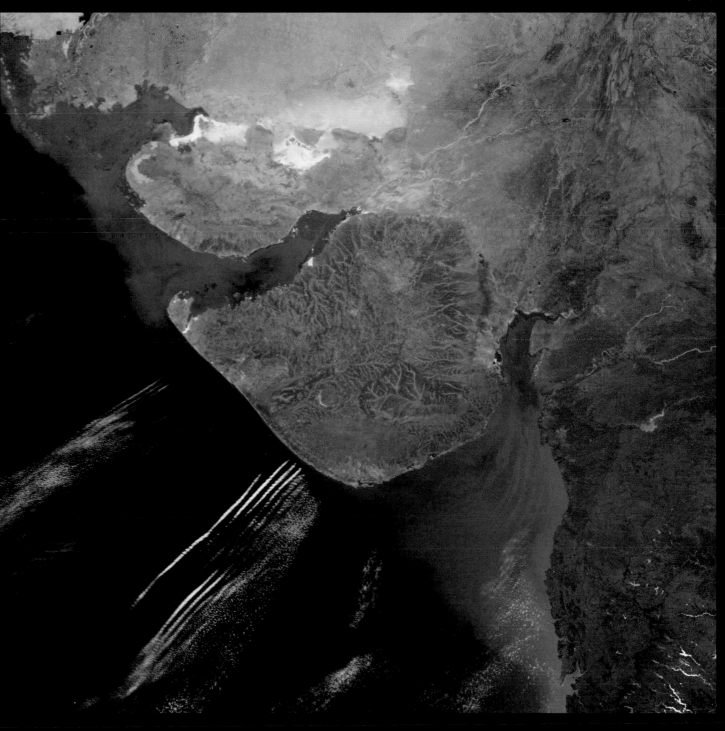

Extremely high sediment loads are delivered to the Arabian Sea along the coast of Pakistan (upper left) and western India. In the case of the Indus River (far upper left) this sedimentation, containing large quantities of desert sand, combines with wave action to create a large sand-bar like delta. In the arid environment, the delta lacks much vegetation, but contains numerous mangrove-lined channels. This true-colour image from May 2001 shows the transition from India's arid northwest to the wetter regions farther south along the coast. The increase in vegetation along the coast is brought about by the moisture trapping effect of the Western Ghats Mountain Range that runs north-south along the coast. Heavy sediment is visible in the Gulf of Kachchh (north) and the Gulf of Khambhatl (south), which surround the Gujarat Peninsula.

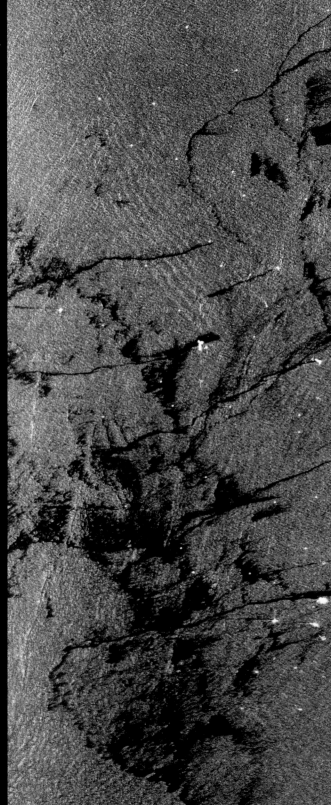

This is a radar image of an offshore drilling field about 150km (93 miles) west of Mumbai (Bombay), India, in the Arabian Sea. The dark streaks are extensive oil slicks surrounding many of the drilling platforms, which appear as bright white spots. Radar images are useful for detecting and measuring the extent of oil seepages on the ocean surface, from both natural and industrial sources. There are also two forms of ocean waves shown in this image. The dominant group of large waves (upper centre) are called internal waves. These waves are formed below the ocean surface at the boundary between layers of warm and cold water and they appear in the radar image because of the way they change the ocean surface. Ocean swells, which are waves generated by winds, are shown throughout the image but are most distinct in the blue area adjacent to the internal waves. Identification of waves provides oceanographers with information about the smaller scale dynamic processes of the ocean. This image was acquired by the Spaceborne Imaging Radar-C/X-Band Synthetic Aperture Radar (SIR-C/X-SAR) aboard the space shuttle Endeavour on October 9, 1994.

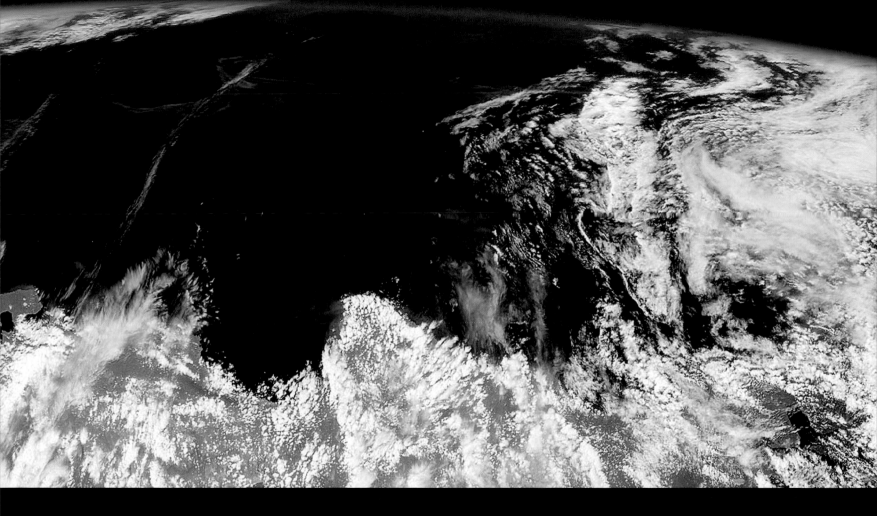

This SeaWifS image from December 26, 2000 shows the curve of the globe and the ocean east of Argentina.
The variety of colours that are visible in the waters have been created by a phytoplankton bloom.

Sea ice drifts in the Labrador Sea
in this photograph taken from the
ISS. The ice is probably breaking
away from pack ice along the
coast of Newfoundland during
the spring melt. NASA scientists
studying satellite data believe
warmer-than-normal temperatures
in the Arctic may be the cause
of a decline in sea ice over the
past 20 years. Astronauts on
board the ISS take thousands of
photographs of the Earth every
mission, which are used to study
geography, transient events (like
the spring thaw), and human
impacts on the Earth.

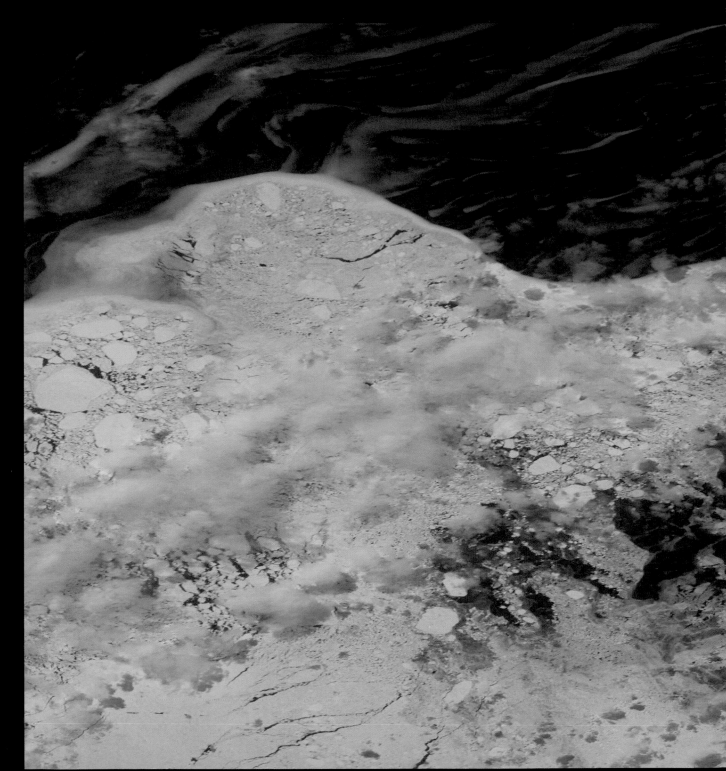

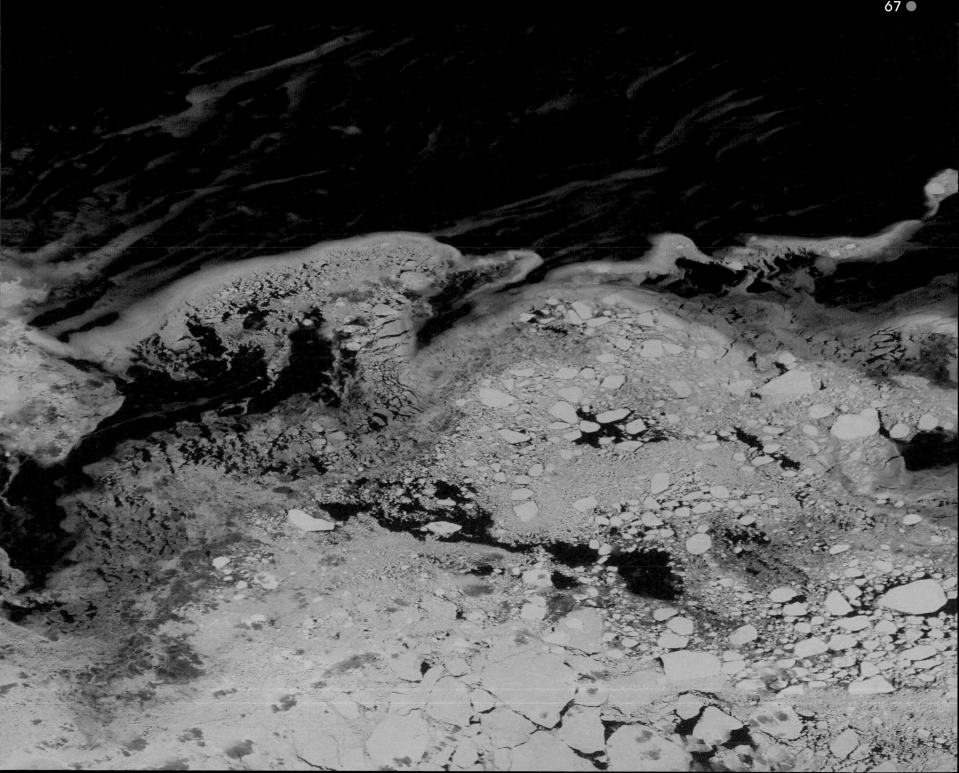

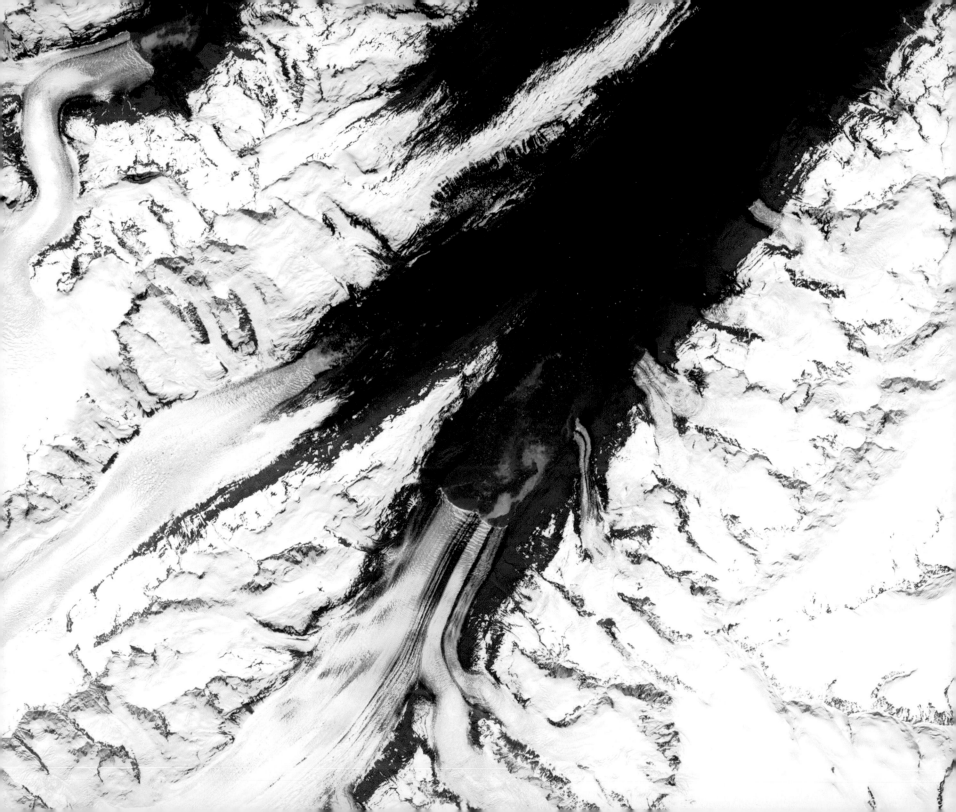

POLES, DESE
REMOTE REGI

PREVIOUS PAGE:

In Alaska's Prince William Sound, College Fjord cuts into the heart of the rugged Chugach Mountains. The two largest tidewater glaciers in the fjord are the Harvard (top centre) and Yale (to the southeast) Glaciers, shown in this infrared-enhanced image. Snow appears white, glaciers bright blue, and land surfaces with vegetation red. Although the two-dimensional image makes it appear that the glaciers simply fill in great ravines, in reality they tumble down steep hillsides like frozen waterfalls.

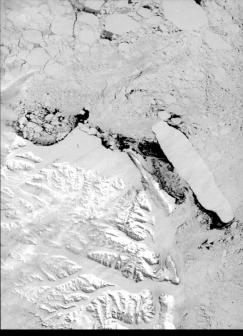

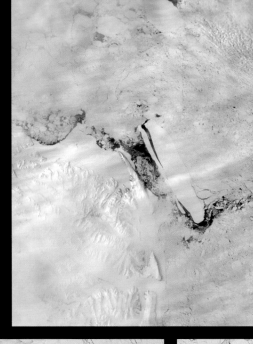

in October 2005. The MODIS instrument captured the iceberg's break-up in this series of images. On October 27, there was no sign that the iceberg was under stress but a few hours later an image showed that two slivers had broken from the berg. By November 1, the lower-left half of B-15A had broken away and several smaller pieces had been chiseled off both sides. The currents tugged B-15A around Cape Adare and by November 4, the shrinking berg was moving out of the Ross Sea on the East Wind Drift that circles Antarctica.

The largest remaining piece of one of the biggest icebergs ever observed began to crumble on October 28, 2005, after running aground off Antarctica's Cape Adare. The B-15A iceberg was the main body of the B-15 iceberg, which broke from the Ross Ice Shelf in March 2000. When it first formed the massive berg measured 270 x 40km (170 x 25 miles). By November 5, 2005, the berg had dwindled to a still respectable 110 x 20km (70 x 13 miles). B-15A had shed several pieces between 2000 and 2005; but unlike previous events the iceberg broke in several locations

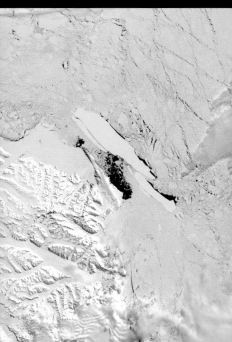

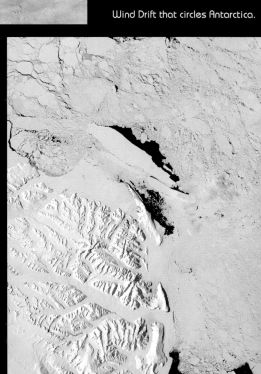

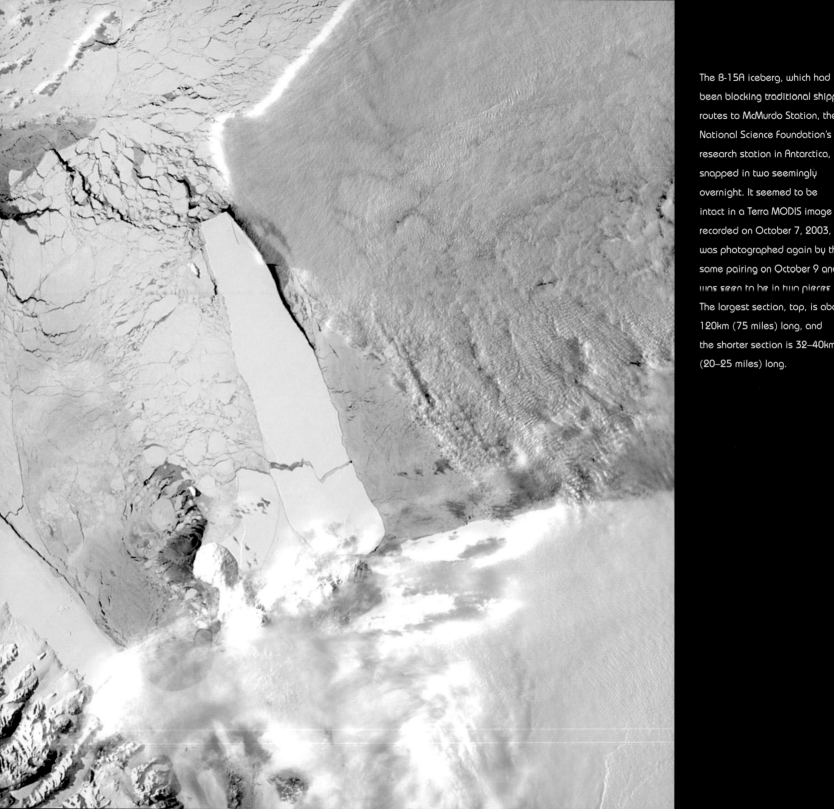

The B-15A iceberg, which had been blocking traditional shipping routes to McMurdo Station, the National Science Foundation's research station in Antarctica, snapped in two seemingly overnight. It seemed to be intact in a Terra MODIS image recorded on October 7, 2003, was photographed again by the same pairing on October 9 and was seen to be in two pieces. The largest section, top, is about 120km (75 miles) long, and the shorter section is 32–40km (20–25 miles) long.

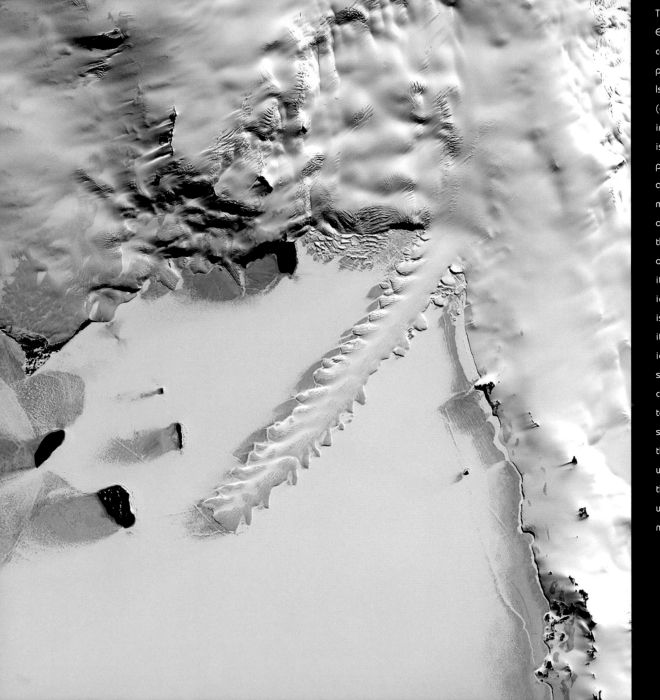

This is an ASTER image of the Erebus glacier in Antarctica, which comes down from Mt Erebus and protrudes off the coast of Ross Island, forming an 11–12km (6½–7½ mile) long ice tongue out into McMurdo Sound. An ice tongue is a long narrow sheet of ice projecting out from the coastline, and it forms when a valley glacier moves very rapidly out into the sea or a lake. When the sea thaws in the summer, the ice tongue floats on the water without thawing, and it also calves off in places, forming icebergs. The Erebus Ice Tongue is only about 10m (33ft) high so its icebergs are small. When the ice around the tongue melts in the summer the waves of sea water constantly batter the edges of the tongue, carving very elaborate structures in the ice. Sometimes these pieces will calve off and the waves will cut very deep caves into the edges of the tongue. In the winter the sea water freezes once more around these new shapes.

Far north within the Arctic Circle off the northern coast of Norway lies a small chain of islands known as Svalbard, which have been scoured into shape by the effect of ice and the sea. The effect of glacial activity can be seen in this image of the northern tip of the island of Spitsbergen. Here, glaciers have carved out a fjord, a U-shaped valley that has been flooded with sea water. Called Bockfjorden, the fjord is located at almost 80-degrees north, and it is still being affected by glaciers. The effect is most obvious in this image through the tan layer of silty freshwater that floats atop the denser blue water of the Arctic Ocean. The fresh water melts off land-bound glaciers and flows over the sandstone, collecting fine red-toned silt. In this image, the tan-coloured fresh water flows northward up the fjord and is being pushed to the east side of the fjord by the rotation of the Earth. The ASTER instrument on NASA's Terra satellite captured this false-colour image, which was created by combining near-infrared, red, and green wavelengths.

In Antarctica, relentless winds have created a unique type of snowdrift pattern known as megadunes. Formed by centuries of nearly continuous winds, megadunes are 1–8m (3–26 ft) high, and 2–6km (1–3¾ miles) from crest to crest. They cover roughly 500,000 sq km (193,000 sq miles) – an area the size of California – in the East Antarctic Plateau. People making ground traverses across the Antarctic Plateau in the 1950s and 1960s passed over several megadune areas, but because the dunes are so much wider than they are high, trekkers didn't notice the unusual terrain underfoot. Pilots flying over the continent saw small portions of the megadune areas, but only satellite imagery fully revealed the scale of these bizarre formations.

On October 8, 2005, a large earthquake shook the mountainous Kashmir region near the border of Pakistan and India. Tens of thousands of people died, and many more were isolated in the mountains by damage to roads and bridges as well as by landslides. Heavy winter snowfall posed an additional threat to millions of survivors made homeless by the quake. In the first week of January 2006, a new snow storm blanketed the mountains of Pakistan, including the region around the epicentre of the quake. This image from the MODIS instrument on NASA's Aqua satellite, taken on January 6, 2006, shows snow highlighting the ridges and ravines in the mountains northeast of the city of Islamabad.

The northeastern corner of Ellesmere Island forms the most northerly extent of Canada. This region has been set aside as the Ellesmere Island National Park Reserve and, as such, it is the most northerly park on Earth, covering nearly 38,000 sq km (14,672 sq miles). The land here is dominated by rock and ice, and it is a polar desert with very little annual precipitation, while many of the glaciers here are remnants from the last episode of glaciation. This image is a small part of a scene acquired by the ASTER instrument aboard NASA's Terra satellite, and shows a tidewater glacier that reaches the sea in the Greely Fjord, situated in the southwestern corner of the National Park Reserve. The strong linear features running through the glacier in the direction of its flow are called flow lines, while the dark blue features are most likely melt ponds that have formed on the glaciers. These small ponds are darker than the ice and absorb more sunlight, thus melting more ice and setting up a growing pond.

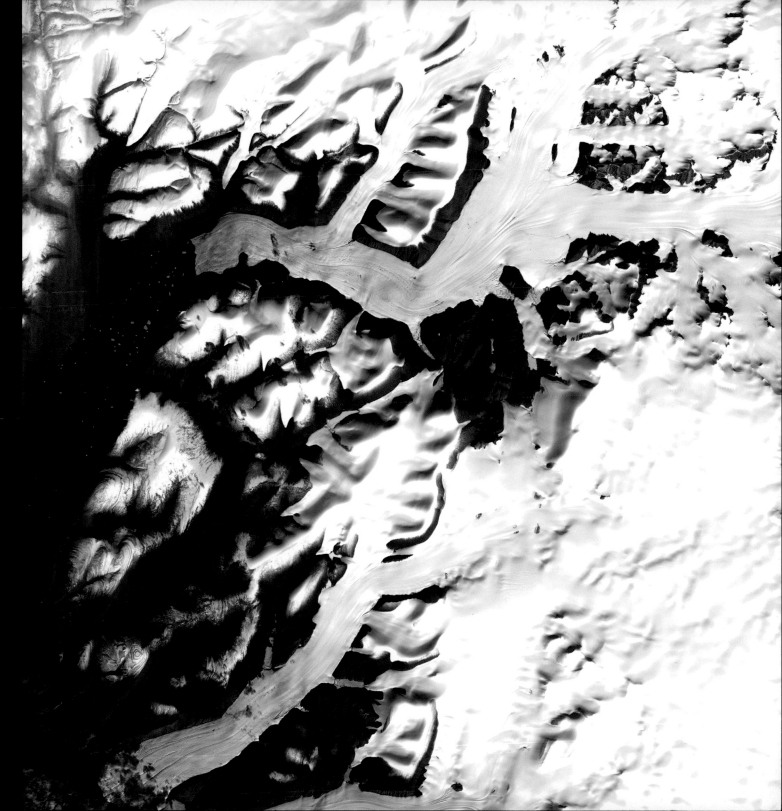

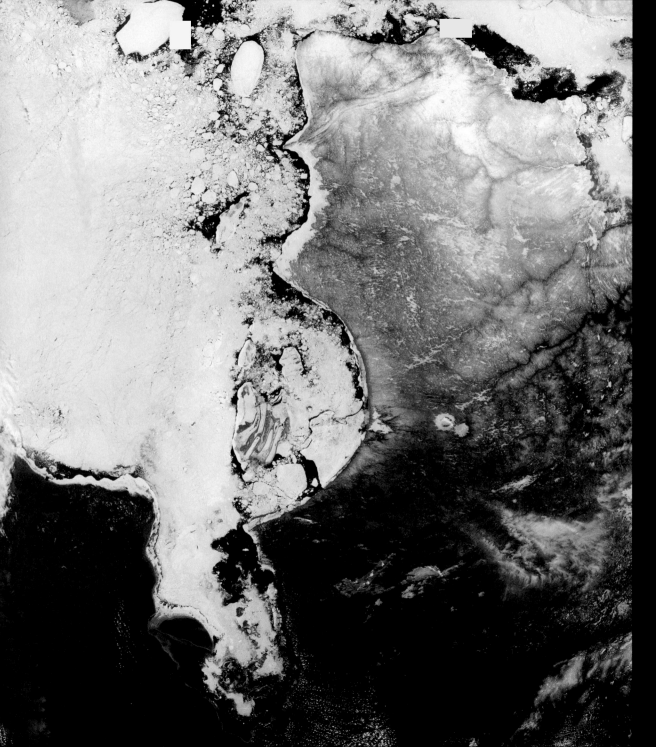

With the coming of spring, the ice on Canada's Hudson Bay begins to break up. In this image captured by the MODIS instrument on NASA's Terra satellite, large chunks of ice float near the eastern shore of the bay, while to the west, the centre of the bay remains frozen. In the upper right corner is the Ungava Peninsula, the northern part of the Canadian province of Quebec. To the south green vegetation slowly blends into the winter-brown landscape, another sign that spring is creeping north. Ontario borders the Hudson Bay in the southwest, the lower left corner of the image, while Quebec forms the southeastern border, lower right.

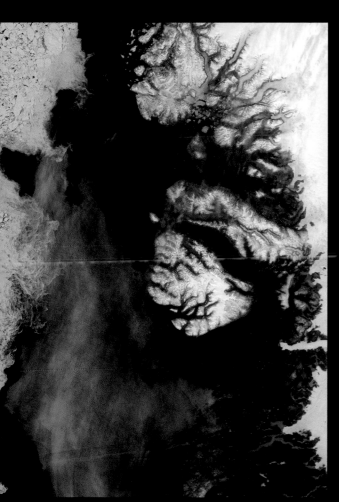

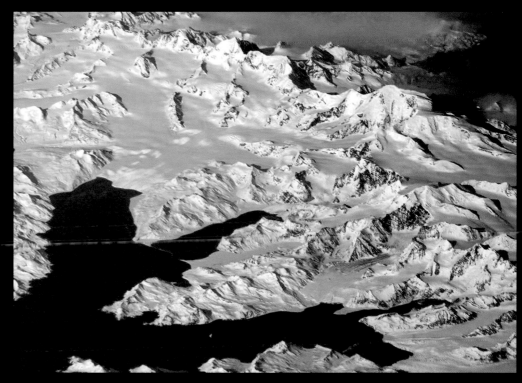

There is no permanent human base on South Georgia Island, a British territory in the South Atlantic Ocean that lies 1,300km (807 miles) east of the Falkland Islands. Using an 800mm telephoto lens on a Kodak 760C digital camera and shooting from an oblique view, the crew of the ISS captured the rugged, isolated landscape of the island's northern shore.

This simulated natural ASTER image shows the Aletsch Glacier, the largest glacier in Europe, which covers more than 120 sq km (45 sq miles) in southern Switzerland. At its eastern extremity lies a glacier lake, Märjelensee, 2,350m (7,711ft) above sea level, while to the west rises Aletschhorn 4,195m (13,763ft), which was first climbed in 1859. The Rhone River flows along the southern flank of the mountains.

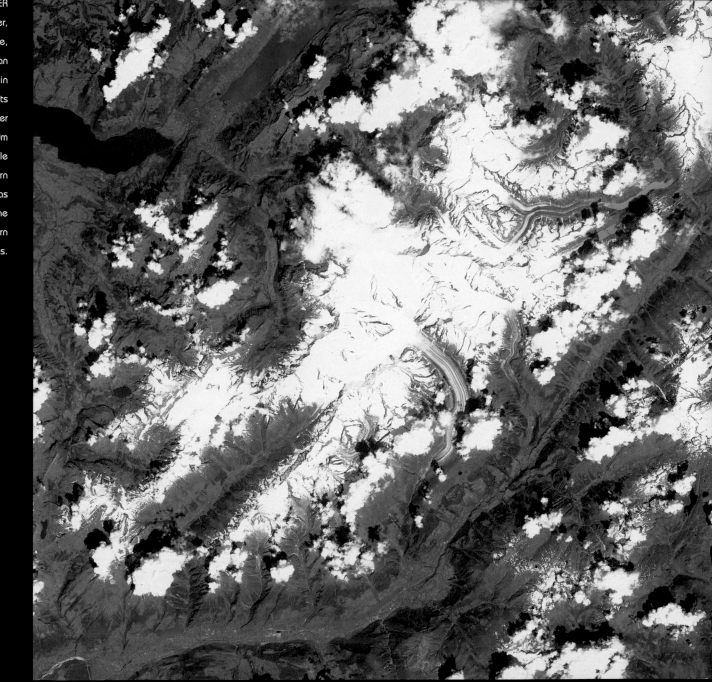

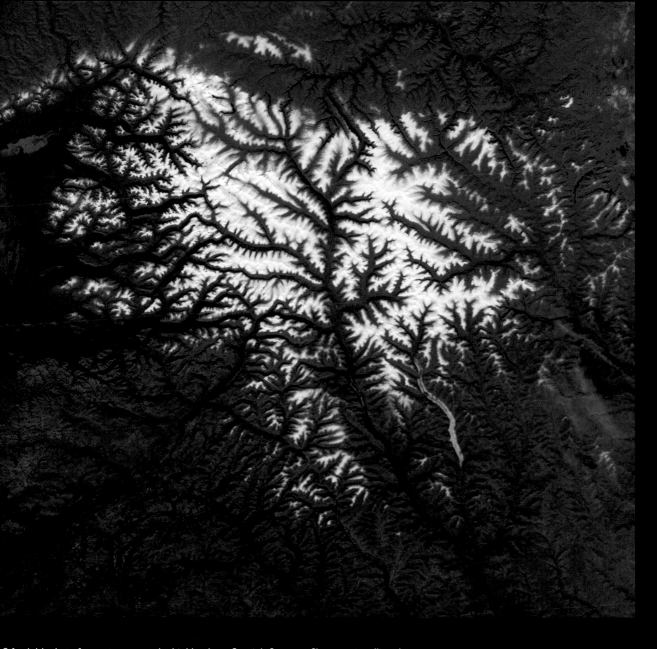

A fresh blanket of snow traces out the highlands on Russia's Putorana Plateau, signalling the onset
of autumn. This true-colour image of the plateau, situated in northwestern Siberia about 600km
(373 miles) south and slightly east of the Kara Sea, was acquired by the MODIS instrument on board
NASA's Aqua satellite. Some of the lakes in the narrow valleys (lower right) are just beginning to freeze
over. One of the lakes running north-south in this scene (lower right) appears to be almost completely
glazed over with ice, while the smaller lake situated roughly 40km (24 miles) to the west has ice
just beginning to form along its western shore.

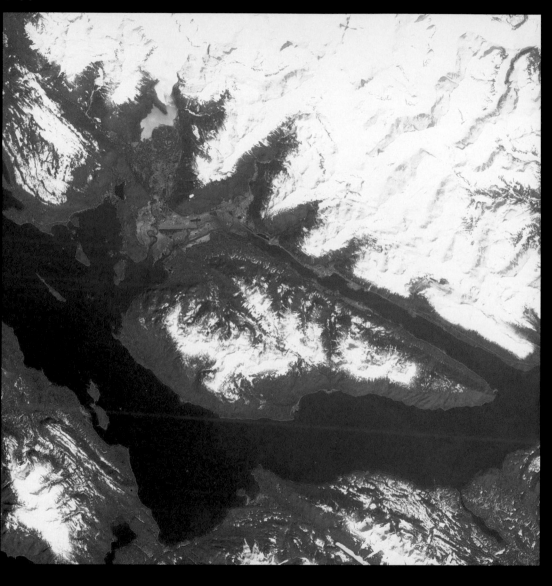

Kavir (Desert) National Park is a 400,000 hectare (1 million acre) protected ecological zone in northern Iran. The park is located 120km (74½ miles) south of Tehran and it sits on the western end of one of Iran's two major deserts, the Dasht-e Kavir (Sand Desert). This Landsat 7 image shows the stark landscape of the park. The scene is dominated by Daracheh-ye Namak (Salt Lake), the huge white salt pan immediately outside the park boundaries. Other prominent features include the high reefs of elevated rocks in the park, and streaked-gray fans of alluvial wash spreading from the base of these outcroppings. This image combines data from two different satellite overpasses of the area collected by the ETM+ on the Landsat 7 satellite. The left half of the image was acquired on August 28, 2000, the right half on September 7, 2001. The image combines red, blue and green wavelengths of reflected light to create a natural-colour view.

Juneau, population 31,000, is a port city and the capital of Alaska, and is the commercial and distribution centre for the panhandle region of the state. Just north of the city is the Mendenhall Glacier. In 1880 Joseph Juneau and Richard Harris discovered gold in the area, which led to the development of the settlement as a gold-mining town. In 1970 Juneau's boundaries were greatly extended, making it one of the largest communities in area in the United States.

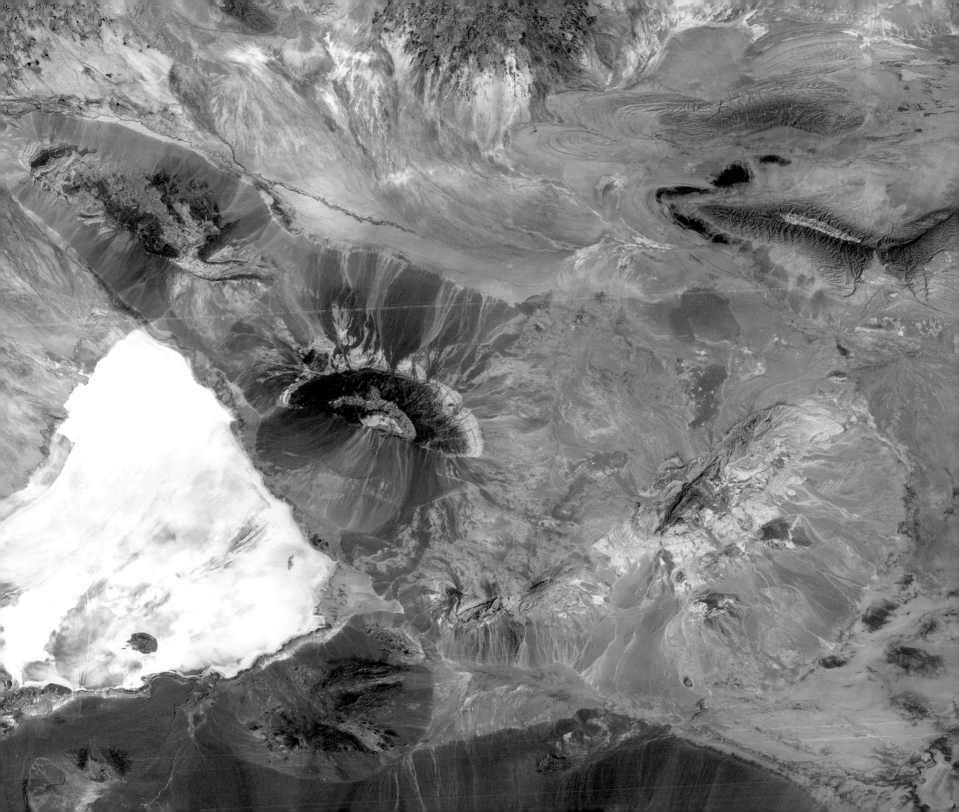

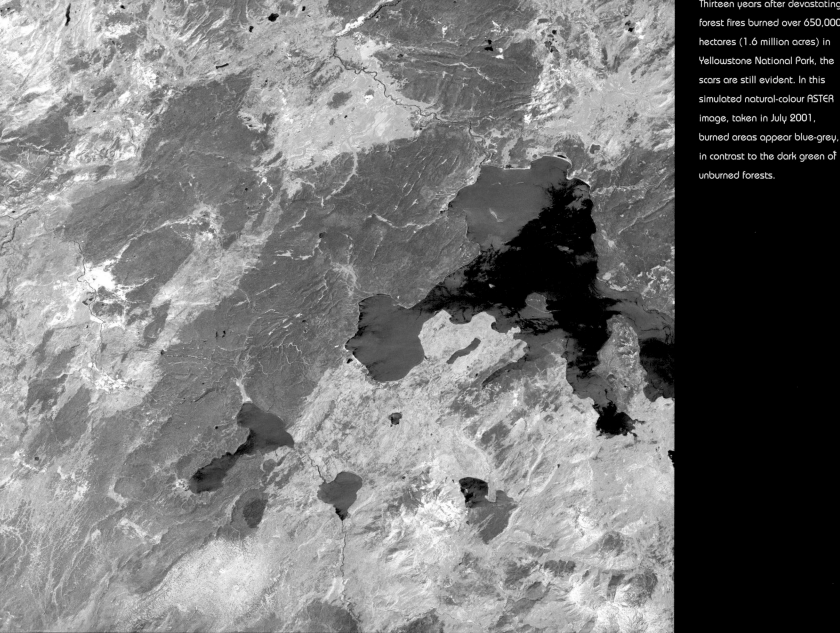

Thirteen years after devastating forest fires burned over 650,000 hectares (1.6 million acres) in Yellowstone National Park, the scars are still evident. In this simulated natural-colour ASTER image, taken in July 2001, burned areas appear blue-grey, in contrast to the dark green of unburned forests.

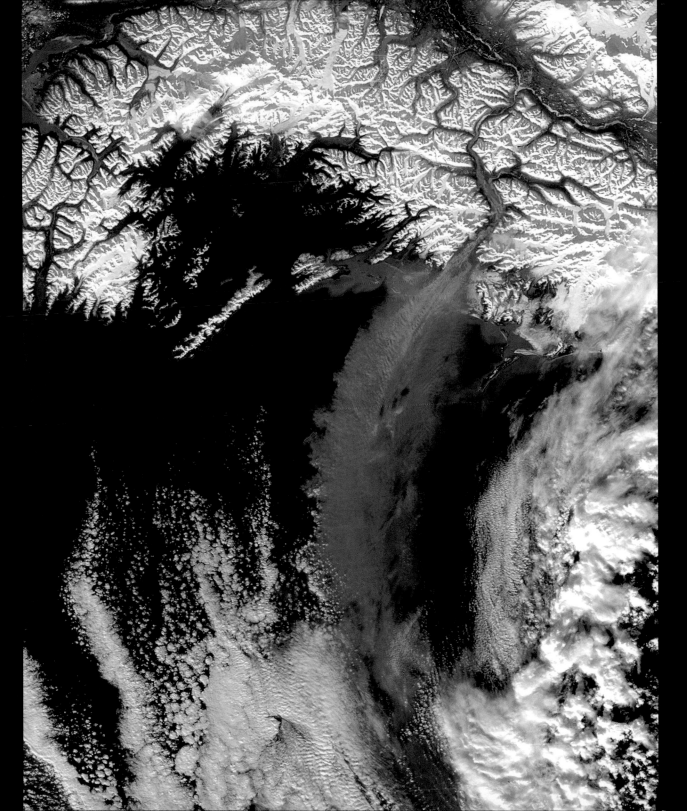

A massive dust storm of glacial sediments swept off the coast of Alaska on November 5, 2005. The MODIS instrument flying on board the Aqua satellite took this picture of the storm as it dispersed over the Gulf of Alaska. In this image, the dust appears as a pale beige plume, standing out from both the snowy landscape and the ocean water underneath it. The plume comes from the Copper River Valley.

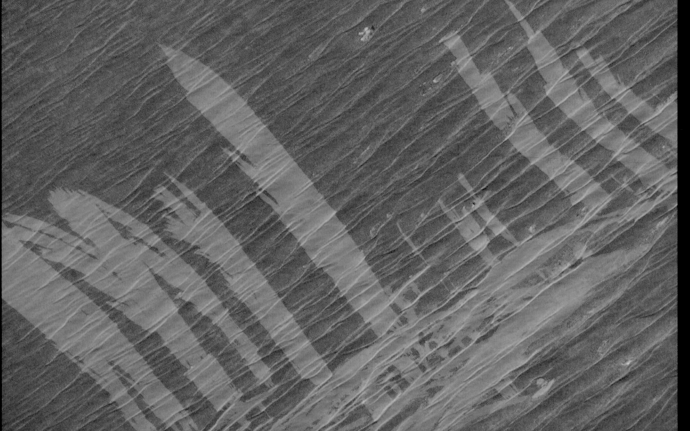

Bright orange fire scars show up the underlying dune sand in the Simpson Desert, 300km (186 miles) east of Alice Springs. The background is an intricate pattern of sand cordons that angle across the view from lower left to upper right. These cordons are now mostly green, showing that, although they were once shifting, they have become more or less static – 'tied down' by a vegetation mat of desert scrub. The fire scars were produced in a recent fire, probably within the last year. The image suggests a time sequence of events: fires first advanced into the view from the lower left, parallel with the major dune trend and dominant wind direction. Then the wind shifted direction by about

90 degrees so that the fires advanced across the dunes in a series of frond-like tendrils. Each frond starts at some point on the earlier fire scar, and the sharp tips of the fronds show where the fires burned out naturally at the end of the episode. The sharp edges of the fire scars are due to steady but probably weak southwesterly winds: weaker winds reduce sparking of additional fires in adjacent scrub on either side of the main fire pathways. Over time, the scars will become less distinct as the vegetation starts to grow back. This image was recorded by an astronaut on the ISS, using a Kodak 760C digital camera fitted with an 800mm lens.

Fans of the *Star Wars* series of films may recognize the Algodones Dunefield – also known as the Imperial Dunes – as portions of the imaginary planet of Tatooine. While not planetary in scale, this dunefield located at the junction of three states (Arizona and California in the United States; Baja California del Norte in Mexico) is a distinctive feature of North America. The field is approximately 72 x 10km (45 x 6 miles) and extends along a northwest-southeast line that correlates to the prevailing northerly and westerly wind directions. The dunefield is a wilderness area, with the only human structure being the All American Canal that cuts across the southern portion from west to east (right side of view). A checkerboard pattern of farms in the Colorado River floodplain is visible on the Mexican side of the border (far right), while wisps of cloud obscure the Cargo Muchacho Mountains (top). This picture was taken from the ISS by an astronaut who was using a Kodak 760D digital camera fitted with a 165mm lens.

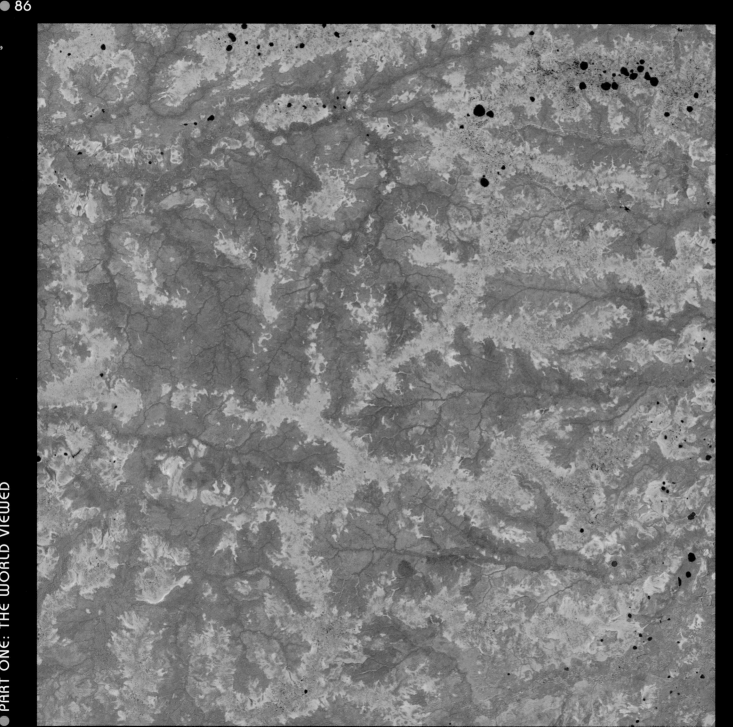

The West Siberian Plain is a vast flatland in central Russia that stretches almost the full latitude of the country, from the Arctic Ocean in the north to the foothills of the Altay Mountains in the south. Bound on the west by the Ural Mountains and on the east by the Yennisey River, the plain is one of the largest flatland areas in the world. From north to south it encompasses multiple biomes, including tundra, several types of forest, and grasslands known as steppes. North of the city of Tomsk, pictured here, the plain is home to a mixture of tundra and mixed taiga (boreal) forest. In this false-colour satellite image, oak-leaf-shaped river and stream drainages are clothed in deep green forests. Occasionally, the evergreen forest is mixed with deciduous trees, creating patches of pink-coloured bare ground. In between the river drainages, the lighter green of the tundra is dotted with blue-black ponds. This image was acquired by the ETM+ sensor on NASA's Landsat satellite, and the image is made from light reflected by the Earth's surface in the visible (green), near-infrared, and shortwave-infrared parts of the electromagnetic spectrum.

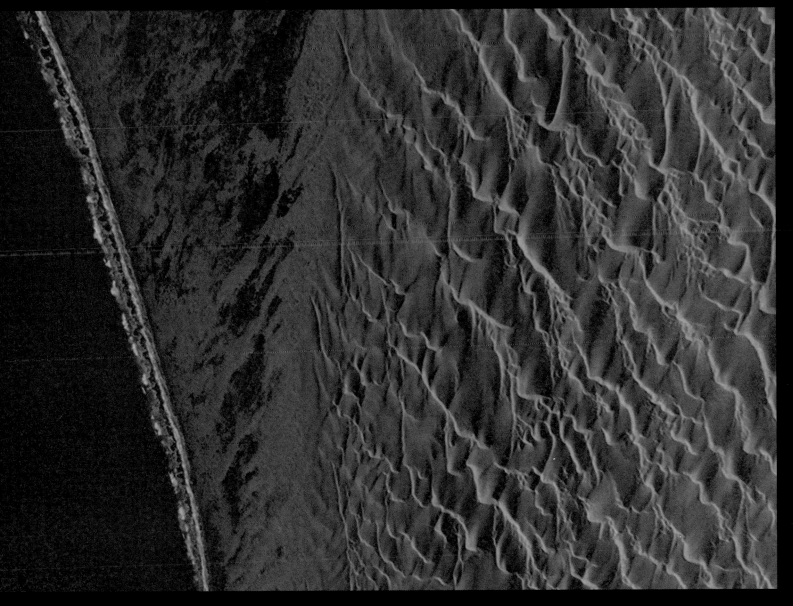

This detailed view of the remote Conception Bay sector of the Namibian coastline shows breakers and a strand plain on the left and the Namib dune sea on the right. A strand plain is a series of dunes, usually associated with and parallel to a beach, sometimes containing small creeks or lakes. The complexity and regularity of the patterns in the Namib dune sea have attracted geologists for decades. The flat strand plain shows a series of wet zones that appear black where seawater seeps inland and evaporates. These patches are aligned with the persistent southerly winds, some of the strongest of any coastal desert.

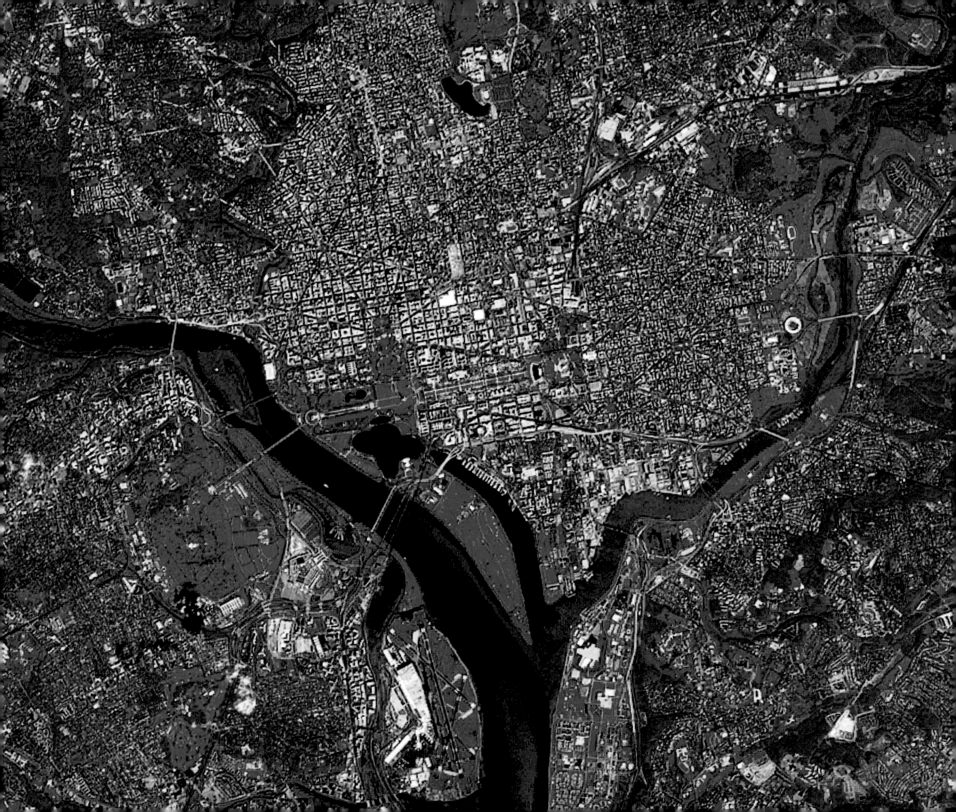

CITIES & LANDMARKS

PREVIOUS PAGE:

Washington DC photographed with the ASTER instrument. The combination of visible and near infrared bands displays vegetation in red, and water in dark greys, and the 15m (50ft) spatial resolution allows individual buildings, including the White House, the Jefferson Memorial, and the Washington Monument with its shadow, to be clearly seen in the centre.

BELOW:

This ASTER image covers an area of 64 x 72km (39¾ x 44¾ miles). Starting as a sleepy Spanish pueblo in 1781, Los Angeles has become an ethnically diverse, semi-tropical megalopolis, laying claim to being the principal centre of the western US and the nation's second largest urban area. The city's economy is based on trade, aerospace, agriculture, tourism and filmmaking.

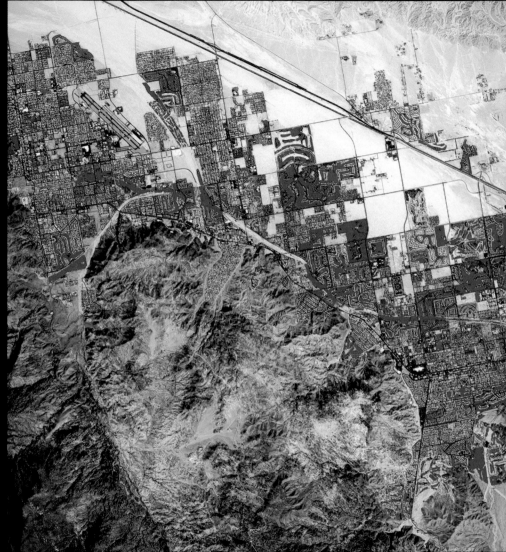

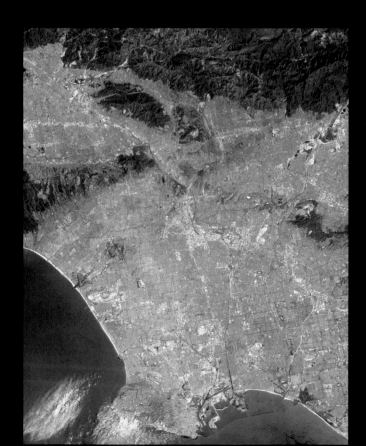

This is the city of Palm Springs, located 160km (99 miles) east of Los Angeles. A verdant oasis in the desert of southern California, Palm Springs is a fashionable residential community and winter resort noted for its fine golf courses (seen in red on this composite). Originally called Agua Caliente (Spanish for warm water), the site was selected in 1863 as a stop on the stagecoach line between New Mexico Territory and Los Angeles. It was developed as a residential community in the 1880s.

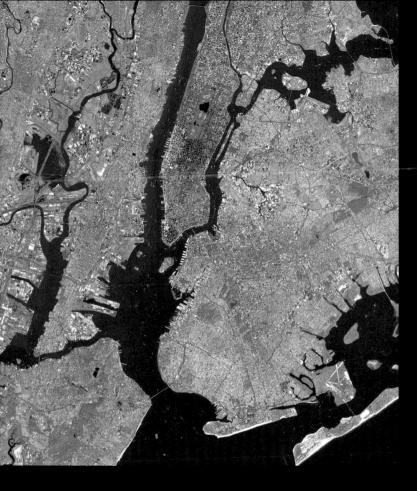

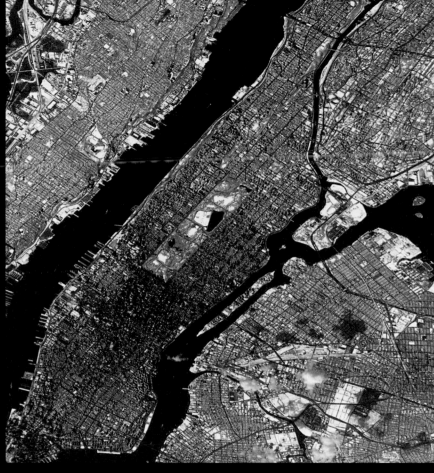

This false-colour image, obtained by the ASTER instrument aboard the Terra satellite, shows greater New York City. The Island of Manhattan is jutting southward from top centre, bordered by the Hudson River to the west and the East River to the east (north is straight up in this scene). In the middle of Manhattan, Central Park appears as a long green

New York in greater detail, this time photographed by an astronaut on board the International Space Station.

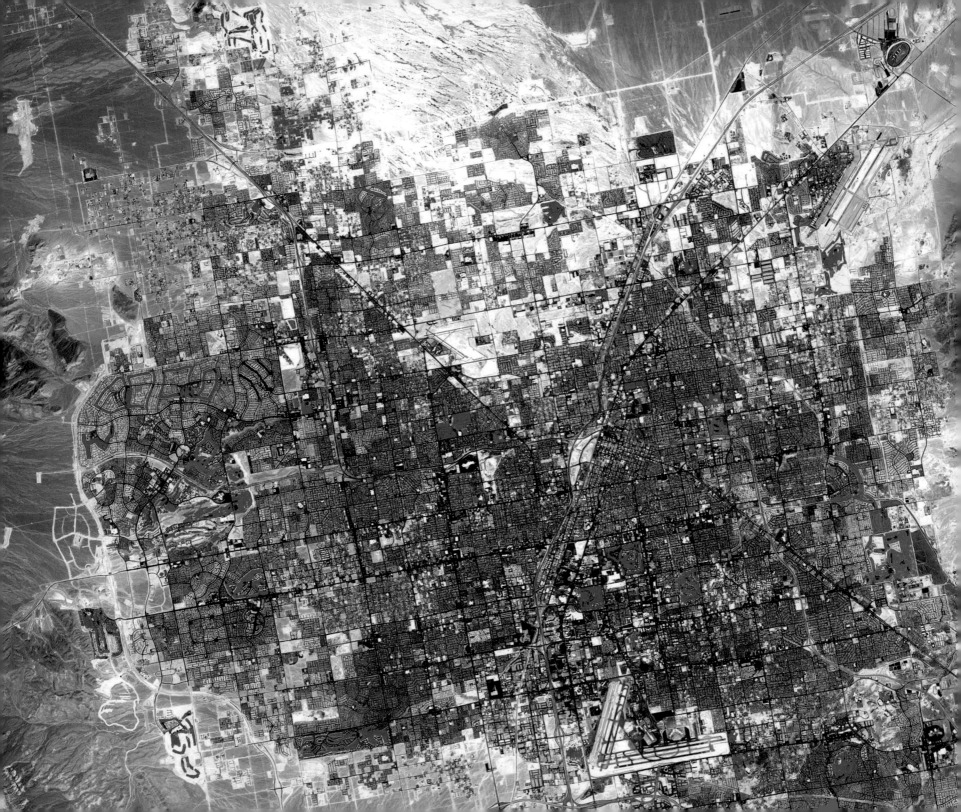

This image of Las Vegas, Nevada covers an area 42km (25 miles) wide and 30km (18 miles) long. The image displays three bands of the reflected visible and infrared wavelength region, with a spatial resolution of 15m (50ft). McCarran International Airport to the south and Nellis Air Force Base to the northeast are the two major airports visible, while golf courses appear as bright red meanders of grass-covered land.

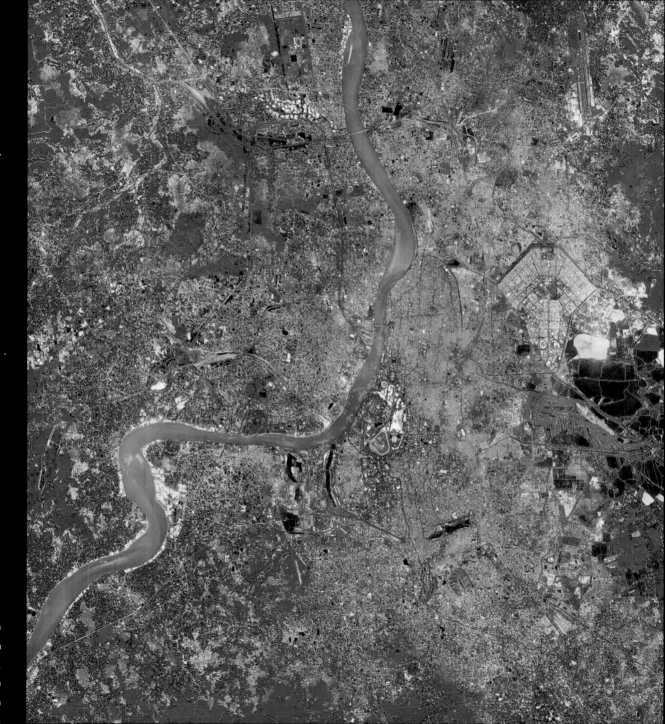

The city of Kolkata (Calcutta) appears in this 24 x 34km (15 x 21 mile) sub-scene. The picture was captured by the ASTER instrument on March 29, 2000.

This image shows the city of Tokyo, and was taken with the ASTER instrument using three bands of the reflected visible and infrared wavelength region, with a spatial resolution of 15m (50ft). The picture shows part of the Tokyo metropolitan area extending south to Yokohama. Included are the Ginza District, Haneda Airport and the Imperial Palace. To the west, Tokyo is hemmed in by mountains, covered with forests (displayed in red); on the southeast, Tokyo Bay is one of the world's great harbours.

Berlin is the capital and the biggest city of Germany. It has a population of about 3.5 million and extends over 889 sq km (343 sq miles). Formerly the capital of Prussia, Berlin was the capital of Germany between 1871 and 1945 and again since the reunification of Germany on October 3, 1990. Between 1949 and 1990, it was divided into East Berlin, the capital of the German Democratic Republic, and West Berlin by the Berlin Wall, which existed between August 13, 1961 and November 9, 1989. The wall is clearly marked in yellow on this simulated natural-colour ASTER image.

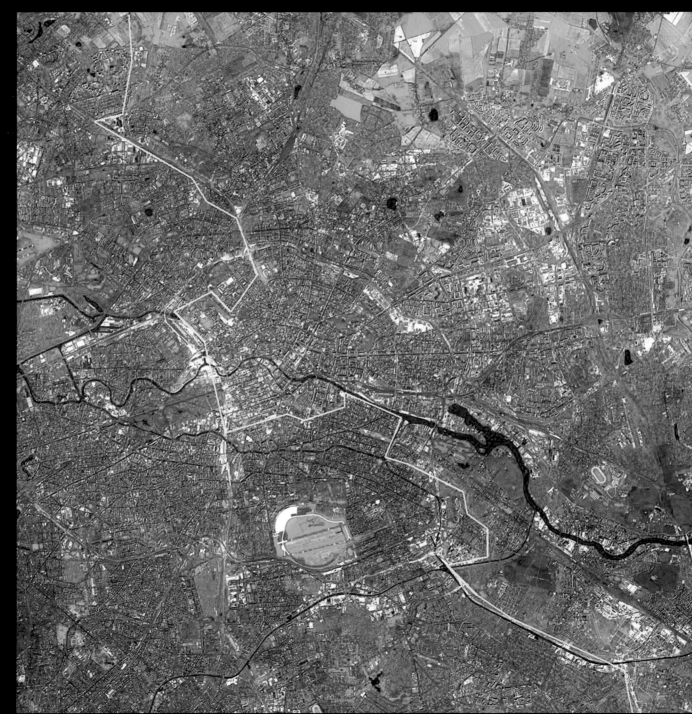

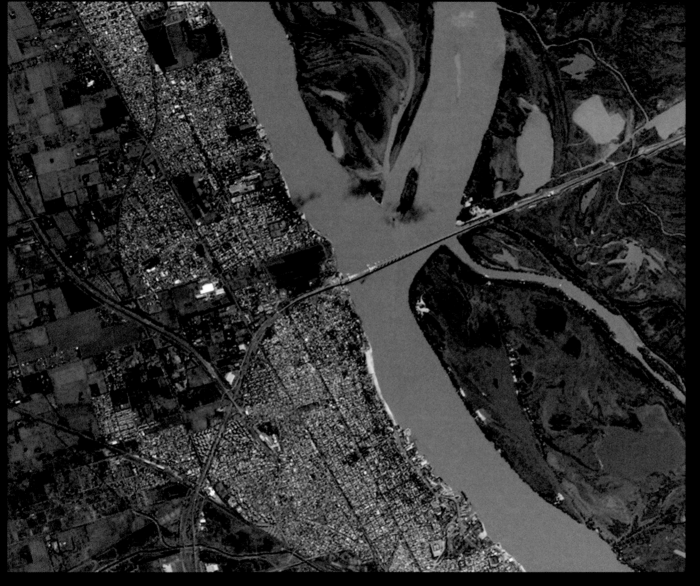

Resembling a work of modern art, variegated green crop circles cover what was once shortgrass prairie in southwestern Kansas. The most common crops in this region – Finney County – are corn, wheat, and sorghum, and each of these crops was at a different point of development when the ASTER instrument captured this image on June 24, 2001, a fact that accounts for the varying shades of green and yellow visible. Healthy, growing corn crops are green, while sorghum, which resembles corn, grows more slowly and would be much smaller and therefore, possibly paler. Wheat is a brilliant gold in this picture since harvest occurs in June, while fields of brown have been recently harvested and ploughed under or have been left to lie fallow.

The Paraná River, in the centre of the view, has been the principal transportation artery of central South America since the times of early colonization. Consequently, the river gave rise to the growth of port cities such as Argentina's second city, Rosario (bottom centre), which is now a major industrial centre. The great Rosario-Victoria bridge (centre), completed in 2002, facilitates the east-west movement of goods, and it casts a shadow where it crosses almost 2km (1 mile) of open river. This picture was acquired by an astronaut aboard the ISS on May 19, 2005, with a Kodak 760C digital camera fitted with a 400mm lens.

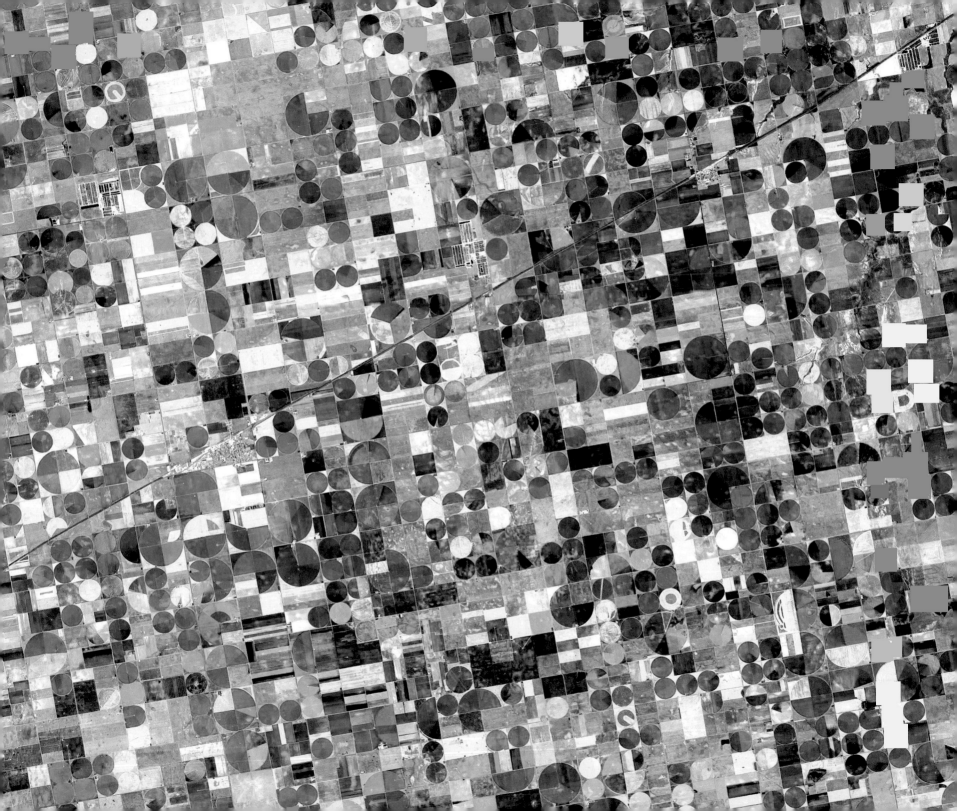

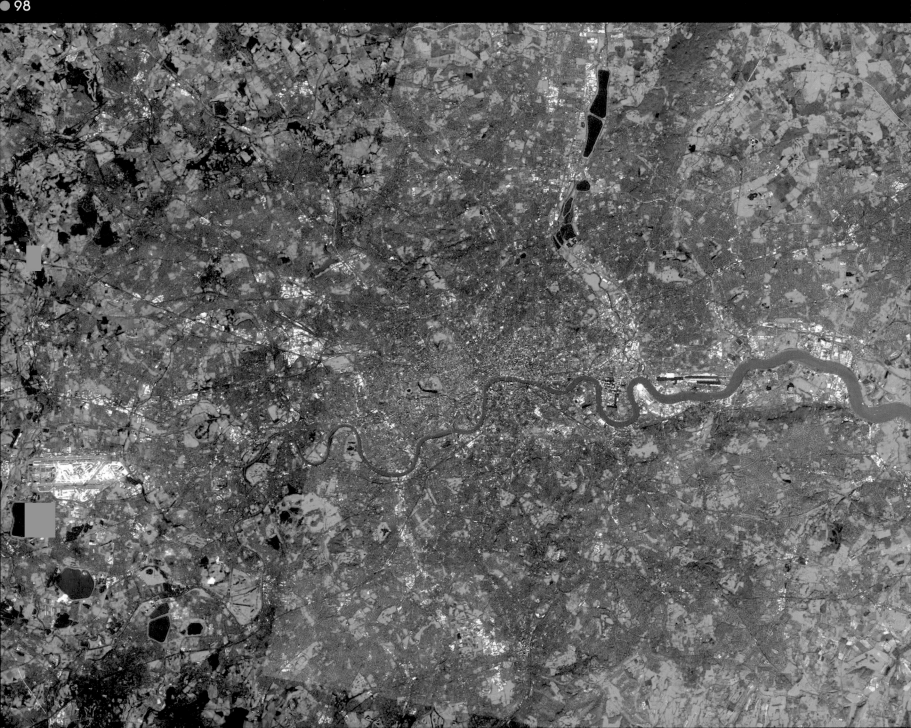

For almost 2,000 years, the River Thames has served as the life force of London, capital of the United Kingdom and one of the world's most famous cities. After coping with the devastating effects of bombing during World War II, London today thrives as a vital modern metropolis and is one of 100 cities being studied using ASTER data to map and monitor urban use patterns and growth. This image covers an area of 55.3 x 39.5 km (34¼ x 24½ miles), and was acquired on October 12, 2001.

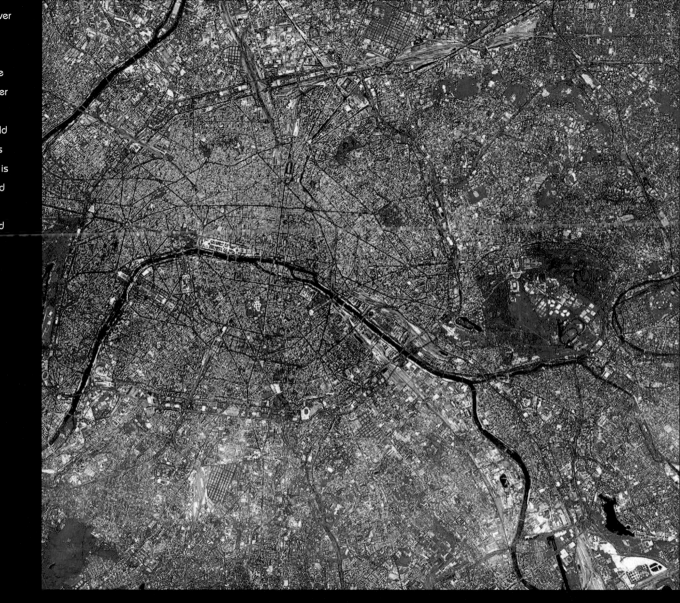

This image of Paris was acquired on July 23, 2000 and covers an area of 23 x 20 km (14 x 12½ miles). Known as the City of Light, Paris has been extolled for centuries as one of the great cities of the world, and its location on the River Seine, at a strategic crossroads of land and river routes, has been the key to its expansion since the Parisii tribe first settled here in the 3rd century BC. The city's cultural life is centered on the Left Bank of the Seine, while business and commerce dominate the Right Bank.

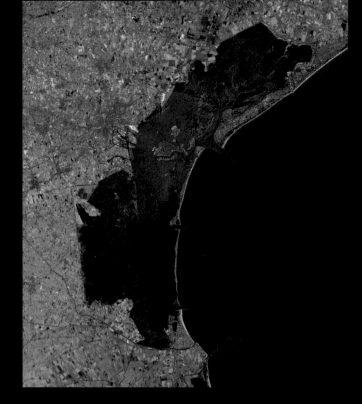

The city of canals, Venice stretches across numerous small islands in a marshy lagoon along the Adriatic Sea in northeastern Italy. This image from the ASTER instrument on board the Terra satellite shows the watery city using false-colour image enhancements that bring out the details of water and vegetation. The heart of Venice is on the largest island in the lagoon known as the Rialto. The city is somewhat protected from the sea by a row of sandbanks but is continually under threat of flooding and has been experimenting with tidal control measures for a thousand years.

Although when this picture was obtained by Advanced Land Imager on NASA's EO-1 satellite on September 6, 2005, the breaches in the levees that allowed water to flow into New Orleans had been sealed, the city was, at this time, still buried under a deep blue blanket of water. Disaster had struck on August 29, when Hurricane Katrina battered the levees along the canals that run through the city from Lake Pontchartrain, seen at the top of the image. In this picture a strip of the city along the banks of the Mississippi River remains dry, an area which includes downtown New Orleans and the historic French Quarter.

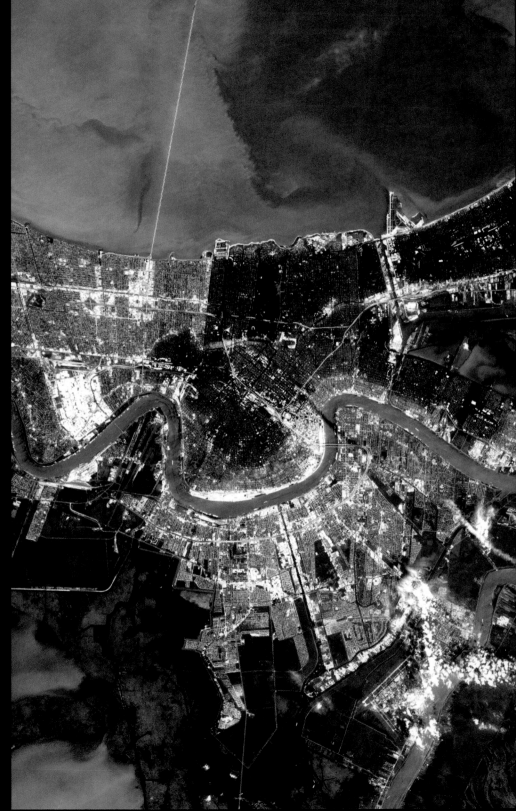

History permeates every corner of the magnificent city of Rome, famed as the Eternal City. Situated on seven hills along the winding Tiber River in central Italy – the site of settlements dating from 1500 BC – ancient Rome first arose as a republic and a significant world force in the 6th century BC. Designated the capital of a united Italy in 1871, Rome has experienced expansion ever since. The sprawling, outlying districts of metropolitan Rome, encompassed by the Grande Raccorda Anulare motorway, present a striking contrast to the monuments of antiquity in the heart of the city. This ASTER image was acquired on May 5, 2003, and covers an area of about 23 x 23km (14 x 14 miles).

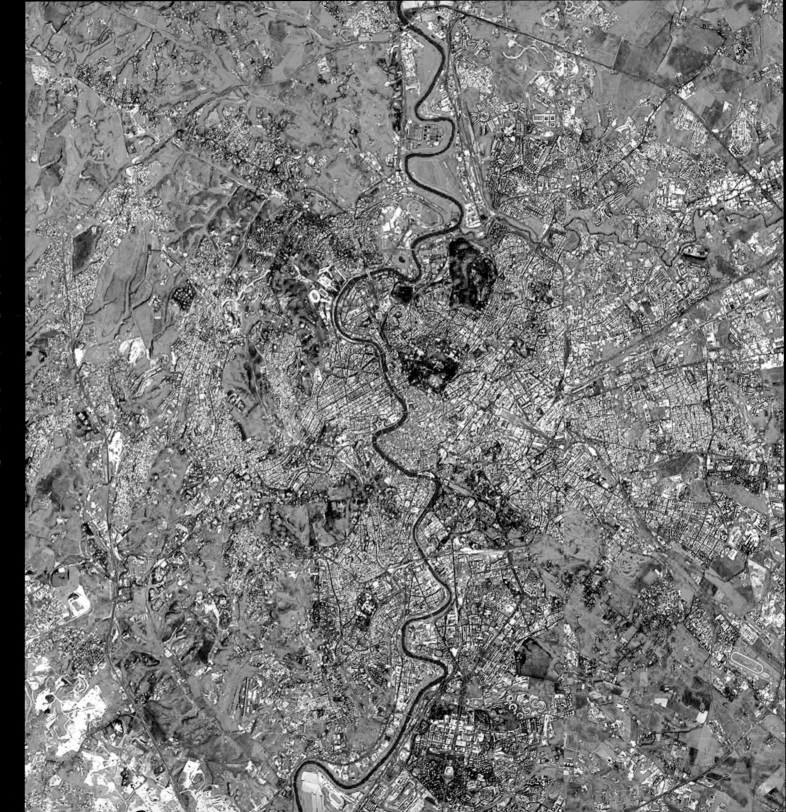

Arches National Park in Utah is home to some 2000 arches and windows in rock, as well as rock spires and pinnacles and covers 308 sq km (119 sq miles) of arid land. This Landsat 7 natural-colour image shows the canyons and rock formations with the sandstone showing pale red and areas of white salt and halite. The deep canyon carved by the Colorado River is unmistakable, as is the vegetation in the canyon where the flood plain provides water in the arid landscape.

The Golden Gate National Recreation Area, with its 30,512 hectares (75,398 acres) of park land, is one of the largest city parks in the world with an estimated 16 million visitors each year. This natural-colour image was created from data collected by the ETM+ instrument on the Landsat 7 satellite. Most sections of the park are quite obvious as green areas that contrast sharply with the surrounding grey of the city of San Francisco. Along the coast are the sandy beaches which are frequented by sea lions and the two islands visible in this image are the large Angel Island and the smaller Alcatraz, once famous as a prison and now part of the city park.

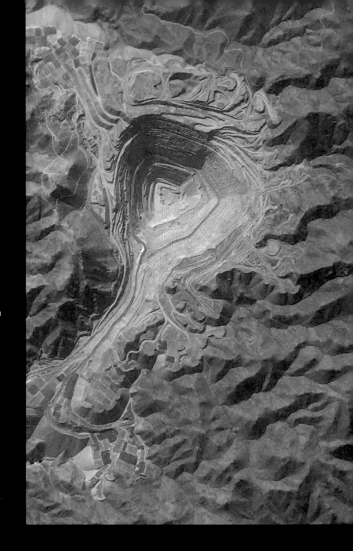

The rugged, mineral-rich Andes support some of the world's biggest mines (gold, silver, copper, and more). This image looks down the bull's-eye of Peru's Toquepala copper mine, a steep sided and stepped open-pit mine. Mid-afternoon sunlight on the arid slopes of the central Andes mountains accentuates the mine contours. At the surface, the open pit is 6.5km (4 miles) across and it descends more than 3000m (9843ft) into the earth. A dark line on the wall of the pit is the main access road to the bottom, and spoil dumps of material mined from the pit are arranged in tiers along the northwest lip of the pit. Numerous angular leaching fields appear lower right, and the railway to the coast is a line that exits the image on the left. This image was taken from the ISS by an astronaut using a Kodak DCS760 digital camera equipped with a 400mm lens.

The approximate boundary between Europe and Asia is defined by the Ural River and the Ural Mountains to its north. The Ural River flows to the great, inland Caspian Sea, and gives its name to the city of Uralsk on its banks. Lying just inside the Kazakh border with Russia, Uralsk is an agricultural and industrial centre, and has been an important trade stop since the early 1600s. Today it is one of the major entry points for rail traffic from Europe to Siberia, servicing the many new oil fields in the Caspian basin and the industrial cities of the southern Urals. ISS astronauts acquired a series of images of Uralsk, highlighting the city under different lighting conditions. The upper view shows the sunglint (light reflected from the water surface towards the observer) on the rivers, lakes, and ponds of the Ural floodplain on the right side of the image and that of a tributary, the Chogan River at the bottom. The cityscape of Uralsk, on the headland between the two, is relatively difficult to see because the water and sunglint dominate the scene.

The lower view was taken 48 seconds earlier, at a more vertical angle that was not affected by sunglint. The different lighting geometry between the two images reveals numerous details, including the city margin, city blocks, and even individual buildings. The green, vegetated parts of the floodplains, and black, inundated areas shown lower left, stand out clearly. The brown Ural River waters contrast with the darker colour of its tributary, the Chogan River in this image.

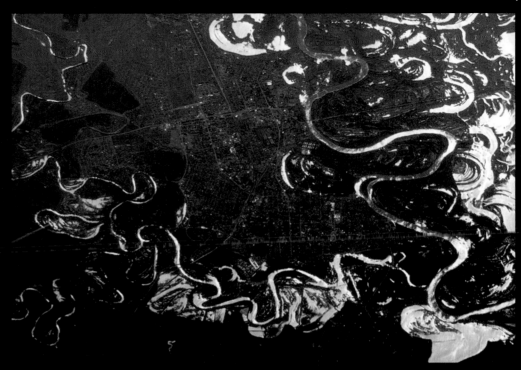

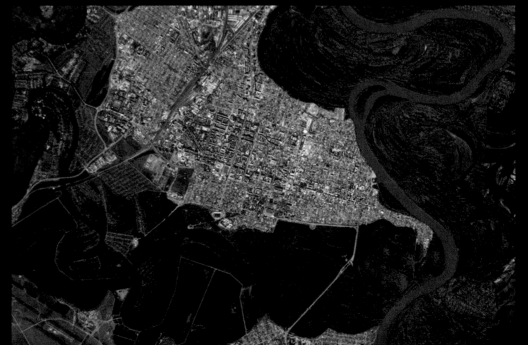

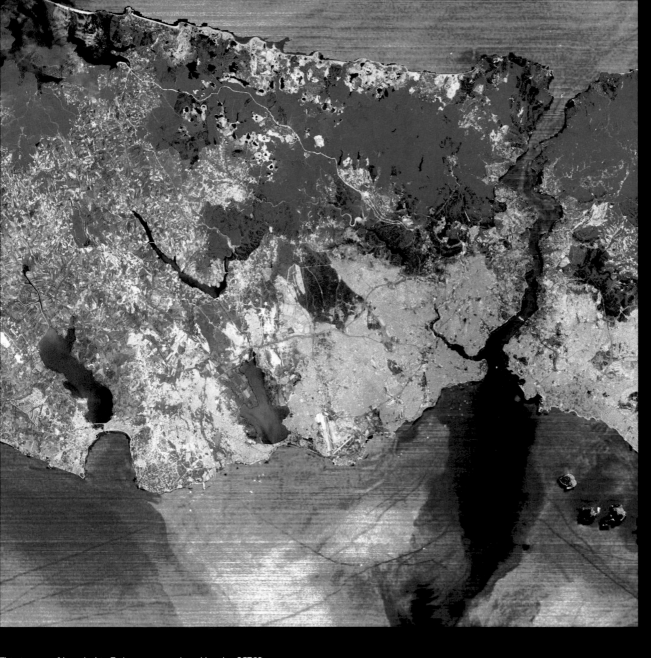

One of the world's largest
artificial lakes, Lake Nasser
is named after the Egyptian
President Gamal Abdul Nasser,
who was largely responsible for
the lake's creation. President
Nasser decided to build the
Aswan High Dam across the Nile,
forming a lake approximately
550km (340 miles) long. In this
astronaut photograph taken from
the ISS, the water of Lake Nasser
stands out from its surroundings
due to sunglint. The Sun's light
reflects off the water's surface
and into the camera lens, giving
Lake Nasser an iridescent
sheen. Sunglint is a common
phenomenon in satellite images
as well as astronaut photographs.

This image of Istanbul in Turkey was produced by the ASTER
instrument, and the infrared channel used has recorded
vegetation as red and urban areas as blue/green.

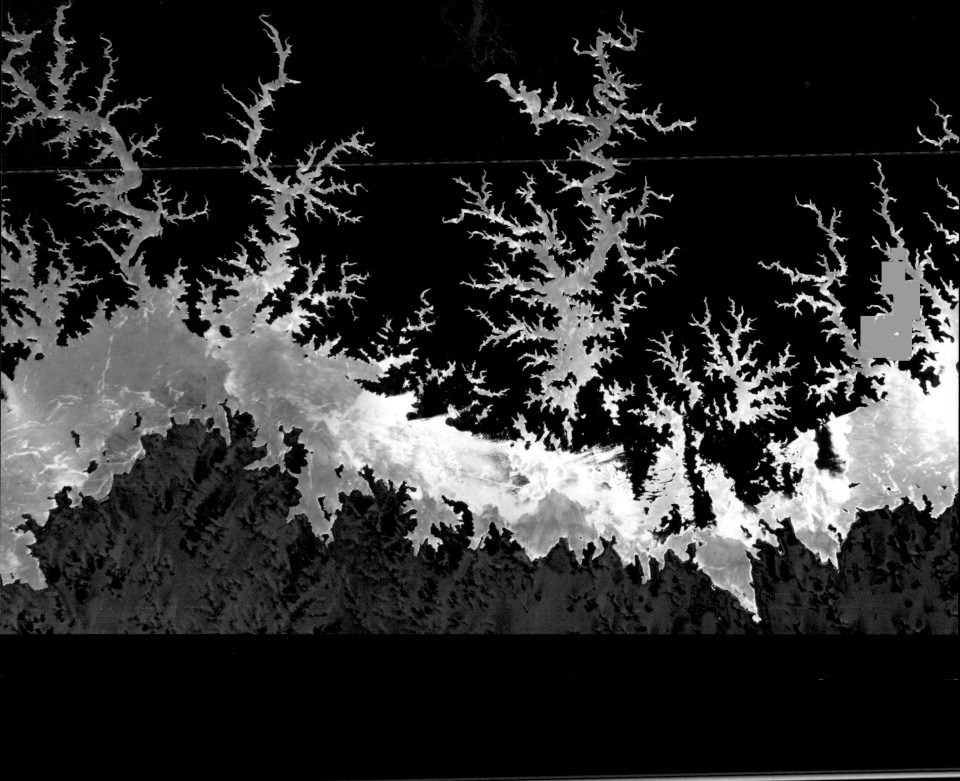

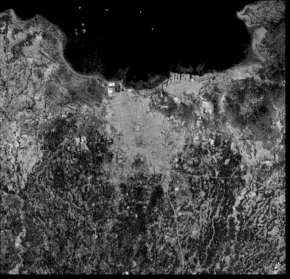
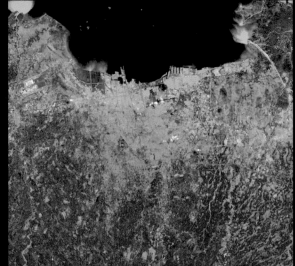
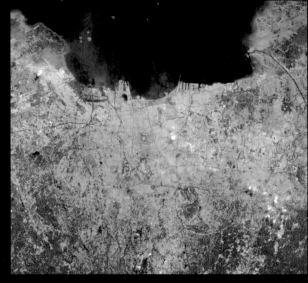

Jakarta, Indonesia, is home to over 13 million people. This series of images taken over a period of 27 years shows the growth of the city from 1976 (6 million) to 1989 (9 million) to 2004 (13 million). The images render vegetation in red, and urban areas in blue-grey. Each covers an area of 49 x 49km (30 x 30 miles), and they are centered near 6.2 degrees south latitude, 106.8 degrees east longitude. The 1976 image was acquired by the Landsat MSS scanner, the 1989 image by the Thematic Mapper, and the 2004 image by ASTER.

The Isle of Jersey (officially called the Bailiwick of Jersey) is the largest Channel Island, positioned in the Bay of Mont St Michel off the north-west coast of France. The island has a population of about 90,000, and covers about 90 sq km (34¾ sq miles).

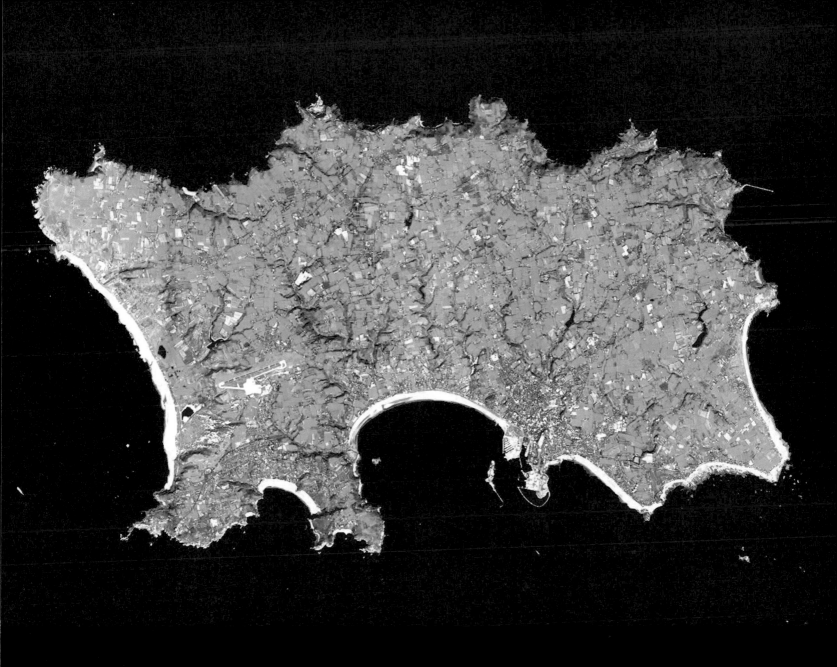

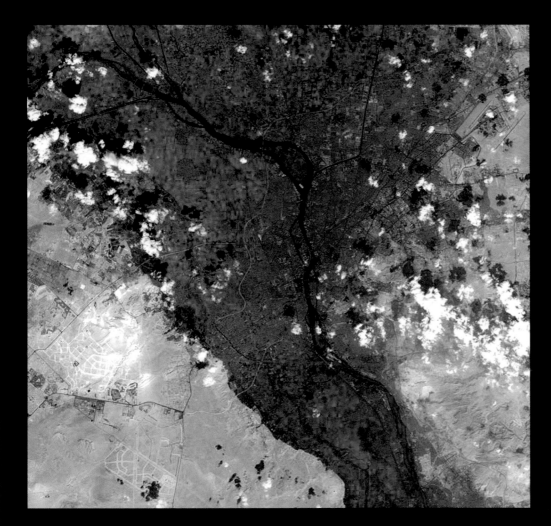

The coast of South Africa, captured by astronaut photography from the International Space Station.

Cairo, the capital of Egypt, is one of the 100 cities worldwide being studied using ASTER data to map and monitor urban growth. This image was acquired October 29, 2001, and covers an area of 40.3 x 44.9km (25 x 27¾ miles).

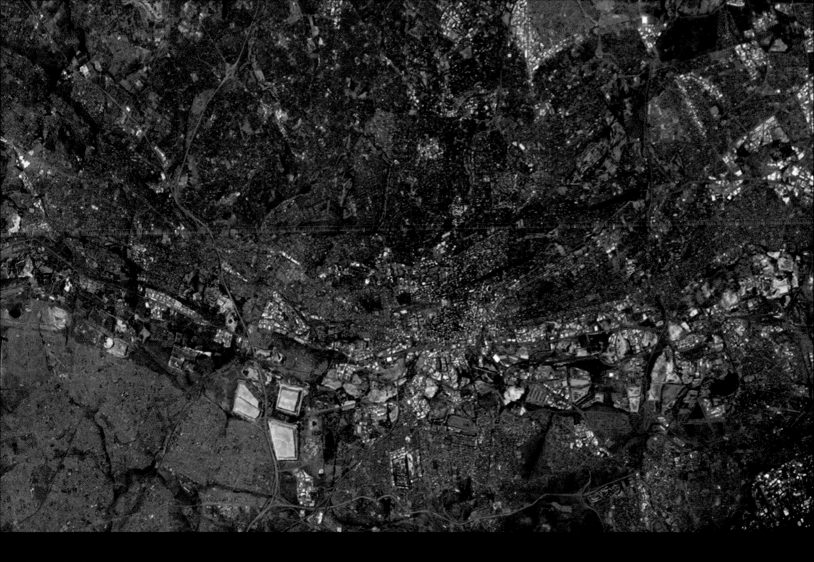

This photograph of Johannesburg, South Africa, taken from the ISS illustrates the human geography of the region. The heart of Johannesburg is the fine-grained pattern, created by shadows cast from the high-rise buildings in the city, in the centre of this mosaic. On the southern fringe of Johannesburg is a line of light coloured, angular patches stretching across the scene. These patches are the great mine dumps, the crushed rock that remains after gold extraction from numerous gold mines. These are the mines that underpinned the South African economy for decades,

and their dumps, or tailing piles, are the visuals that orbiting crews see when they overfly. Top right are the leafy northern suburbs, where hundreds of square miles of grassland have been progressively forested since Johannesburg was founded in 1886. By contrast, a major ghetto (the famous Soweto Township established by the former South African government) typical of developing-world urban migration, appears as the grey zone lower left. Soweto is largely treeless except for protected valley bottoms.

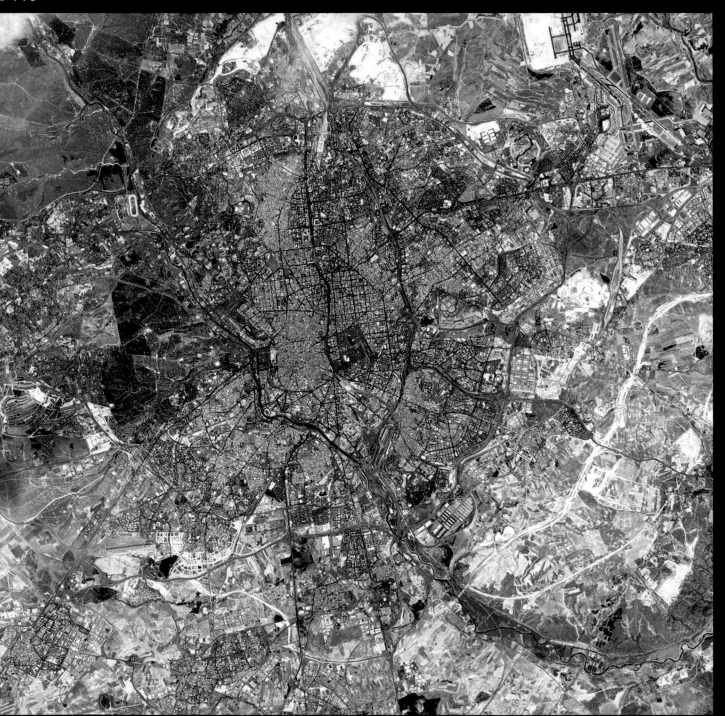

Madrid was pictured by the ASTER sensor, using a false-colour technique that includes some of ASTER's observations in the shortwave infrared as well as the visible part of the electromagnetic spectrum. Seen through infrared, vegetation reflects a lot of energy, and if image creators put those observations into the red 'channel' of a digital image, vegetated areas appear bright red. In this scene, the gardens surrounding Palacio de Velázquez and Palacio de Cristal make a distinct red rectangle in the centre of the image, while surrounding the parks and gardens, red changes to light green, which is the colour of buildings and paved streets. Two large rivers run through Madrid. The Rio Manzanares runs from northwest to southeast through this image in a dark blue, wavy line. The thin strip of vegetation (red) that lines the river at upper left fades as the river passes into the heart of Madrid, and then reappears in the bottom right, as the river exits the city. At upper right, vegetation also lines the banks of the Rio Jarama.

This 60 x 55km (37 x 34 mile) ASTER scene shows almost the entire island of Oahu, Hawaii. Bands 2, 3, and 1 are displayed in red, green and blue, making the vegetation appear green. Oahu is the commercial centre of Hawaii and is important to United States defence in the Pacific, with the Pearl Harbor naval base being situated here. Among the many popular beaches is the renowned Waikiki Beach, backed by the famous Diamond Head, an extinct volcano. The largest community, Honolulu, is the state capital.

The city of Dubai is located in the northeastern part of the United Arab Emirates (UAE) along the Persian Gulf. Dubai is the capital city of the emirate of Dubai, one of seven emirates forming the United Arab Emirates. Dubai is the second largest city next to Abu Dhabi in UAE. The upper part of the image shows the centre of the city, which developed along the west side of the Dubai Creek. Dubai shows two different characters: one as a business district lined with high-rise buildings along the creek; and another as a resort with Jumeirah Beach with its safari tours of the desert, shown at the lower left of the image. Off the coast of Jumeirah Beach is the world's largest man-made island resort, The Palm in the Persian Gulf. The design of the palm tree-shaped island can clearly be seen in the image.

On the northern tip of New Zealand's South Island, Farewell Spit stretches 30km (18½ miles) eastward into the Tasman Sea from the Cape Farewell mainland. A sandy beach faces the open waters of the Tasman Sea, while an intricate wetland ecosystem faces south toward Golden Bay. On the southern side, the spit is protected by large areas of mudflats, which are alternately exposed and inundated with the tidal rhythms of the ocean. The wetlands of Farewell Spit are on the Ramsar List of Wetlands of International Significance. This image from the ASTER sensor on NASA's Terra satellite shows Cape Farewell (left) and Farewell Spit. The sandy dunes on the north side of the spit give way to green vegetation along the southern perimeters. The image captured a great amount of detail of the submerged tidal flats, which appear in shades of bluish-purple. The flats are etched with many channels, giving them the appearance of underwater mountains and canyons. Near the shore, the blue-purple colour of the flats is tinged with green, suggesting it is home to aquatic plants that can tolerate daily flooding.

This ASTER image of Baltimore was acquired on April 4, 2000, and covers an area of 17 x 20km (10½ x 12½ miles). Baltimore is the largest city in Maryland and one of the busiest ports in the United States. Its economy focuses on research and development, especially in the areas of aquaculture, pharmaceuticals, and medical supplies and services. Before European settlement, the site was inhabited by Native Americans of the Susquehannock tribe. The town was founded in 1729 and named for the barons Baltimore, the British founders of the Maryland Colony

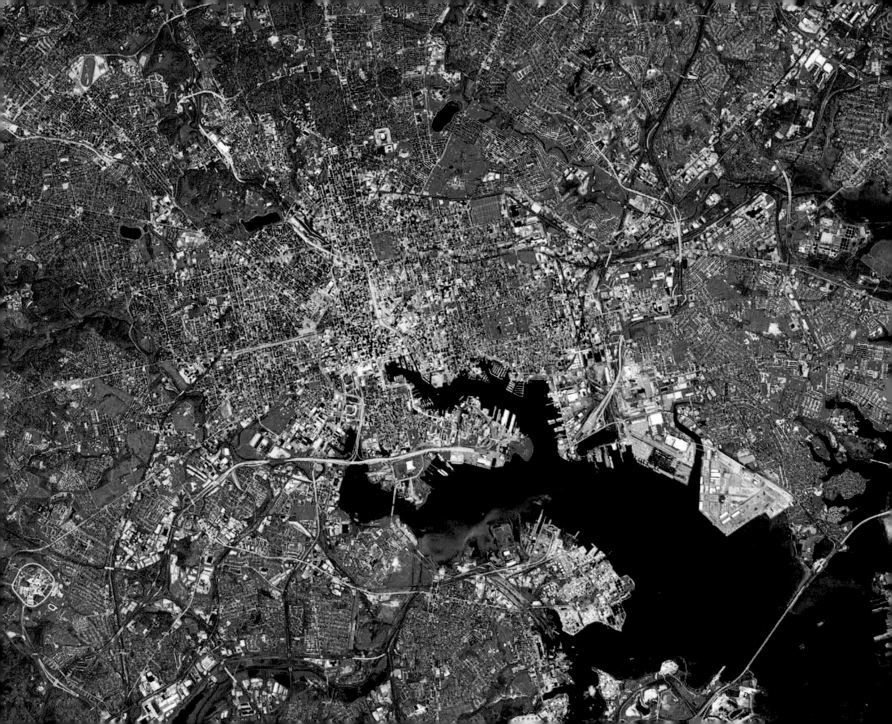

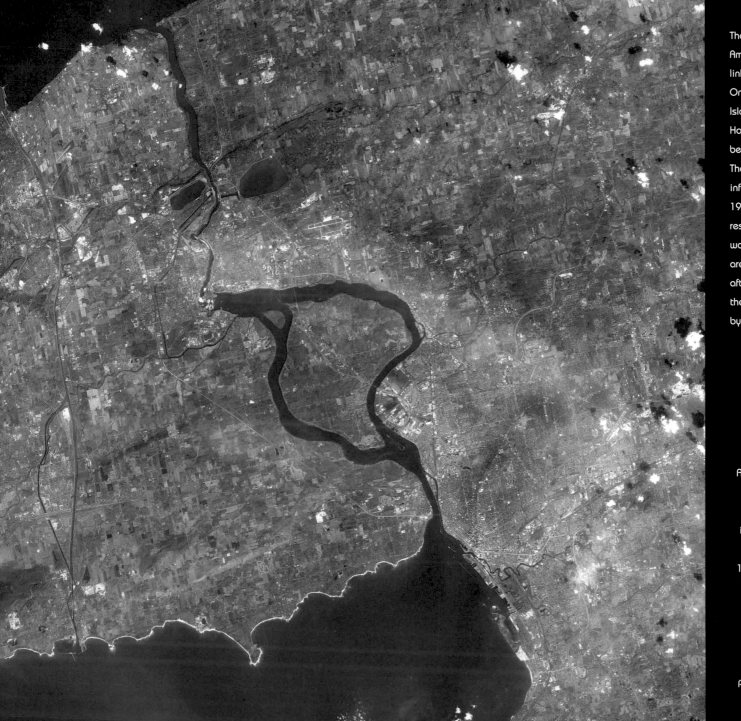

The Niagara River (a Native American word for 'at the neck'), linking Lake Erie and Lake Ontario, flows around Niagara Island, and then plummets over Horseshoe and American Falls, better known as Niagara Falls. The image also includes the infamous Love Canal. In the late 1970s and early 1980s, as a result of the dumping of chemical wastes from 1947 to 1952, the area was evacuated. In 1990, after a 12-year cleanup, parts of the area were declared habitable by government and reopened.

On the side of Tonle Sap Lake in Cambodia stood the capital of the Angkor era that flourished between the 9th and 15th centuries. Vestiges of its prosperity can be found in the Angkor ruins that are designated as a World Heritage site. Amongst the ruins, Angkor Wat is the most famous temple, built by Suryavarman II in the early 12th century to honour the Hindu god Vishnu. It can be identified by the blue frame of water to the lower right of centre. The large rectangular lake to the left, known as West Baray, was part of a sophisticated irrigation system largely responsible for the city's prosperity

Hong Kong, Special Administrative
Region of the People's Republic
of China, is located at the
southeastern part of China on
the coast of the South China
Sea. Hong Kong consists of Hong
Kong Island, Kowloon peninsula,
and other smaller surrounding
islands. Hong Kong came under
British administration as a direct
result of the Opium War; it was
re-unified with China in 1997.
The Kai Tak International Airport,
seen at the right of the image,
was closed in 1998. Replacing
it, the Hong Kong International
Airport at Chek Lap Kok opened
off of Lantau Island. The new
airport (the grey area towards
the bottom left) incorporates a
terminal, shaped like the letter
Y, which is the world's largest
building associated with airports.
This simulated natural-colour
image is a mosaic of four ASTER
scenes, acquired on October 2
and November 3, 2003.

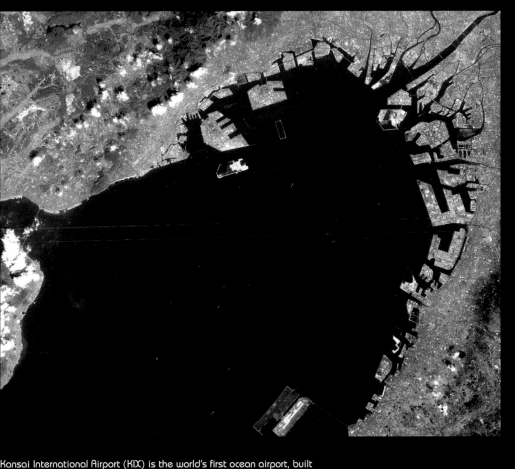

in this ASTER-generated image of the city of Baghdad, the plumes of smoke, which originate along major roads and canals, are believed to have been created by burning pools of oil from pipelines. The plumes, which blanketed large sections of the city of approximately 5 million people, created an environmental health hazard for residents of the city and surrounding regions. ASTER's broad spectral coverage and high spectral resolution are ideally suited for monitoring dynamic environmental conditions caused by natural and human-induced factors.

Kansai International Airport (KIX) is the world's first ocean airport, built on a landfill island in Osaka Bay, Japan. Opened in 1994, KIX was a modern engineering marvel, built entirely as an artificial island. Because the site is built upon compacted fill, it suffers from subsidence, sinking 2–4cm (½–1in) per year. The Kansai terminal is 1.7km (1 mile) long, and was designed by world famous architect Renzo Piano. KIX is linked to the mainland by a 3.7km (2¼ mile) long bridge, and provides air service for the nearby cities of Osaka, Kobe and Kyoto. Four months after opening, the airport was severely tested by the magnitude of the 6.7 Kobe Earthquake; it survived with only minor damage, and provided continuous operation during the relief efforts. This simulated natural-colour ASTER image was acquired on September 19, 2003.

CITIES & LANDMAR

The Wasatch Range forms an impressive backdrop to the Salt Lake City metropolitan area, and it is a popular destination for hikers, backpackers, and skiers. The range is considered to be the westernmost part of the Rocky Mountains, and rises to elevations of approximately 3,600m (12,000ft) above sea level. This astronaut photograph, taken at the end of September

from the ISS with a Kodak 760C digital camera fitted with an 800mm lens, captures hill slopes mantled in red (maple trees) and gold (aspen trees). Other common tree species at these elevations include pine, fir, spruce, willow, birch, and oak. The elevation of Lone Peak, visible at upper right, is approximately 3,410m (11,253 ft).

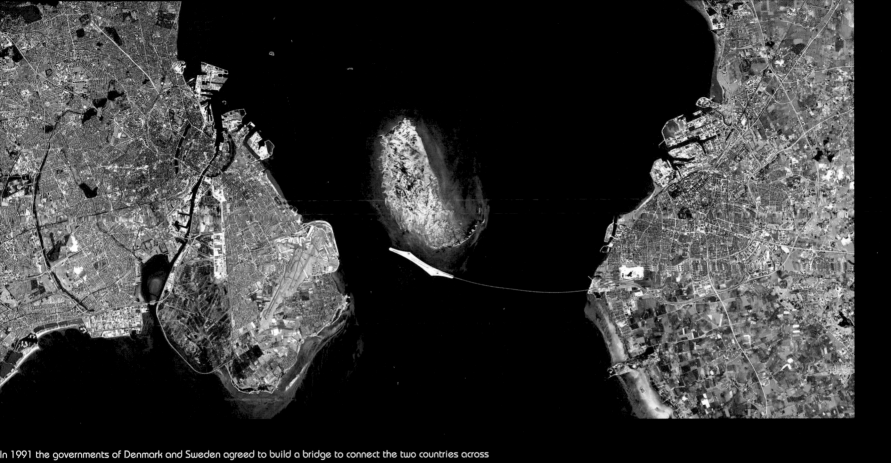

In 1991 the governments of Denmark and Sweden agreed to build a bridge to connect the two countries across the Oresund Strait. The 16km (10 mile) long Oresund link between Malmo, Sweden (right) and Copenhagen, Denmark (left) was completed and opened to traffic in 2000. Denmark and Sweden were linked once more – 7,000 years after the Ice Age when they were landlocked. The Oresund Bridge is the world's longest single bridge carrying both road and railway traffic. The high bridge with its record-breaking cable-stayed span of 490m (1,608ft) is designed to harmonize both structurally and aesthetically with the approach bridges. The connection starts on the Denmark side near the airport as an underwater tunnel that emerges on a man-made island. From there, the bridge continues to the Swedish side. This ASTER image was acquired on April 10, 2004.

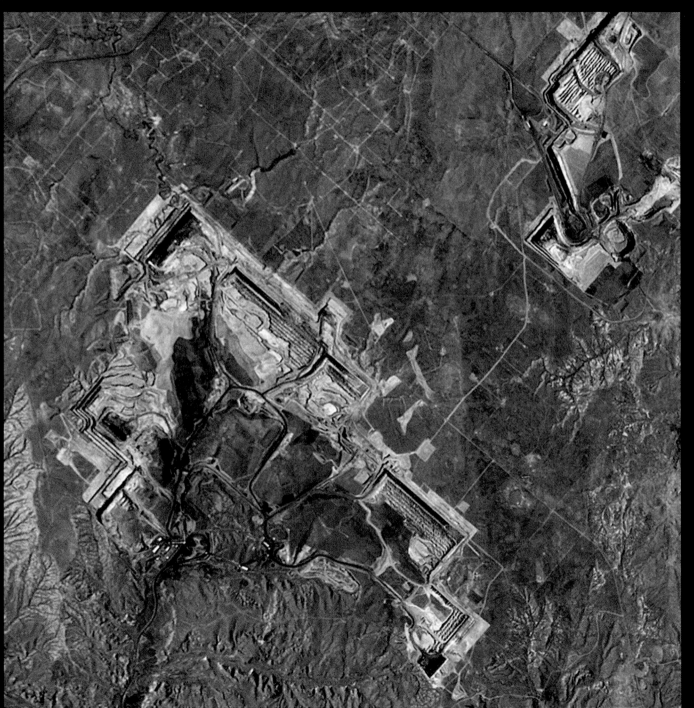

Most of the United States' coal production is in Wyoming, and open-cast strip mining is the technique that operators prefer for removing the sparsely vegetated surface that covers the coal seams of north-eastern Wyoming. One of the largest of these mines, Peabody Energy's North Antelope Rochelle Complex, is shown in this astronaut photograph from the ISS. A portion of Arch Coal's Black Thunder Mine Complex is also seen to the north. Active coal seam faces are visible as black lines, and the stepped benches along the sides of the pit allow access for trucks. Large draglines and shovels remove the overburden and expose the coal seam; blasting reduces the coal to loadable fragments for the trucks. The coal is then transported by up to 2000 railway wagons per day. Mining companies are required to reclaim and re-vegetate former mine workings.

This simulated natural colour ASTER image of the German state of North Rhine Westphalia covers an area of 30 x 36km (18½ x 22 miles), and was acquired on August 26, 2000. Clearly visible in the picture are three enormous opencast coal mines. The Hambach mine has recently been brought to full output capacity through the addition of the No. 293 giant bucket wheel excavator. This is the largest machine in the world; it is twice as long as a soccer field and as tall as a building with 30 floors. To uncover the 2.4 billion tons of brown coal (lignite) found at Hambach, five years were required to remove a 200m (656ft) thick layer of waste sand and to redeposit it off site. The mine currently yields 30 million tons of lignite annually, with annual capacity scheduled to increase to 40 million tons in coming years.

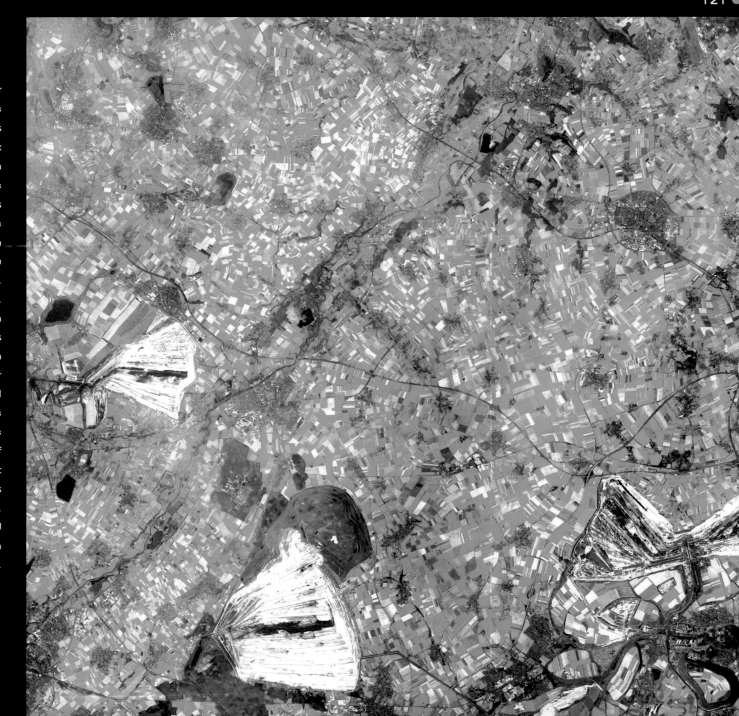

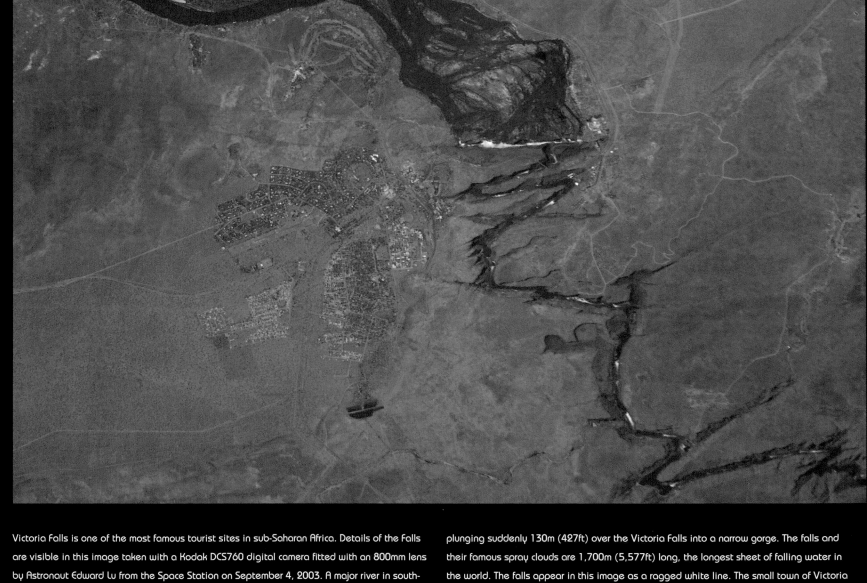

Victoria Falls is one of the most famous tourist sites in sub-Saharan Africa. Details of the Falls are visible in this image taken with a Kodak DCS760 digital camera fitted with an 800mm lens by Astronaut Edward Lu from the Space Station on September 4, 2003. A major river in south-central Africa, the Zambezi flows from western Zambia to the Indian Ocean in Mozambique. In the sector imaged here, it flows southeast (top left to bottom right) in a wide bed before plunging suddenly 130m (427ft) over the Victoria Falls into a narrow gorge. The falls and their famous spray clouds are 1,700m (5,577ft) long, the longest sheet of falling water in the world. The falls appear in this image as a ragged white line. The small town of Victoria Falls in Zimbabwe appears just west (left) of the falls, and there are smaller tourist facilities located on the east bank in Zambia.

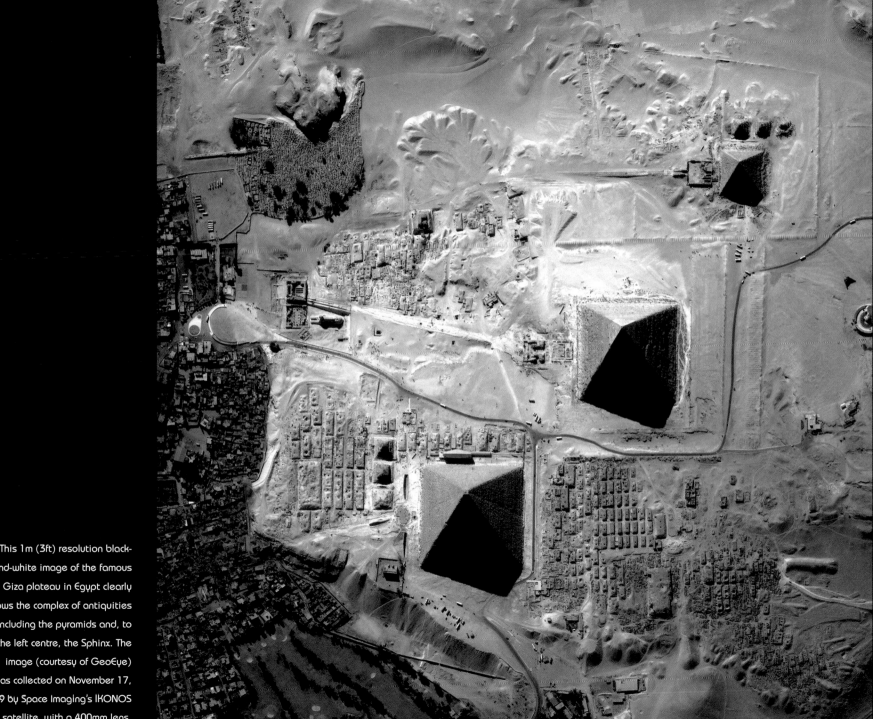

This 1m (3ft) resolution black-and-white image of the famous Giza plateau in Egypt clearly shows the complex of antiquities including the pyramids and, to the left centre, the Sphinx. The image (courtesy of GeoEye) was collected on November 17, 1999 by Space Imaging's IKONOS satellite, with a 400mm lens,

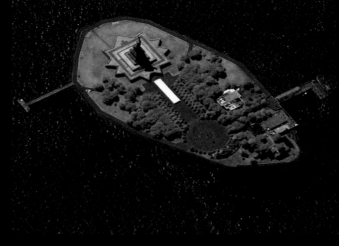

LEFT:
This image of the Statue of Liberty was collected by the QuickBird Satellite on August 2, 2002. The statue was constructed in France from 1881–84, and was dismantled for transportation to America in 1885. QuickBird collects over 75 sq km (30 sq miles) of image data annually to ensure that DigitalGlobe's image library is constantly expanding.

LEFT:
Throughout the conflict in Iraq satellite photography has played a vital role by allowing detailed surveillance to take place. These are bunkers in Al Qaqaa, recorded by the QuickBird satellite. The QuickBird satellite is the first in a constellation of spacecraft that DigitalGlobe has been developing, with the aim of offering highly accurate, commercial high-resolution imagery of Earth.

TOP LEFT:
This natural-colour image of Ayers Rock in Australia, collected by the QuickBird satellite on February 4, 2002, shows the landmark geographic feature with a richness of colour and detail never before seen from space. QuickBird's global collection of panchromatic and multispectral imagery is designed to support applications ranging from map publishing to land and asset management to insurance risk assessment.

BOTTOM LEFT:
This image of the Davis-Monthan Air Force Base in Tucson, Arizona, was collected by the QuickBird Satellite in August 2002. Known as the boneyard, this site is a holding place for out-of-rotation airplanes until their fate is decided; the dry climate provides an ideal environment for aircraft storage, as they can sit indefinitely without rusting. The hard desert soil also makes for easy towing of the planes without roads.

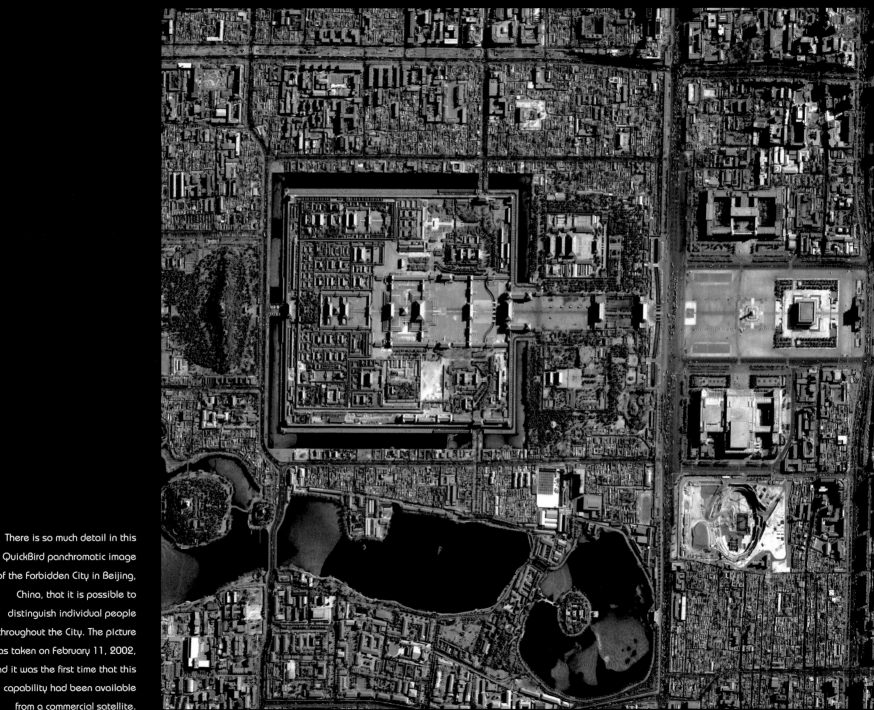

There is so much detail in this QuickBird panchromatic image of the Forbidden City in Beijing, China, that it is possible to distinguish individual people throughout the City. The picture was taken on February 11, 2002, and it was the first time that this capability had been available from a commercial satellite.

THE WORLD VIEWED

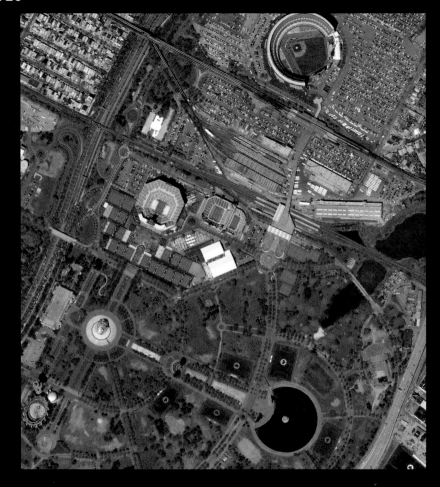

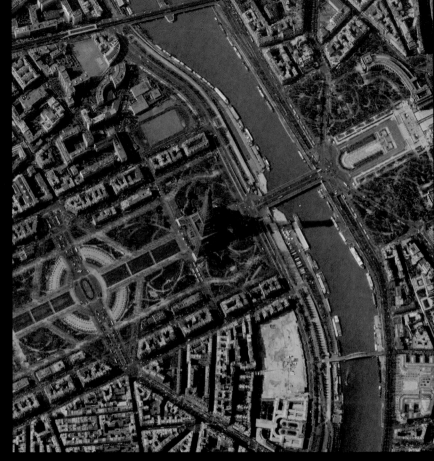

The Arthur Ashe Stadium, Flushing Meadow in New York, a natural-colour QuickBird satellite image taken on April 11, 2005. DigitalGlobe's QuickBird is currently the only spacecraft able to offer sub-metre resolution imagery, and this is combined with industry-leading geolocational accuracy, large on-board data storage, and an imaging footprint two to ten times larger than any other commercial high-resolution satellite.

This natural-colour image of the Eiffel Tower in Paris was collected by the QuickBird Satellite on March 27, 2002. At the completion of its construction in 1889, the Eiffel Tower was the tallest building in the world at 300m (984ft) in height. Originally built for the International Exhibition of Paris of 1889 in commemoration of the centenary of the French Revolution, the tower now serves as the television transmitter for the greater Paris region, as well as being a major tourist attraction.

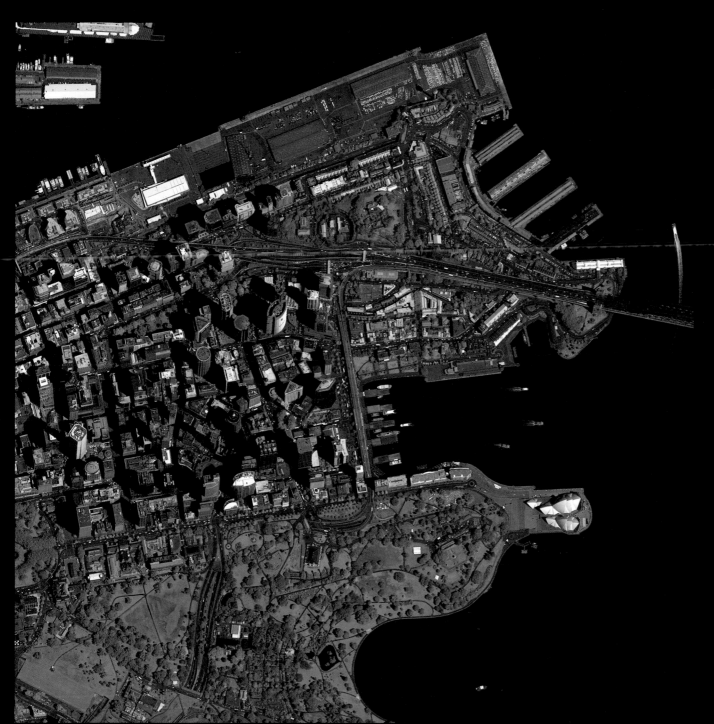

This natural-colour image of the Sydney Harbour was collected by the QuickBird Satellite on April 4, 2002. Visible in the right-hand side of the image is Sydney's famous Opera House, designed by the Danish architect Jorn Utzon. After 14 years of construction, the structure was completed and officially opened in 1973.

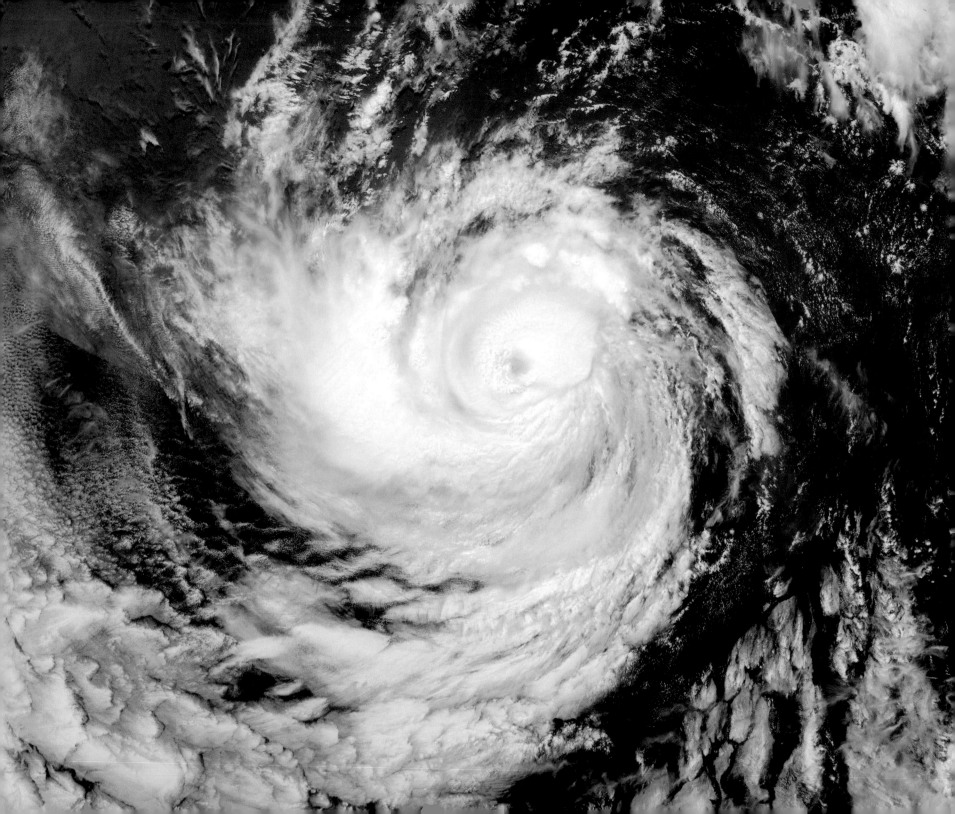

WEATHER &
NATURAL EVENTS

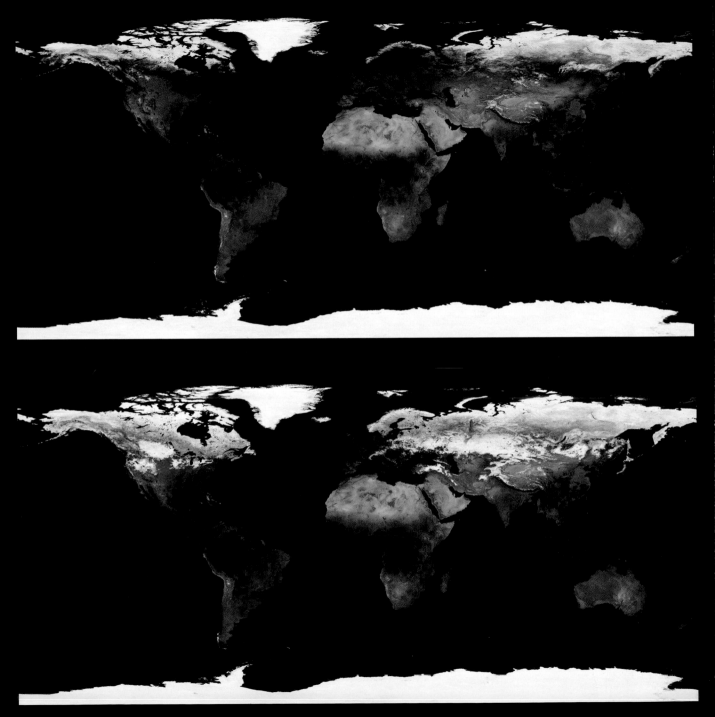

PREVIOUS PAGE:

Hurricane Alma, pictured by the
MODIS instrument aboard the
Terra satellite in the Eastern
Pacific Ocean. Shortly after this
picture was taken on Wednesday
May 29, 2002, Hurricane Alma
became a Category 2 hurricane,
with sustained winds up to
177kph (110mph) and gusts up
to 217kph (135mph).

Astronaut photographs taken
during the Apollo missions
provided full-colour images of
Earth, and fostered a greater
awareness of the need to
understand our home planet. In
1972, from a distance of about
45,000km (28,000 miles), the
crew of Apollo 17 took one of
the most famous photographs
ever made of the Earth, and
this beautiful 'Blue Marble'
inspired later images of the
Earth compiled from satellite
data. In 2000, NASA data
visualizers compiled an image of
the western hemisphere using
data from the National Oceanic
and Atmospheric Administration
including GOES-8 imagery, the
NOAA's Advanced Very High
Resolution Radiometer, and NASA/

● PART ONE: THE WORLD VIEWED

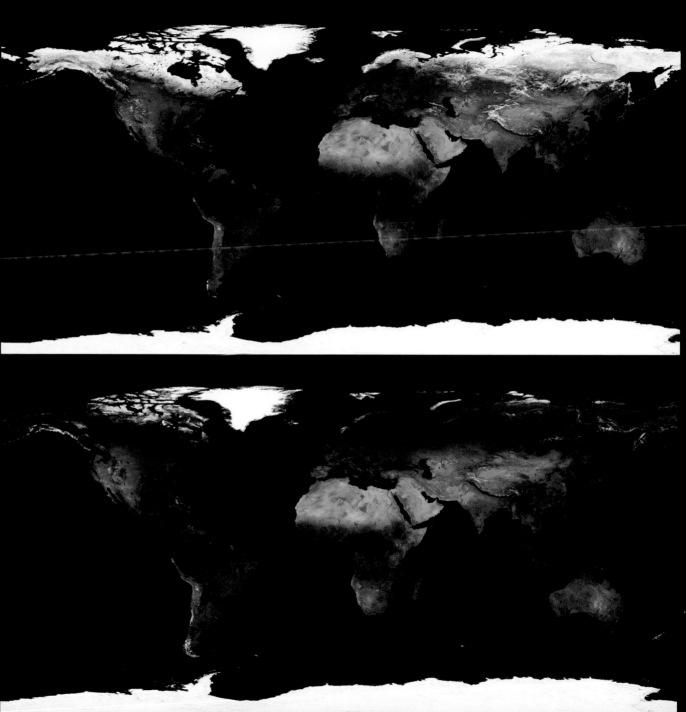

Orbital Science's Sea-viewing Wide Field-of-view Sensor. Two years later NASA created the Blue Marble, the most detailed true-colour image of the Earth's surface ever produced. Using data from NASA's Terra satellite, scientists and data visualizers stitched together four months of observations of the land surface, coastal oceans, sea ice, and clouds into a seamless, photo-like mosaic of every sq km (0.39 sq mile) of our planet. In October 2005, the creators of the Blue Marble released a new version of the spectacular image collection that provides a full year's worth of monthly observations with twice the level of detail as the original. The new collection is called the Blue Marble: Next Generation. Like the original, the Blue Marble: Next Generation is a mosaic of satellite data taken mostly from NASA's MODIS sensor that flies onboard NASA's Terra and Aqua satellites. The image, top left, shows a view of the Earth during autumn, while the picture bottom left shows winter.The picture top right shows the Earth in spring, and image bottom right was produced in summer.

WEATHER & NATURAL EVENTS ●

In mid-December 2005, the diminutive Amsterdam Island made waves – not in the Indian Ocean where it resides, but in the clouds overhead. Described casually as wave clouds, these features took on the shape of a giant ship before blending in with a larger cloud formation to the north and east, and the result was captured by the MODIS sensor flying onboard the Terra satellite. The island itself is almost too small see in this image, but it serves as the starting point for the clouds that flow toward the northeast in a giant V shape. Amsterdam Island itself is a volcanic summit, the northernmost volcano on the Antarctic tectonic plate. The volcano's summit, poking above the ocean surface, conspired

with atmospheric conditions to make these clouds. Pushed by wind, air ascended one side of this island then descended the other. As air rises, it cools and expands, and water vapour in the air condenses to form clouds. As air falls, the clouds evaporate. If the air is uniformly humid, it is likely to form a uniform layer of clouds. If the air is dry, it may produce no clouds. But if the air contains alternating moist and dry layers, clouds form only in the moist layers of air. Known as lenticular clouds, they often look like flipped-over plates. Many of these clouds strung together form larger wave patterns like the spectacular one seen here.

On the west coast of South America, an intricate network of clouds presented a spectacular view to the MODIS instrument on NASA's Terra satellite when it flew overhead on September 30, 2005. In this image, the Pacific Ocean is covered by three closely related cloud types: open-cell, closed-cell, and actinoform clouds. Open cell cloud formations have an open space in their centres fringed by clouds. Closed-cell cloud formations are the opposite: a cloud block in the centre, separated from adjoining blocks by a perimeter of clear air. Actinoform clouds have a ray or leaf-like shape. In this picture, open-cell clouds appear at the top, while a distinct leaf-like actinoform cloud appears below and left of the open-cell clouds. These lace-like clouds were first observed by the TIROS operated by NOAA in the early 1960s. These open- and closed-cell cloud formations result from convective cells, which are loops of rising and sinking air. As a general, atmospheric rule of thumb, clouds form in places where the air is rising, and therefore cooling and causing more water vapour to condense. The reverse of that is true as well: clear areas suggest where air is sinking, and therefore warming, making cloud formation less likely.

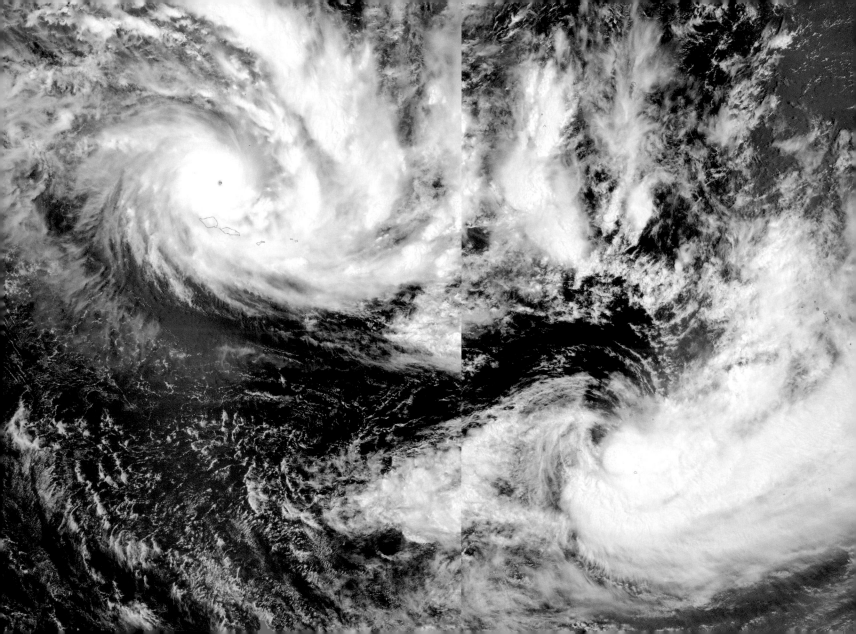

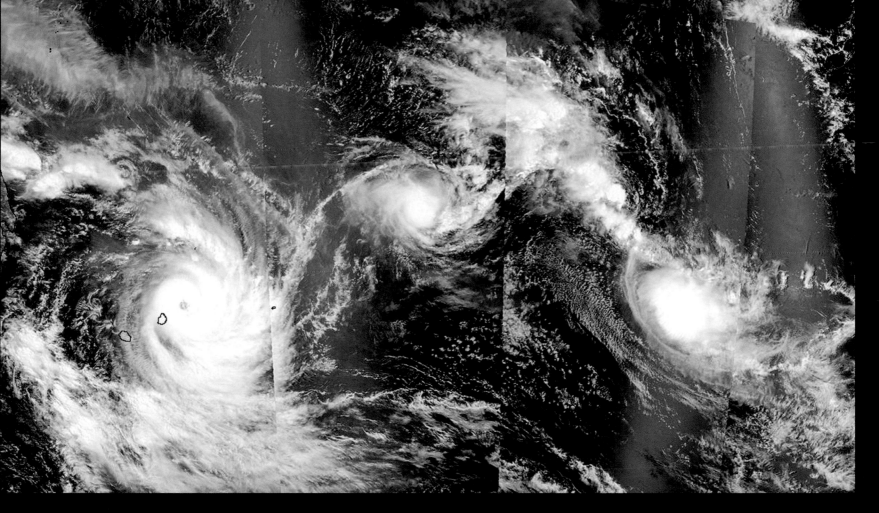

LEFT:

The MODIS instrument onboard NASA's Aqua satellite captured this true-
colour image of Tropical Cyclones Olaf and Nancy in the South Pacific
Ocean. At the time this image was taken, both cyclones were packing
winds of up to 250kph (155mph) and were buffeting the outlying
islands of Samoa, American Samoa and the Cook islands.

ABOVE:

In the southern Indian Ocean, multiple tropical cyclones were lining up on February 13, 2003. This true-colour
image of three of the storms was made by combining alternating passes of the Terra and Aqua satellites. Over
four hours and 35 minutes, the Terra MODIS instrument collected (from right to left) sections two and four of the
image (moving from east to west), and then Aqua MODIS collected sections one and three (also from east to
west). Storms pictured are (west to east) Isha (formerly Tropical Cyclone 18S), Hape, and Gerry.

LEFT AND RIGHT:

These two images give some idea of Colorado's changeable weather: following several days with highs of 21°C (70°F) or higher, Denver's temperatures plummeted, and heavy snow fell in the nearby mountains. The MODIS instrument flying onboard NASA's Terra satellite captured these images on November 1 (left) and November 15, 2005, (right). On November 1, snow cover was sparse, but by the middle of the month, snow covered much of the Continental Divide. The sheet of white spread over mountains and spilled out on to the plains to the east. Some clouds obscure the mountains in the November 15 image, but snow cover can still be discerned as it outlines the underlying mountain peaks.

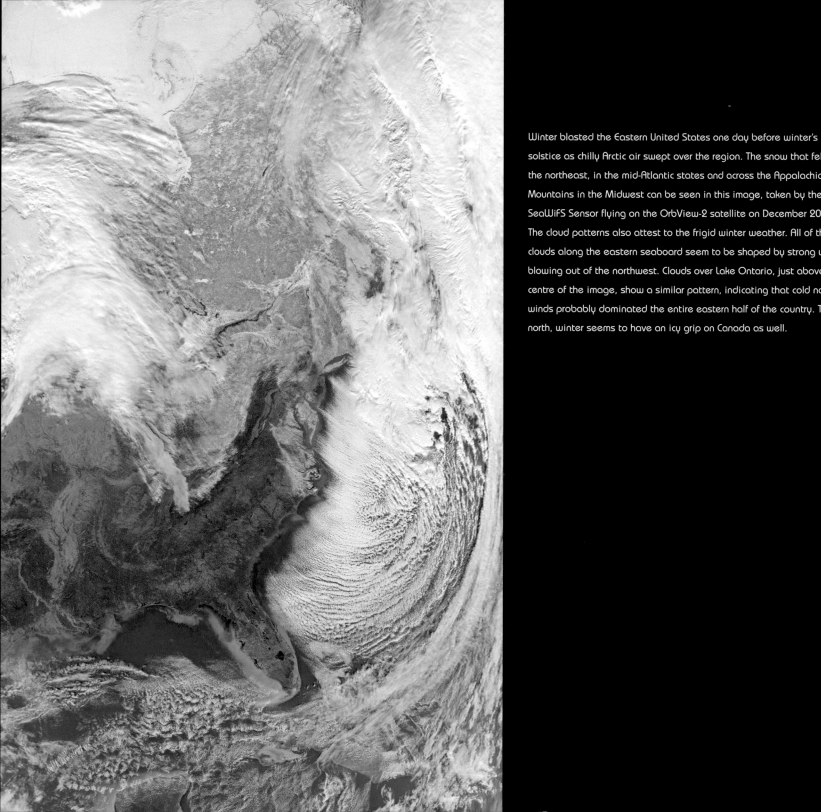

Winter blasted the Eastern United States one day before winter's solstice as chilly Arctic air swept over the region. The snow that fell over the northeast, in the mid-Atlantic states and across the Appalachian Mountains in the Midwest can be seen in this image, taken by the SeaWiFS Sensor flying on the OrbView-2 satellite on December 20, 2004. The cloud patterns also attest to the frigid winter weather. All of the clouds along the eastern seaboard seem to be shaped by strong winds blowing out of the northwest. Clouds over Lake Ontario, just above the centre of the image, show a similar pattern, indicating that cold northern winds probably dominated the entire eastern half of the country. To the north, winter seems to have an icy grip on Canada as well.

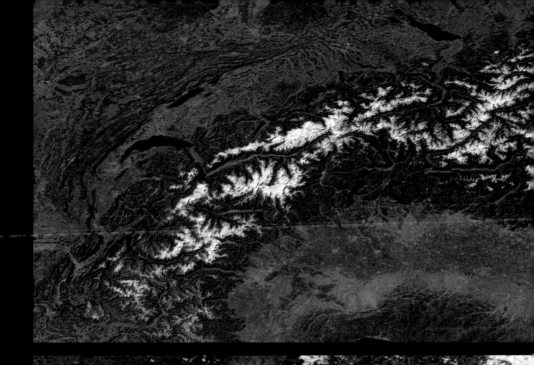

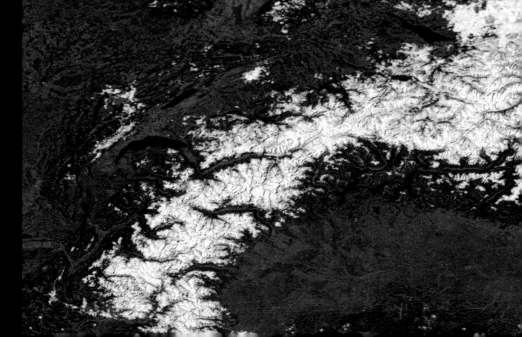

Seen from space, these two views of the Alps, taken in January 2004, right, and July 2004, above right, make it clear in dramatic fashion how the effect of weather on the Earth below can be clearly identified, allowing useful records to be collected and collated

This true-colour image over Kodiak Island, Alaska, shows a plume of re-suspended volcanic ash (beige pixels) extending south eastward from the mainland out over the Gulf of Alaska. According to the Alaska Volcano Observatory, strong winds in the Katmai National Park and Preserve region were picking up old, loose volcanic ash and blowing it toward the southeast. Although this particular plume is not the result of an active volcano, airplane pilots were advised to consider re-suspended ash just as hazardous as the ash from an actively erupting volcano.

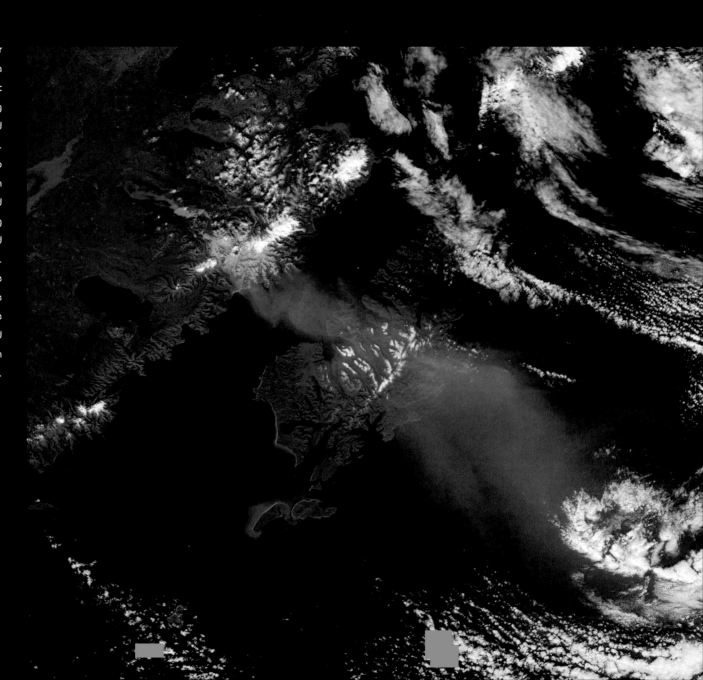

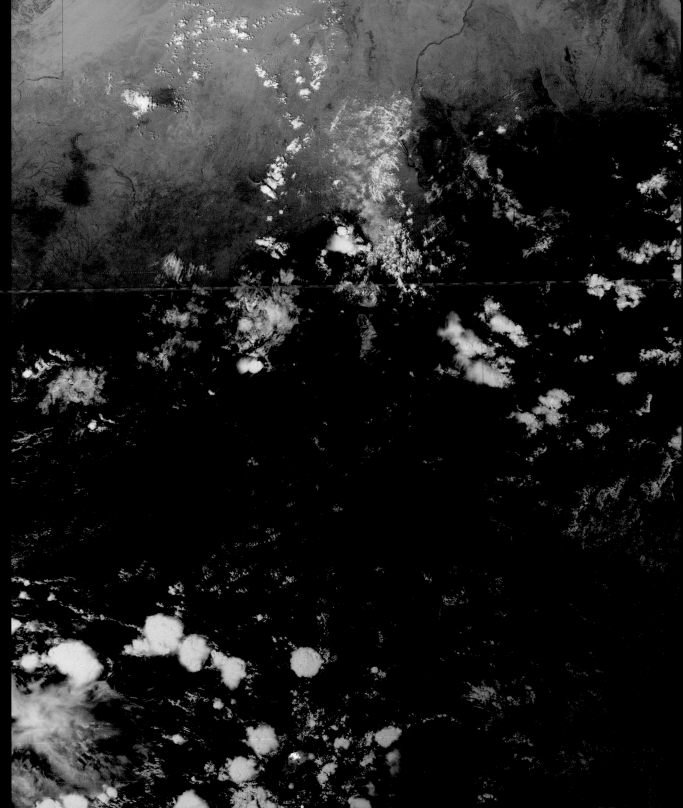

Eastern Africa was cloaked in darkness when the MODIS instrument onboard NASA's Aqua satellite caught this image on October 3, 2005. The inky blackness in this image was caused when the moon crossed in front of the sun in an annular solar eclipse during which the sun is visible as a fiery circle around the black disk of the moon. In the dimness beneath the moon's shadow, very little light remained for MODIS to capture this image. Under normal conditions, the land in the lower half of the image is a lush green, with patches of tan where the land is bare. Here, the beige areas have a red tint in the low light, while the green is completely black. Red dots show where fires were burning in vegetated areas. In the top half of the image, the orange of the Sahara Desert is shown in darker tones than normal. Gradations of darkness within the shadowed area can be seen in the clouds. Bright white clouds reflect light well, so they are easily visible, even in shadow. When this image was taken, the deepest shadow lay over Kenya in the lower right corner of the image. Here the clouds are darker, an indication that there was less light to reflect back to the satellite.

WEATHER & NATURAL EVENTS •

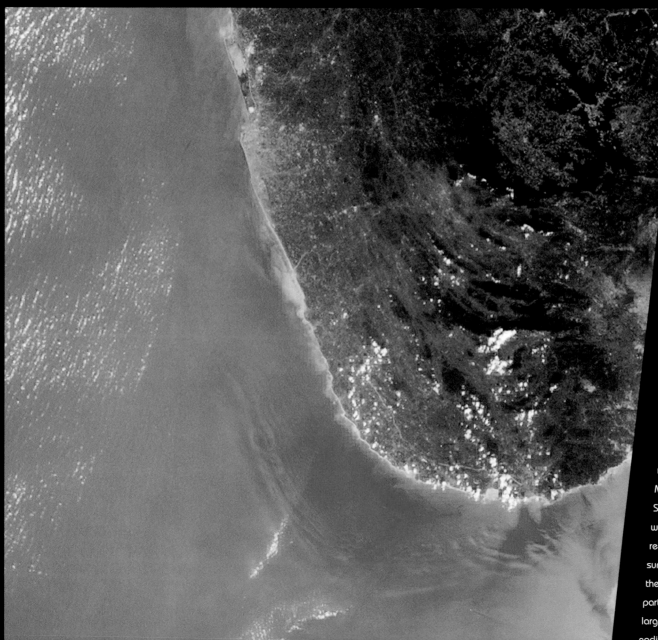

The initial tsunami waves resulting from the undersea earthquake that occurred at 00:58:53 UTC (Coordinated Universal Time) on December 26, 2004, off the island of Sumatra, Indonesia, took a little over two hours to reach the teardrop-shaped island of Sri Lanka. Additional waves continued to arrive for many hours afterward. At approximately 05:15 UTC, as NASA's Terra satellite passed overhead, its MISR instrument captured this image of deep ocean tsunami waves about 30–40km (18–25 miles) from Sri Lanka's southwestern coast. The waves were made visible due to the effects of changes in sea-surface slope on the reflected sunglint pattern, shown here in MISR's 46-degree-forward-pointing camera. Sunglint occurs when sunlight reflects off a water surface in much the same way light reflects off a mirror, and the position of the sun, angle of observation, and orientation of the sea surface determines how bright each part of the ocean appears in the image. These large wave features were invisible to MISR's nadir (vertical-viewing) camera.

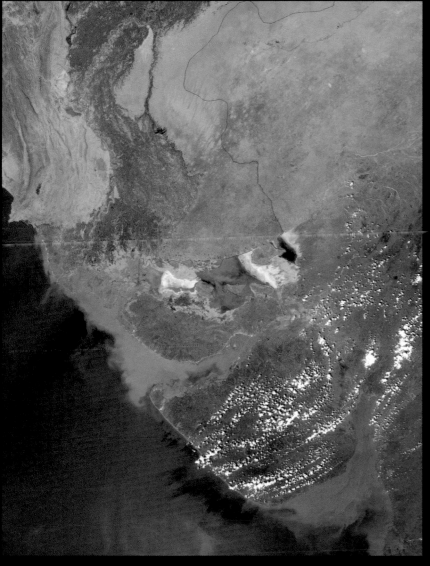
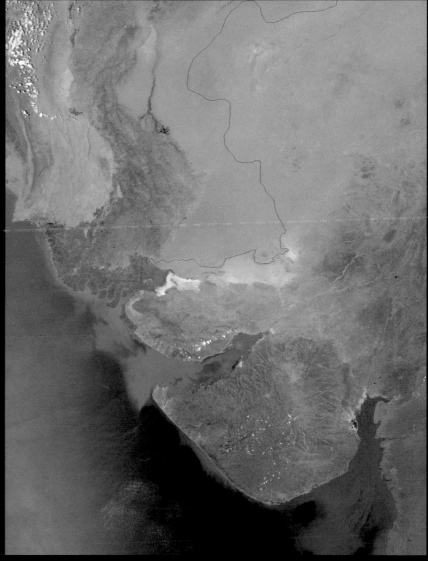

The heavy rains of India's summer monsoon drench the land, filling lakes and rivers. These MODIS images contrast the wet and the dry seasons in the Rann of Kutch in northwestern India. The image on the left, captured by NASA's Aqua satellite on October 3, 2003, shows vast regions of standing water over what is otherwise desert land. Taken earlier in the year, on May 10, 2003, the picture on the right shows the land as it exists for much of the period outside the monsoon season, which usually runs from July through to September. Normally an area of salt clay desert covering some 27,972 sq km (10,800 sq miles), the Rann of Kutch becomes a salt marsh during the annual rains. Nestled between the Gulf of Kutch in India's northwestern state of Gujarat and the mouth of the Indus River in southern Pakistan, the region is home to Asin's last remaining herds of wild asses. Patches of high ground seen in the image become a refuge for the wildlife in the area during the wet season.

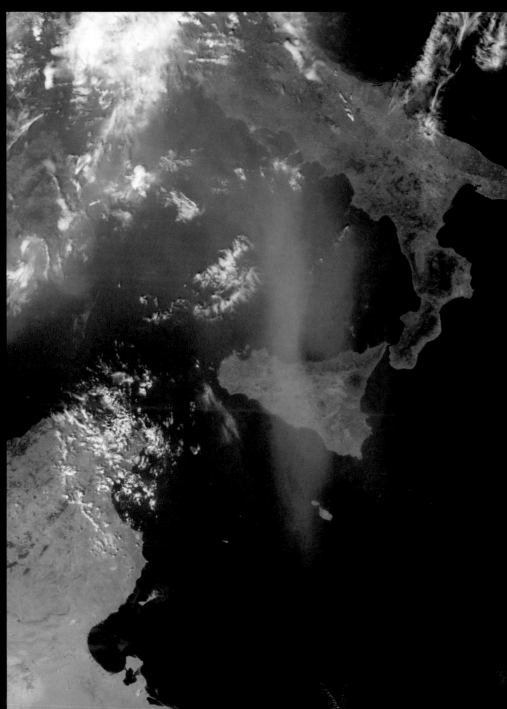

A large plume of Saharan Desert dust can be seen arcing across the northern Mediterranean Sea in this true-colour image acquired on August 29, 2003, by the Terra MODIS sensor. The beige dust is easy to distinguish from the much brighter, white clouds in this scene. Parts of Sardinia and Sicily are obscured from view as the dust cloud appears to be moving towards mainland Italy. The red dots shown on Sicily indicate the locations of hot spots, which are most likely fires burning on the surface.

Across the dark brown ridges and rock formations of southern Afghanistan (top), Iran (left), and Pakistan (bottom right), streamers of pale dust swirl over the arid terrain in this true-colour image acquired on August 20, 2003 by MODIS onboard Terra. Wave after wave of dust storms sweep across the region during the summer, many of them originating in the dry salt flats where there was once a lush oasis of lakes and wetlands straddling the border between Afghanistan and Iran. For more than 5,000 years the Hamoun wetlands served as a primary source of food and shelter for the people in Central Asia. Fed by the Helmand River, the Sistan basin held two large lakes and a large expanse of wetlands, all together covering roughly 2,000 sq km (800 sq miles). The Sistan basin was a thriving blue-green oasis set amid the various beige and brown hues of surrounding deserts and dry plains that reach for hundreds of kilometres in every direction. However, recent drought combined with over irrigation have choked the flow of the Helmand River and all but erased the Hamoun wetlands, leaving only drying reed stands amid a desiccated landscape to mark its passing. In addition to producing severe dust storms – which not only adversely impact air quality but also inhibit rainfall in the region – the destruction of the Hamoun wetlands also presents significant risk to the region's biodiversity.

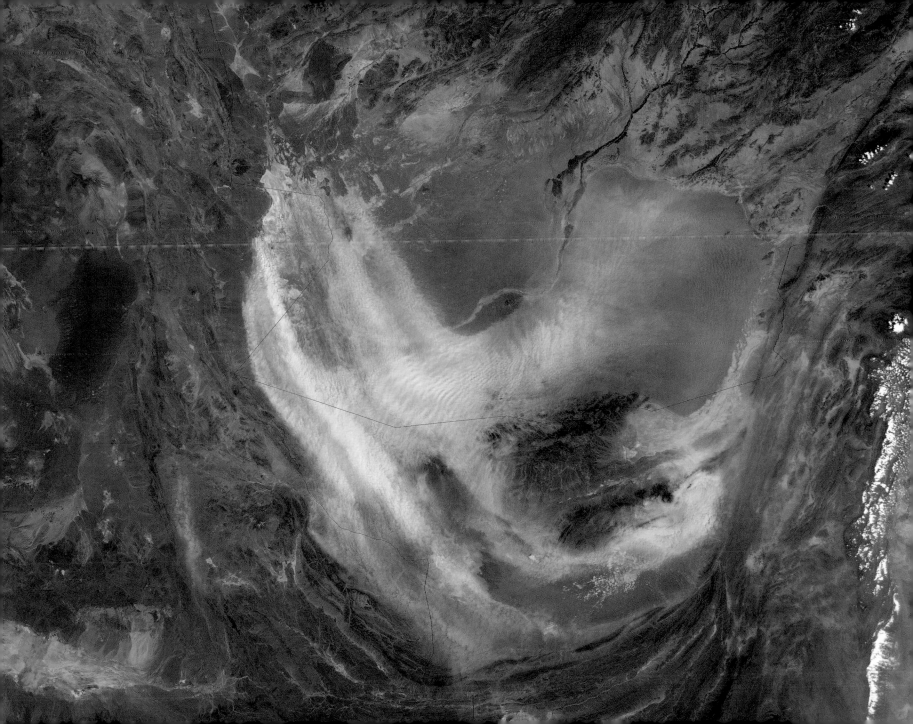

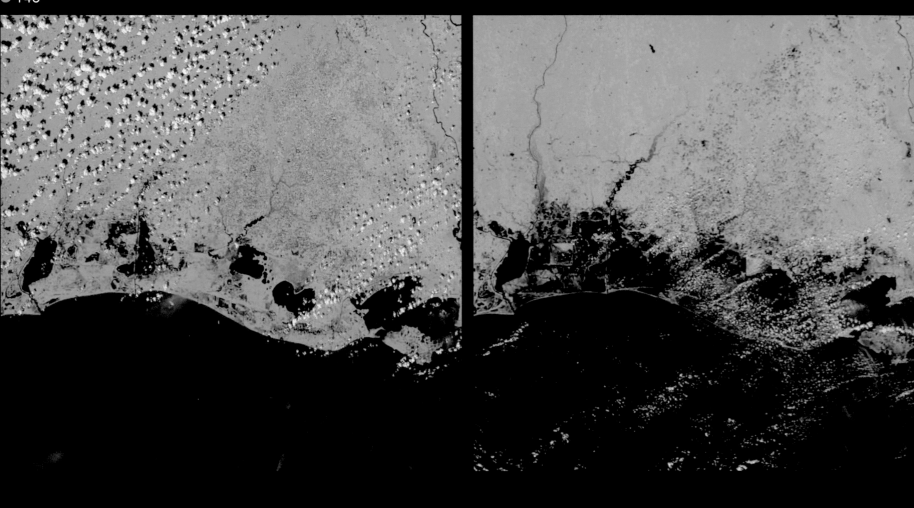

Hurricane Rita's 4.5m (15ft) storm surge and heavy rains caused widespread flooding along the Louisiana coastline. The storm came ashore near the Texas and Louisiana border on September 24, 2005, and the region was still flooded two days later, when MODIS captured the right hand image. In this false-colour picture, water is black or dark blue where it is coloured with mud. The storm burst through levees lining canals, lakes and bayous throughout southeastern and central Louisiana. Water poured into low-lying areas, leaving much of the region flooded to such a degree that the large lakes that lined the coast were no longer distinguishable from each other. The picture on the left, taken on September 21, gives a comparison of the region before the hurricane.

Dozens of villages were inundated when rain pushed the rivers of northwestern Bangladesh over their banks in early October 2005. The MODIS instrument onboard NASA's Terra satellite captured the top image of the flooded Ghaghat and Atrai Rivers on October 12, 2005, and this can be contrasted against the lower view, which was taken on September 19. The deep blue of the rivers is spread across the countryside in the flood image, and a few clouds – light blue and white in this false-colour treatment – cover the region. Low-lying Bangladesh floods often, since the country is built over the flood plains of three major rivers, the Brahmaputra, Meghna, and Ganges. The three rivers converge in Bangladesh and empty into the Bay of Bengal through the largest river delta in the world. The flat land within each flood plain is fertile, and the country is densely populated. As a result, floods on any of the three rivers can affect a vast number of people. When all of the rivers run high with monsoon rains and melting snow from the Himalaya Mountains (the source of the rivers), much of Bangladesh can be under water.

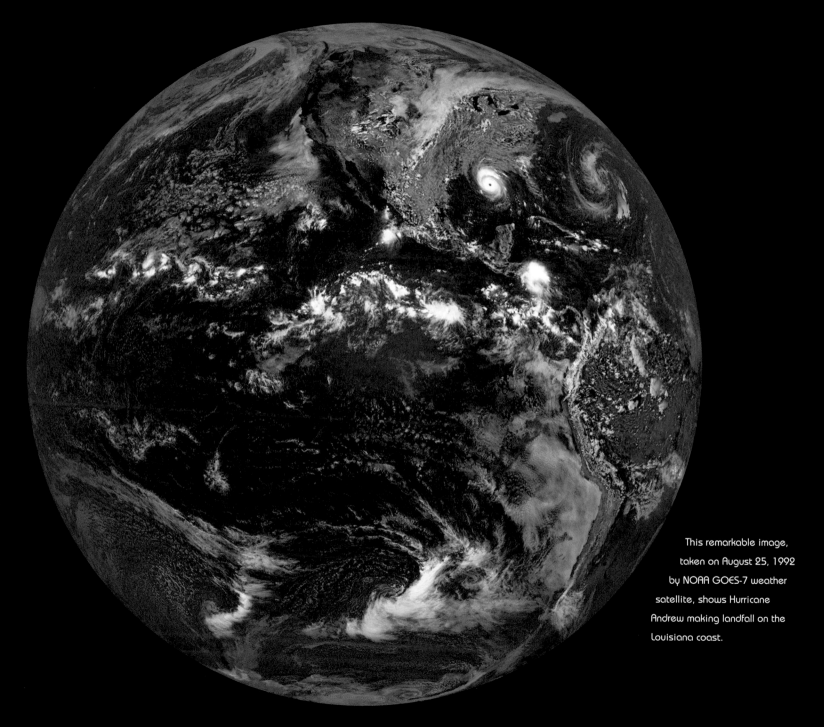

This remarkable image, taken on August 25, 1992 by NOAA GOES-7 weather satellite, shows Hurricane Andrew making landfall on the Louisiana coast.

Hurricane Rita pummelled the Louisiana and Texas shoreline when it came ashore on September 24, 2005. Though the Category 3 storm spared major cities, it left much of the southwestern and central Louisiana shoreline under water. The picture on the left shows the region four days before Rita hit, and the one on the right was taken by the MODIS instrument on NASA's Aqua satellite on September 25, 2005. The trailing edge of Rita's clouds, light blue and white in this false-colour image, still cover the region. Many of the communities most severely affected by the storm are shown in these images: Cameron and other coastal communities such as Pecan Island and Grand Chenier (located on the shore just east of the plume of smoke seen in the left-hand image) appear to be almost entirely under water. Offshore, sediment swirls in the waters of the Gulf of Mexico, colouring the water blue in contrast to its normal inky black. The sediment is probably a combination of sludge stirred up from the ocean floor when Rita's winds and rains churned Gulf waters and run-off from the extensive flooding seen in this image.

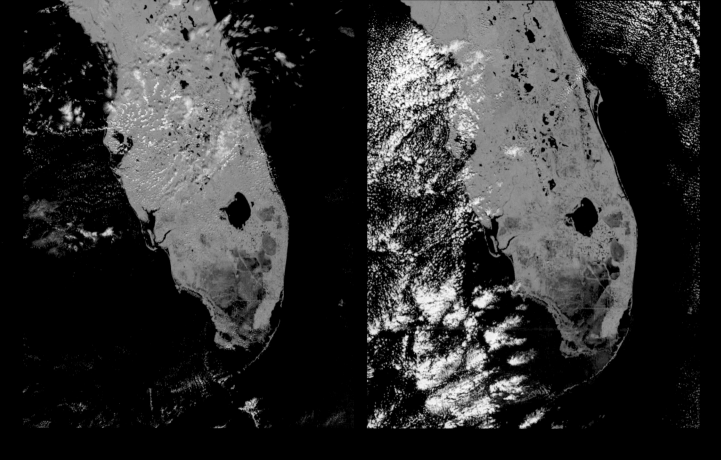

In an image, taken by the MODIS instrument onboard Terra on October 25, 2005, dark pools of water cover sections of Florida the day after Hurricane Wilma cut diagonally across the state. The patterns of flooding shown are more a reflection of land use than the intensity of the storm. Wilma moved from the Gulf of Mexico in the west, over the Everglades, and then pounded the populated eastern shore as it made its exit into the Atlantic. The Category 3 hurricane brought heavy rain, which caused the inland flooding seen here. The picture on the far left, taken on September 14, shows southern Florida under normal conditions.

Hurricane Wilma is seen crossing Florida on October 24, 2005. Although Wilma had lost strength while over the Yucatan Peninsular, the warm waters of the Gulf of Mexico allowed the storm to re-strengthen before landfall. With sustained winds of 200kph (125mph), the Category 3 storm raced across Florida, levelling trees and knocking out power in many communities. Wilma was the 21st named storm of the 2005 Atlantic Hurricane Season, equalling the number of Atlantic storms in 1933. She was briefly accompanied by Tropical Storm Alpha – a record-breaking 22nd named storm. This image shows Wilma moving off the Florida coastline at 9:55 EDT (13:55 UTC), and it is a frame from an animation of data collected by NOAA's GOES, combined with colour land surface data collected by NASA's MODIS instrument.

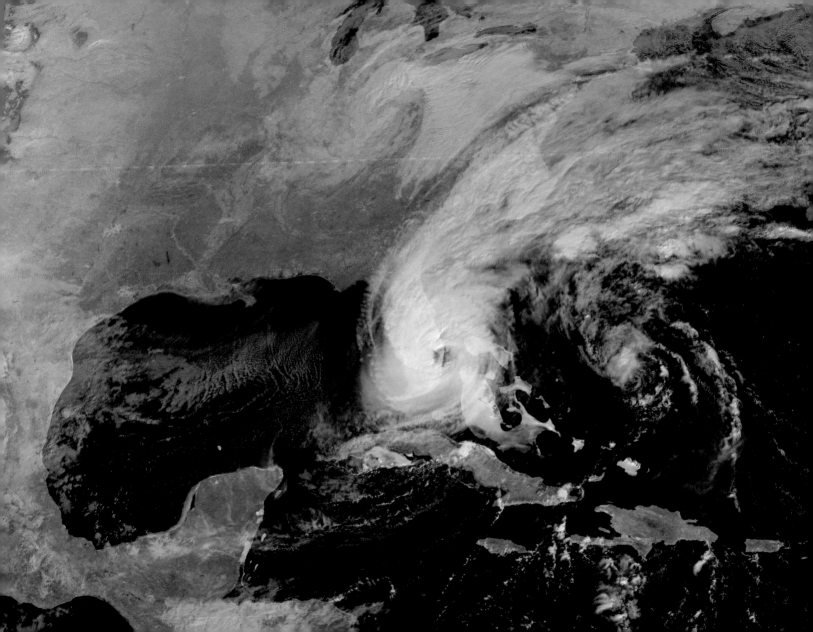

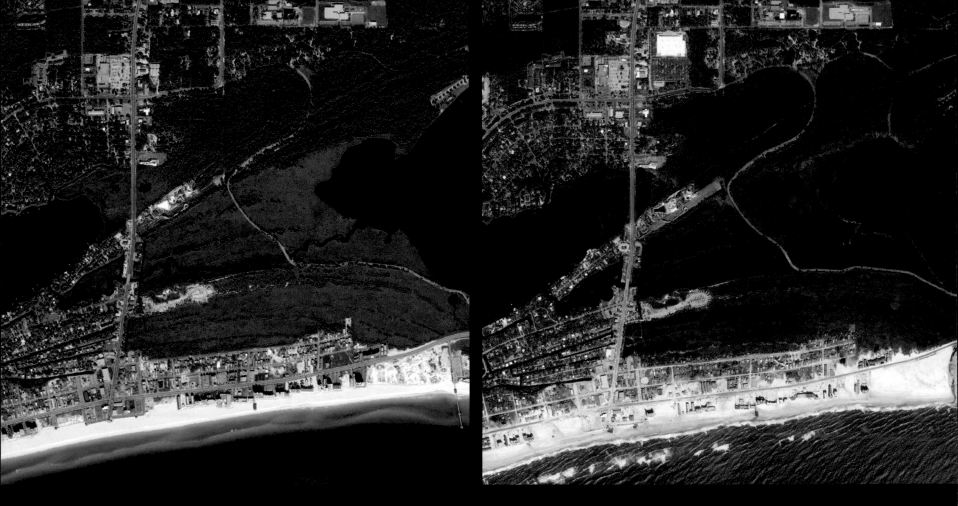

The Gulf Shores in Alabama, appear to have been sand-blasted, after

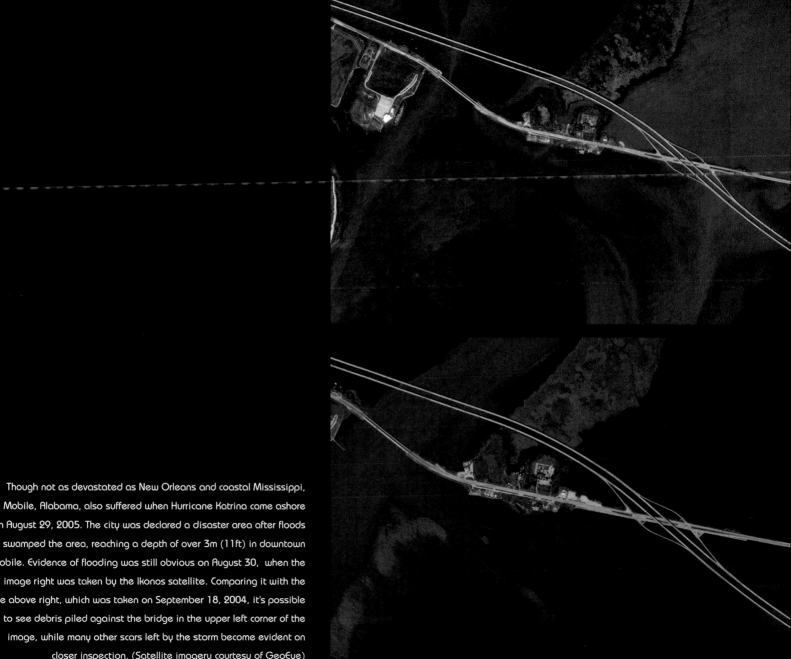

Though not as devastated as New Orleans and coastal Mississippi, Mobile, Alabama, also suffered when Hurricane Katrina came ashore on August 29, 2005. The city was declared a disaster area after floods swamped the area, reaching a depth of over 3m (11ft) in downtown Mobile. Evidence of flooding was still obvious on August 30, when the image right was taken by the Ikonos satellite. Comparing it with the image above right, which was taken on September 18, 2004, it's possible to see debris piled against the bridge in the upper left corner of the image, while many other scars left by the storm become evident on closer inspection. (Satellite imagery courtesy of GeoEye)

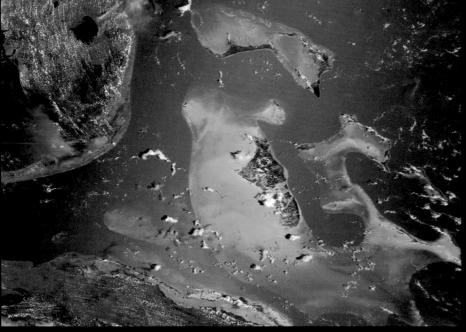

The water around Andros Island in the Bahamas has turned a chalky white in the wake of Hurricane Frances in the image, below left, that was obtained by MODIS on Terra on September 6, 2004. The storm churned the ocean waters, bringing white carbonate sediment (chalk) to the surface. In an image taken two weeks earlier (left), the waters around the island appeared to be bright turquoise, an effect of the reflection of the coral on the Great Bahama Bank through the clear, shallow water. After the storm, the chalk-clouded water is even brighter than normal.

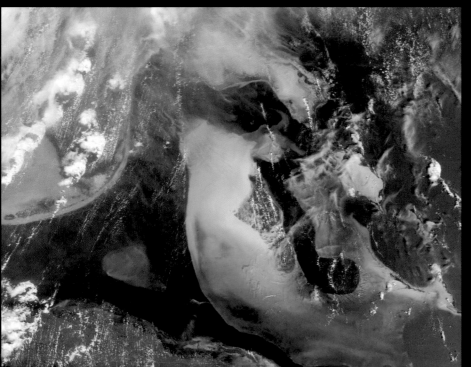

A large tornado cut a 66km (41 mile) swathe of destruction across southern Indiana and northwestern Kentucky in the early morning hours of November 6, 2005. The tornado killed 23 and left at least 200 injured. Ranked a strong F2 or weak F3 on the Fujita Tornado Damage Scale, the storm destroyed more than 100 buildings and homes as it tore across the two states with winds estimated at 320kph (200mph). Four days later the Landsat 5 satellite captured this image of the storm-hit section of Indiana and Kentucky. A pale, interrupted stripe across the image – like someone dragged an eraser across the scene – shows the track the tornado made as it moved from southwest to northeast along the outskirts of Evansville, Indiana. The tornado's track begins on the northern banks of the Ohio River on the left side of the image. It sliced across Ellis Park, the oval-shaped Churchill Downs horse-racing track, killing at least three horses stabled in the track's barns. The tornado then moved northeast across open fields into the neighbourhoods southeast of downtown Evansville. Populated areas are cement white, black, and brown. Here, the contrast between the still-standing structures and the white swathe of destruction becomes greater, making the tornado track easier to follow. Every year, some 1,000 tornadoes strike the United States, though their toll has decreased as weather forecasts and warning systems have improved.

In the far north of the planet, short summers thaw only the top layer of the frozen ground. Beneath this shallow layer, the soil is permanently frozen – permafrost. The permafrost acts like the cement bottom of a swimming pool: water saturates the soil above the permafrost and collects on the surface of the tundra in tens of thousands of lakes. However, temperatures are climbing in the Arctic, and the bottom of the pool appears to be cracking. Using satellite imagery, scientists have documented that, in the past two decades, a significant number of lakes have shrunk or disappeared altogether as the permafrost thaws and lake water drains deeper into the

ground. This pair of images, taken in 1973 (left) and 2002 (right) shows lakes dotting the tundra in northern Siberia to the east of the Taz River. The tundra vegetation is coloured a faded red, while lakes appear blue or blue-green. After studying satellite imagery of about 10,000 large lakes in a 500,000 sq km (193,050 sq mile) area in northern Siberia, scientists have documented a decline of 11 per cent in the number of lakes, with at least 125 disappearing completely. These images were taken using near-infrared, red, and green wavelength data from the Landsat MSS sensor (1973) and the Landsat ETM+ sensor (2002).

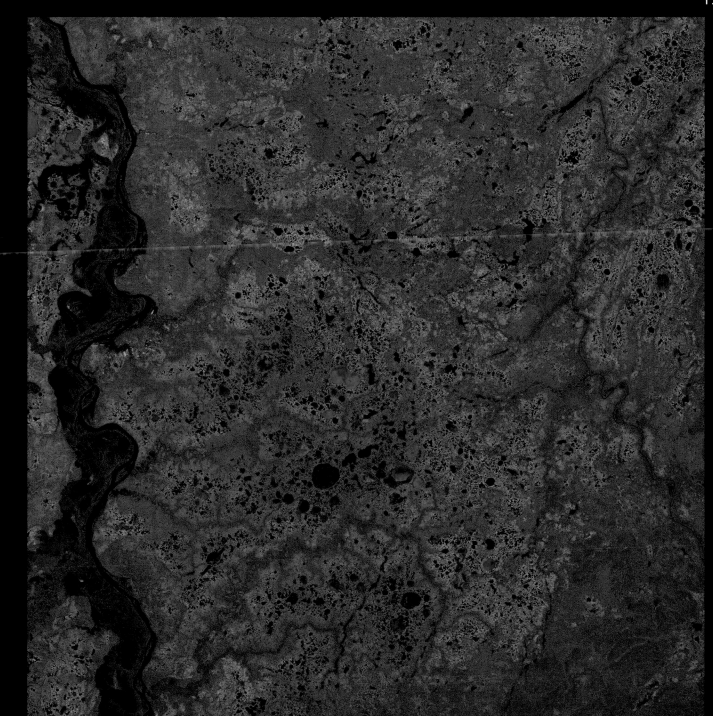

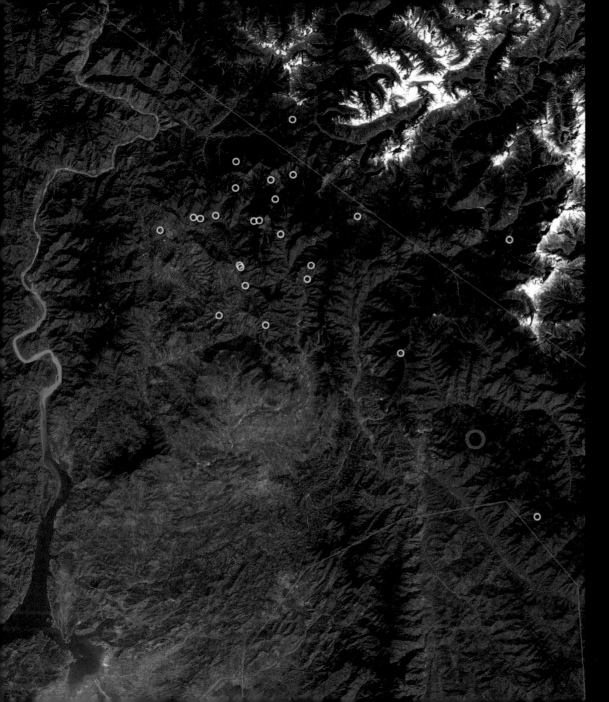

On the morning of October 8, 2005, a powerful earthquake rattled northern Pakistan, India, and Afghanistan. Centered in northern Pakistan, the 7.6 quake flattened nearby cities, causing an estimated 41,000 deaths and leaving millions homeless. The massive quake was followed by dozens of strong aftershocks, most of which were larger than 5.0 on the Richter scale. The geologic forces that triggered the powerful quakes also shaped the rugged, mountainous region shown in this Landsat image. Geology in northern Pakistan and India is controlled by the motion of the Indian subcontinent as it is shoved under the Asian continent at a rate of about 40mm (1½in) per year. As the continents collide, they push up the highest mountain ranges on the planet: the Himalaya, the Hindu Kush, the Karakoram and the Pamir. The friction also breaks the Earth's solid surface into an intricate series of faults. Eventually, the faults slip, releasing their tension and giving vent to an earthquake. In this image, the boundary between the Indian plate and the Asian plate is traced in red. The boundary is not a neat line, as the image depicts, but rather a broad region where the two continents meet. The boundary is equally well-defined by the location of the earthquake, marked with a red circle, and its aftershocks, white circles, which are clustered along the edge of the plate. To the south of the earthquake is a large local fault system. Landsat took the image on October 7, 2001.

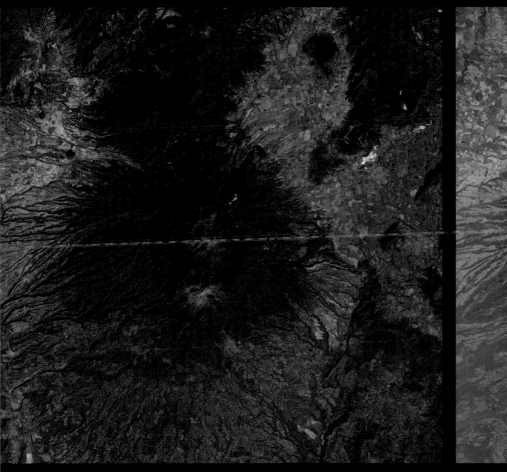
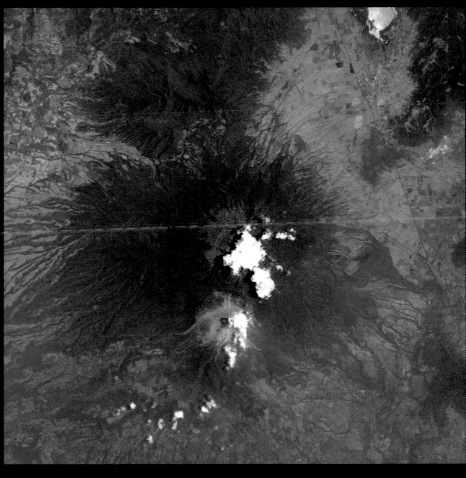

A series of explosive eruptions thundered from the Colima Volcano, Mexico's most active
volcano in 2005. The ASTER sensor captured an image of the Colima Volcano on June 3, 2005
(right), just hours after two spectacular eruptions rumbled from the volcano. Two days later, on
June 5, Colima experienced its strongest eruption in 20 years when it sent a dark column of ash
more than 5km (3 miles) into the atmosphere at a rate of roughly 30kph (18mph). The picture
of the eruption contrasts with the image on the left, which was taken on February 6, 2003.
Here dense vegetation surrounding the volcano, seen as red in this false-colour image, much of
which has disappeared in the wake of Colima's eruption.

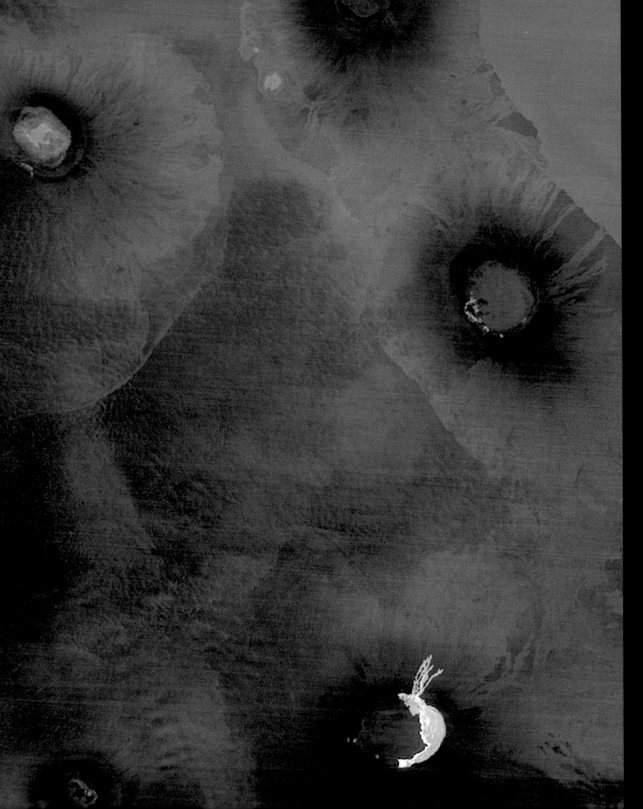

The Sierra Negra Volcano in
the Galapagos Islands began
erupting on October 22, 2005.
In early November, Sierra Negra's
lava flow was so hot it could
be seen at night by a thermal
infrared satellite sensor. On
November 2, 2005, the ASTER
sensor on Terra captured this
night time image of the volcano.
This false-colour photograph
shows the summits of the Sierra
Negra Volcano (Black Mountain
Range) at the bottom of the
image in the east with the Cerro
Azul (Blue Hill) to the southwest.
These volcanoes form part of the
largest island in the Galapagos,
Isla Isabela. All the other major
islands in the Galapagos are
single volcanic summits reaching
just above sea level. The most
remarkable thing about this
image is the lava flow from Sierra
Negra, which is hot enough to
stand out from the surrounding
landscape, and is seen as the
white splotch on the eastern
side of the volcano's summit.
As this image shows, some
threads of lava have broken
away from the large mass
and flowed farther downhill.

This is another view of the
erupting Sierra Negra Volcano on
Isla Isabela, taken on October
25 by the MODIS instrument
on Terra. This image shows a
strong plume of volcanic ash and
steam blowing to the southwest
over the Pacific. The lava flow
produced by the same eruption,
however, flowed down the
volcano's northeast flank, and
the direction of the lava flow
threatened neither humans,
whose village rested on the
south flank of the volcano, nor
the island's famous wildlife.

On October 1, 2005, El Salvador's Santa Ana volcano, also known as the Ilamatepec volcano, erupted for the first time since 1904. The eruption reportedly shot out car-sized lava rocks and a flood of boiling mud and water. This false-colour image was made from data collected by the ASTER sensor on NASA's Terra satellite on February 3, 2001, well before the 2005 eruption. The Santa Ana volcano rises on the left side of the image, forming a large flat-topped mound, and sports several crescent-like craters at its summit and a 20km- (12 mile-) long system of fissures. A tiny blue spot in the centre of the inner-most crater is a crater lake, the likely source of the boiling water flood. Behind Santa Ana is a large caldera lake inside the Coatepeque Caldera, created when a series of volcanoes collapsed in explosive eruptions between 57,000 and 72,000 years ago. In the foreground is El Salvador's newest volcano, Izalco, which sprang up in 1770 and erupted frequently until 1966. The young volcano isn't covered in vegetation (red in this image), but remains black with recent lava flows. Santa Ana is the highest point in El Salvador, and the volcano is 2,381m (7,812ft) above sea level and is 65km (40 miles) west of the country's capital, San Salvador.

The first recorded eruption of Mount Belinda Volcano, of Montagu Island in the remote South Sandwich Islands, began in October 2001. The eruption was first detected by the MODIS Thermal Alert System (MODVOLC) an automated volcano alert system based on thermal anomalies, or 'hot spots', that are detected in satellite data. The first visual confirmation of the eruption came from ships that were passing the islands in February and March 2003, at which time the volcano was still erupting. The ASTER instrument flying onboard NASA's Terra satellite captured this image of Mount Belinda Volcano on September 23, 2005. In this false-colour image, red indicates the hot areas, blue indicates snow covered areas, white indicates steam, and grey indicates volcanic ash

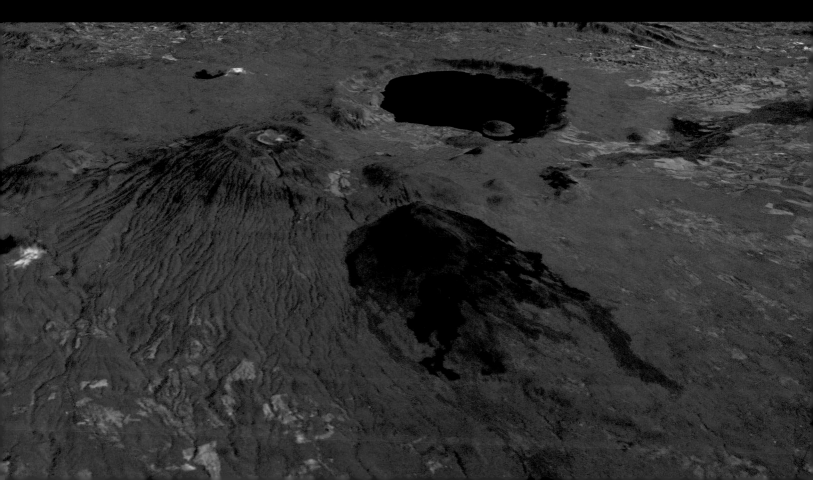

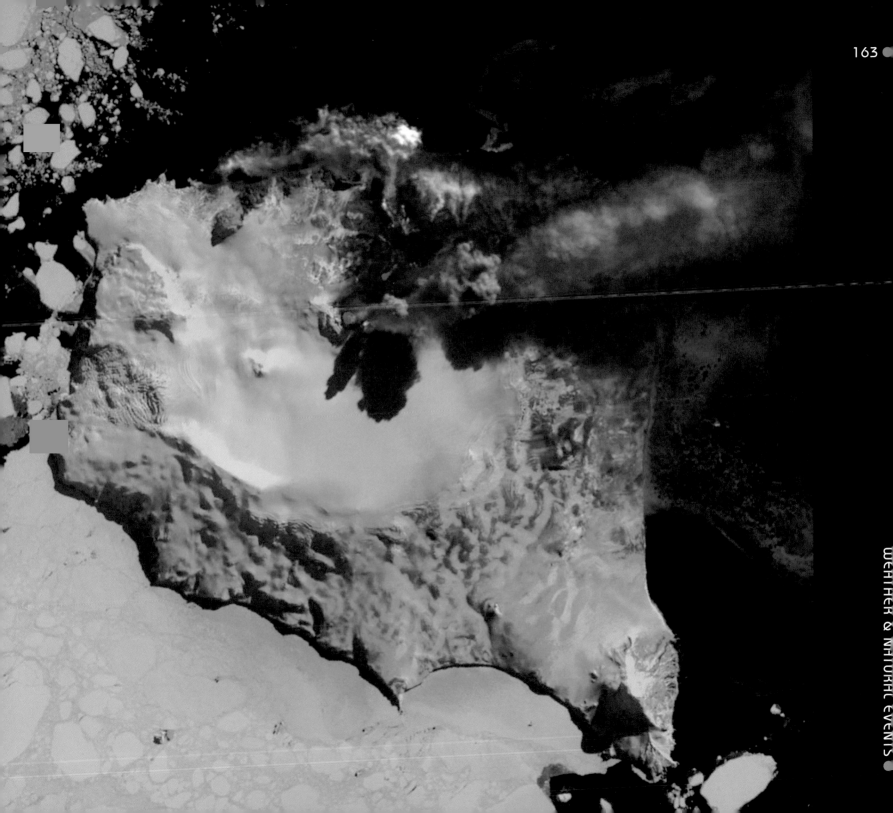

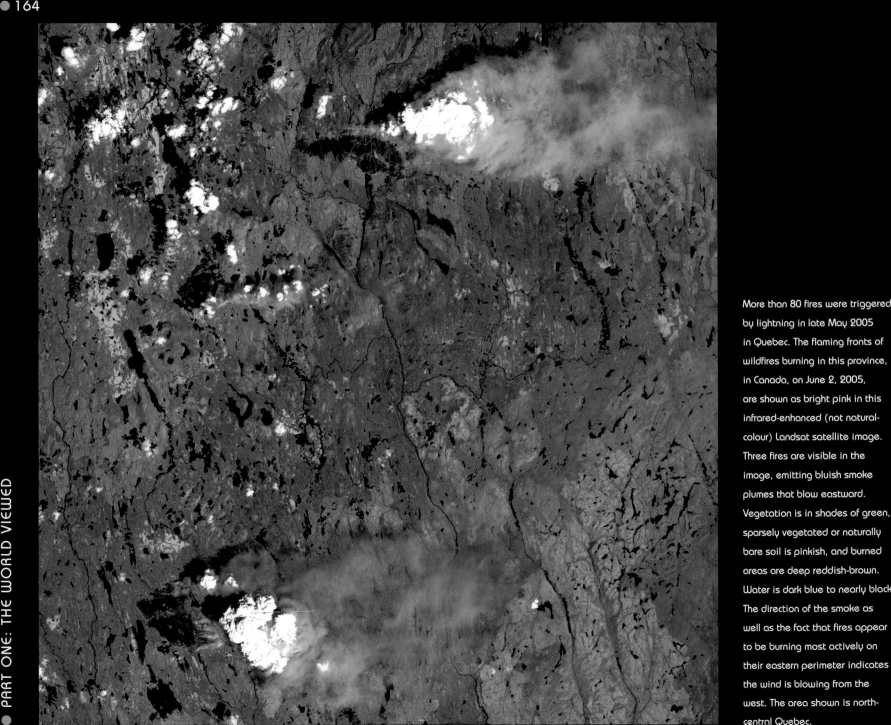

More than 80 fires were triggered by lightning in late May 2005 in Quebec. The flaming fronts of wildfires burning in this province, in Canada, on June 2, 2005, are shown as bright pink in this infrared-enhanced (not natural-colour) Landsat satellite image. Three fires are visible in the image, emitting bluish smoke plumes that blow eastward. Vegetation is in shades of green, sparsely vegetated or naturally bare soil is pinkish, and burned areas are deep reddish-brown. Water is dark blue to nearly black. The direction of the smoke as well as the fact that fires appear to be burning most actively on their eastern perimeter indicates the wind is blowing from the west. The area shown is north-central Quebec.

Several massive wildfires are seen here raging across southern California. Whipped by the hot, dry Santa Ana winds that blow toward the coast from interior deserts, at least one fire grew 4,000 hectares (10,000 acres) in just 6 hours. The MODIS on the Terra satellite captured this image of the fires and clouds of smoke spreading over the region on October 26, 2003. The red specks indicate precisely where the fires are burning, or have recently burned. In and around Simi Valley are the Piru, Verdale, and Simi Incident Fires; the next cluster – to the right of Los Angeles – is the Grand Prix (left) and Old (right) Fires. Closer to San Diego is the Roblar 2 Fire burning in the Camp Pendleton marine base. The Paradise Fire is encroaching on Escondido. The smoke of the massive Cedar Fire is completely obscuring the coastal city of San Diego. Finally, further south at the California-Mexico border, is the Otay Fire.

While Portugal faced its worst drought in 60 years in the summer of 2005, more than 3000 firefighters struggled to contain almost 20 fires ravaging the countryside. The MODIS sensor on the Terra satellite captured this image on August 5 of that year. In this image, heavy smoke is blowing westward from the wildfires, shown by red outlines, over the Atlantic Ocean. Smoke can also be seen blowing west across Portugal from its neighbour Spain.

In the state of Acre in western Brazil, farms and pastures are surrounded by large, undisturbed areas of Amazon rainforest. However, a period of severe drought combined with a number of agricultural fires, many of them illegal, led to a number of disastrous forest fires, and NASA scientists became involved to help the Brazilians respond to the disaster by providing daily summaries of fire detections made by satellite, aircraft, and ground observations. These images, from the MODIS sensor on the Terra satellite, show a pattern of forest and farmland east of the city of Rio Branco before (above right) and after (right) the peak of the 2005 agricultural burning season. The images are made from visible, shortwave, and near-infrared light detected by MODIS. Bright green is unburned forest, bright red is recently burned areas, and beige is cleared, but unburned land. Next to some burned fields, the forest appears dark green, or 'bruised,' probably indicating places where fires escaped from fields and burned into the forest understory.

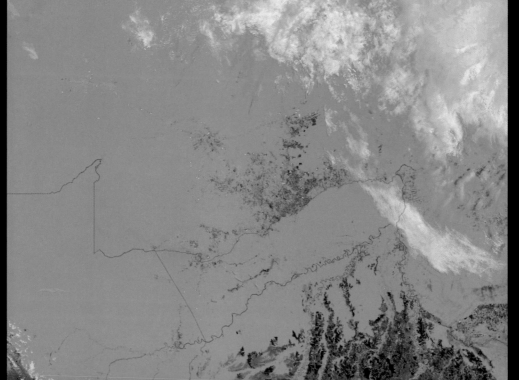

On August 14, 2005, the MODIS sensor on the Terra satellite captured this stunning image of forest fires raging across the width of Alaska. Smoke from scores of fires (marked in red) filled the state's broad central valley and poured out to sea. Hemmed in by mountains to the north and the south, the smoke spread westward and spilt out over the Bering and Chukchi Seas. More than a hundred fires were burning across the state as of August 14.

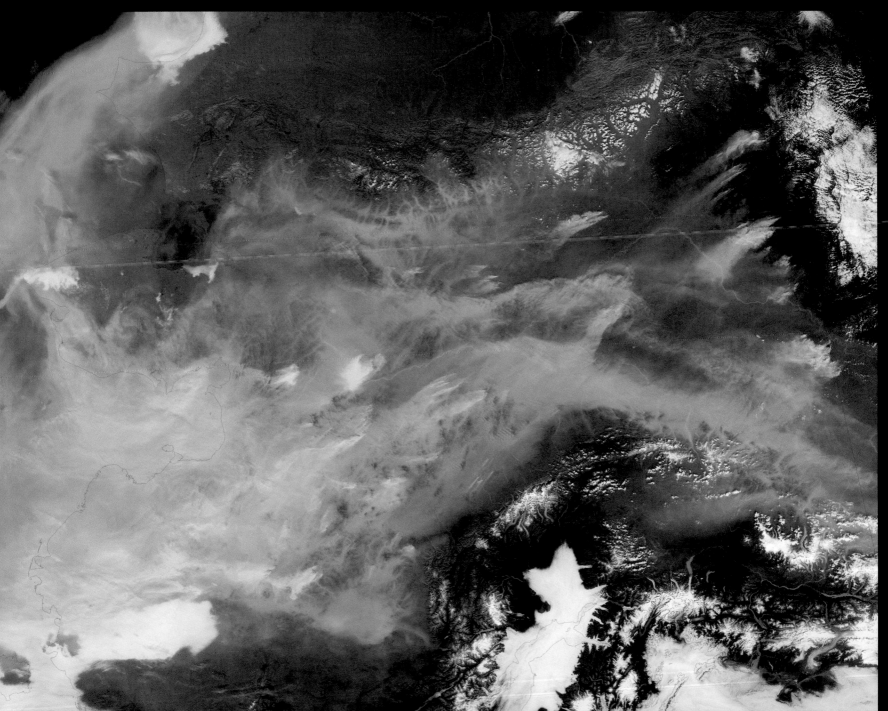

Northwest of Los Angeles, California, a brush fire exploded in late September 2005. Growing to more than 6,475 hectares (16,000 acres) in around two days, the blaze threatened homes, natural resources, power lines, and communications equipment in the Thousand Oaks region north of the Santa Monica Mountains. This image of the Topanga Fire was captured by the MODIS sensor on the Terra satellite on September 29, 2005. The actively burning part of the fire that MODIS detected is outlined in red.

This ASTER image shows a huge forest fire burning in Okanagan Mountain Park in British Columbia, Canada. The huge fire forced nearly 30,000 people from their homes in the city of Kelowna at one point, around one third of the entire population. The image is a simulated true-colour composite, with the active fires highlighted in red from ASTER's infrared bands.

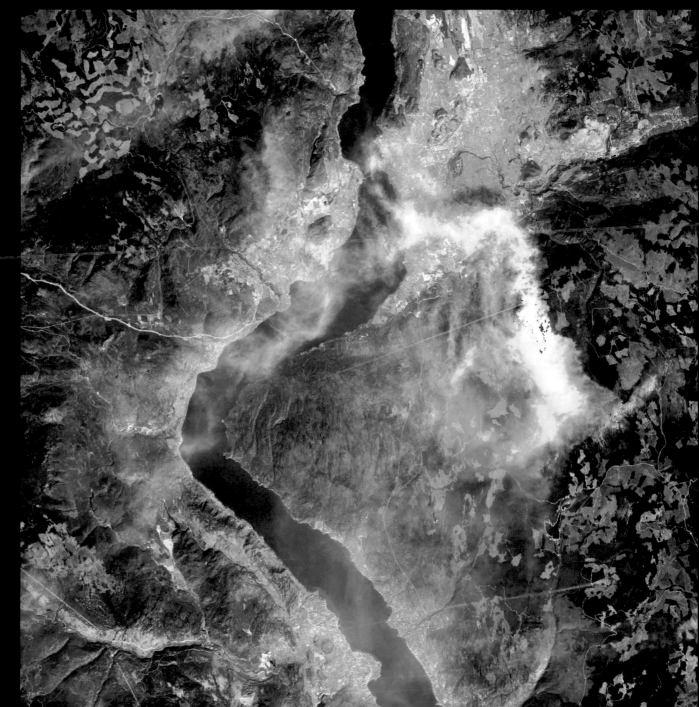

On April 30, 2005, a river of dust flowed across China to the north of the Korean Peninsula and spread out over the Sea of Japan. The thick, beige-coloured plume almost completely obscured the island of Honshu from the view of the MODIS sensor on NASA's Aqua satellite. By May 2, the plume was more than 1,000km (620 miles) out over the open waters of the Pacific Ocean.

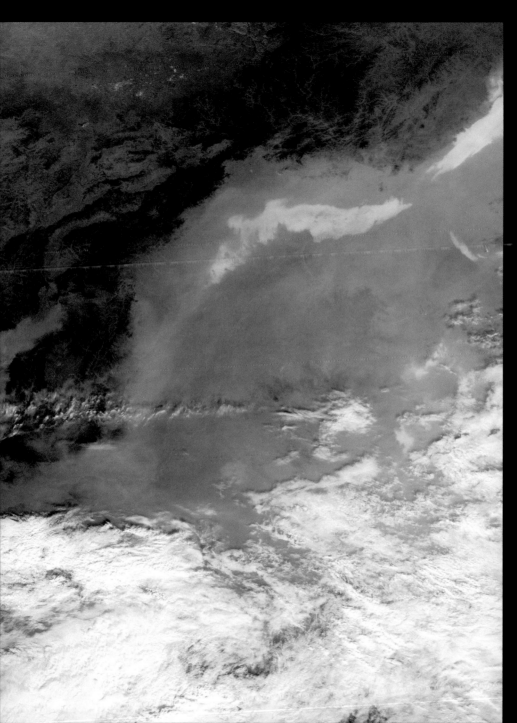

Thick pollution obscured the sky over Beijing and nearby regions on November 4, 2005. According to news reports, the city's pollution index reached the highest level on the scale between November 4–5, and residents were warned to spend as little time as possible outdoors. The MODIS instrument on the Terra satellite captured this image on November 4 as pollutants lingered over the area. In this image, a nearly opaque band of grey smog obscures the view of Beijing and the region to the south. Whiter clouds lie over the smog in the lower portion of the scene, while nearer to the centre top of the image, the haze appears to be hovering above a strip of fog. Various weather conditions can contribute to a pile-up of pollution, including high pressure, high humidity, and large pools of cold air settling near the Earth's surface. Most of the time, atmospheric temperature decreases as altitude increases, and warmer air near the surface rises upward, mixing pollution away. Occasionally, the atmosphere's temperature profile becomes inverted, with cold air near the surface and warm air higher up. Cold air is less buoyant, and pollution doesn't disperse.

WEATHER & NATURAL EVENTS

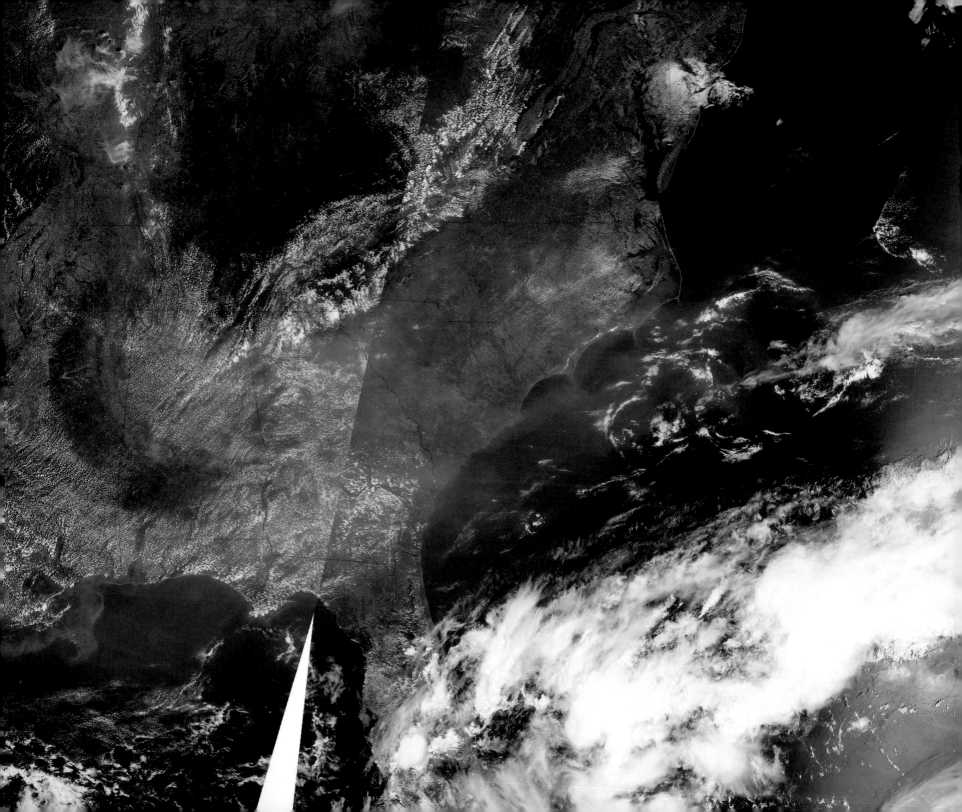

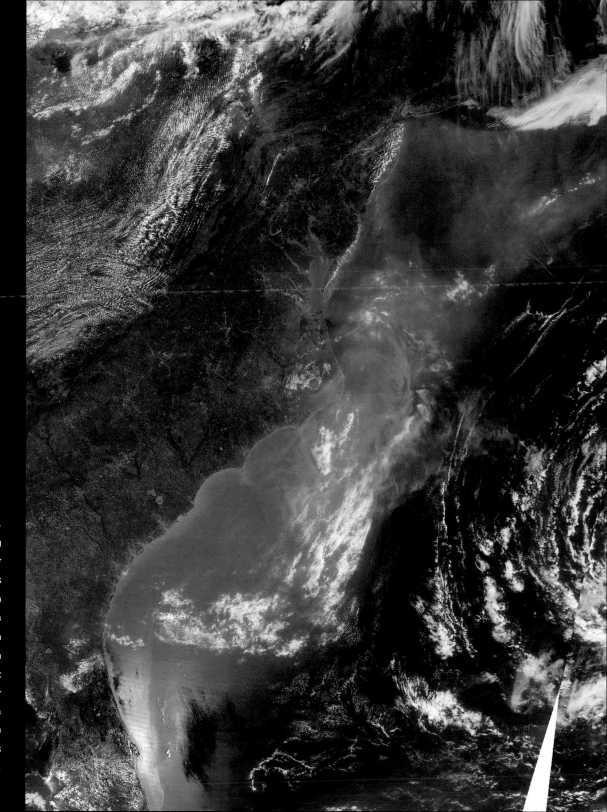

In the eastern United States, weather conditions conspired with human activities to generate hazy skies across a broad area. Haze, or particle pollution, had been lingering in the skies over the Mississippi River Valley, the Deep South, the Mid-Atlantic, and the Southeast, due to the air over the region being stable and humid – atmospheric conditions that keep the tiny aerosol particles produced by vehicles, power plants, and fires hovering thickly in the air. In this MODIS image, the grey haze hung over the lower Midwest (left), plunged southward over the Gulf of Mexico (bottom), and flowed off the East Coast (right) in a broad swathe that veiled the scalloped North Carolina coastline. The image is not seamless because it was made from observations collected during two consecutive overpasses of NASA's Terra satellite. Terra passes over the United States in an east-to-west path, so the right side of the image came first. MODIS collected the left-hand part of the image about 90 minutes later, which is why the clouds don't line up perfectly.

This image of the Eastern United States was captured on July 26, 2005, by the MODIS sensor onboard NASA's Terra satellite. Hazy air from along the eastern seaboard from Pennsylvania to Georgia was lingering over coastal regions and spreading out over the Atlantic Ocean. Numerous fires were detected by MODIS and have been marked on this image with red dots. Although many meteorological and human factors influence air quality, among the major culprits is high atmospheric pressure. High pressure usually creates a stable – stagnant – region of air in which the emissions from vehicles, power plants, and fires keep piling up. Not only does the hot humid air trap emissions and cause them to linger over the region, but the extremely uncomfortable conditions also cause electricity needs to peak: the power grid must generate more electricity to run refrigeration and air conditioning. The increased demand creates additional air pollution, making the air quality problems worse.

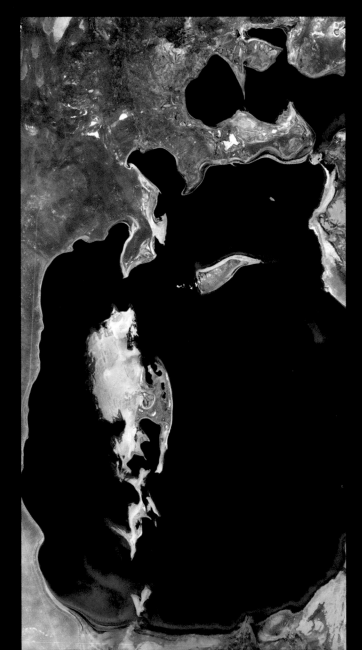

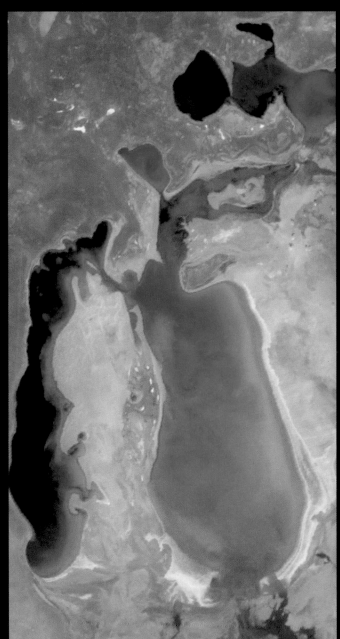

Once the fourth largest lake on Earth, the Aral Sea has shrunk dramatically over the past few decades. By 1989 the Landsat satellite image (far left) showed that the northern half of the sea had become virtually separated. The image at left was captured by MODIS in 2003, and shows the rapid retreat of the Sea's southern half, now separated into two. Recent hydrographic surveys have revised the lifespan of the dying lake; complete desiccation could happen in 15 years. The southern Aral Sea has been deemed beyond salvaging, so restoration effort will focus on the smaller, less polluted and saline, northern sea. The Kazakhstan government, with World Bank funds, began a massive restoration project to construct a dyke between the two portions of the Sea, sealing the southern half's fate. The northern Small Aral Sea will refill from the Syrdar'ya River, and planners think that it will support fishing and help to stabilize the continental climate, increasing rainfall, smoothing out temperature extremes, and suppressing dust storms.

In 2003, wildfires covered more
than 213,269 hectares (527,000
acres) in Montana along the
crest of the Rocky Mountains. The
2003 fire season in the United
States was on par with 2001,
with roughly 1,214,056 hectares
(3,000,000 acres) burned by
September 8. In contrast, about
2,428,113 hectares (6,000,000
acres) had burned by the same
date in the record years of 2000
and 2002. The ten-year average
is 1,537,805 hectares (3,800,000
acres) burned from January 1.
This true-colour image of western
Montana was acquired by MODIS
aboard NASA's Terra satellite on
September 6, 2003. Fire locations
are marked in red.

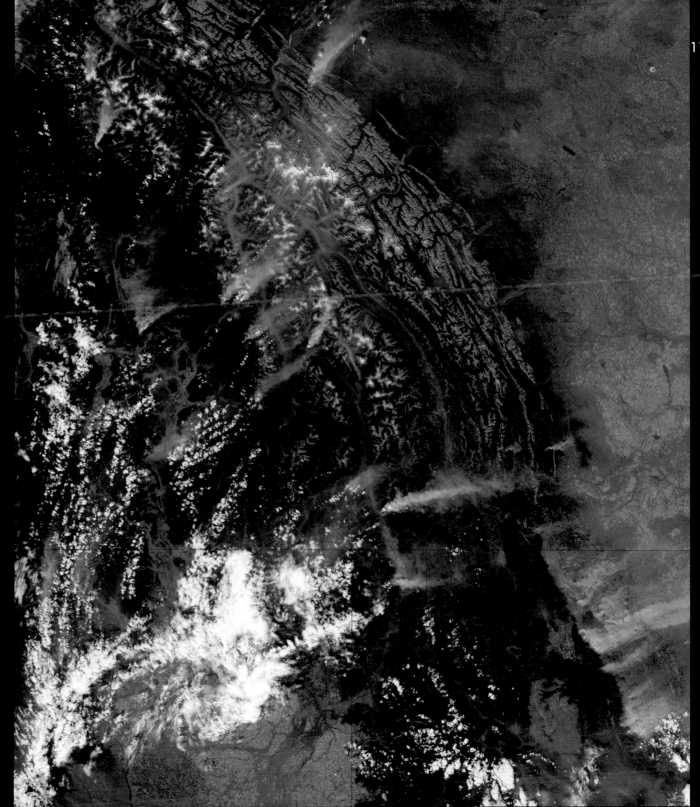

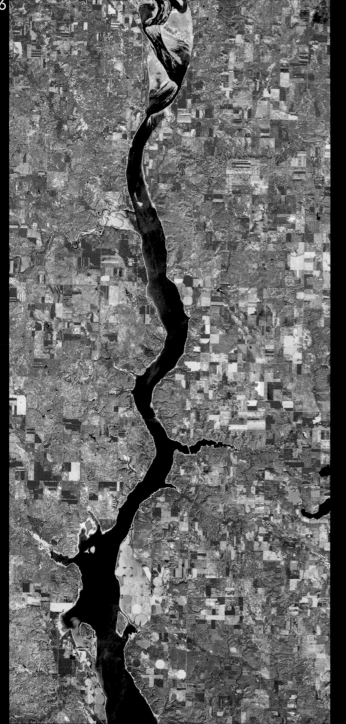
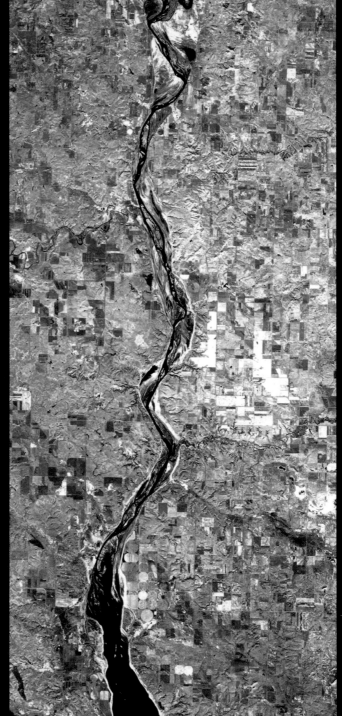

The Missouri River, the longest in the US, is seen here struggling in the grip of a severe six-year drought. In North Dakota, 374km (232 mile) long Lake Oahe, the nation's fourth largest reservoir, became so low that it effectively left the state. From Bismarck to the South Dakota border, more than 100km (62 miles) have reverted to a narrow river where the lake was once 8km (5 miles) wide. Left behind are weedy mudflats and boat ramps stranded 2km (1 mile) from water. The drought's list of effects has been long and painful: shortage of drinking and irrigation water; reduction in hydroelectric capacity; decrease in tourism; reduction in shipping; threats to endangered wildlife. The cause has been the continuing yearly shortage of snow pack in the Rocky Mountains in Montana, where the Missouri River has its headwaters. The image on the far left was acquired by Landsat on May 18, 2000, and the one on the left on April 4, 2004 by ASTER. Both cover an area of 28.7 x 65.6km (17¾ x 40½ miles), and are centred along the North and South Dakota border.

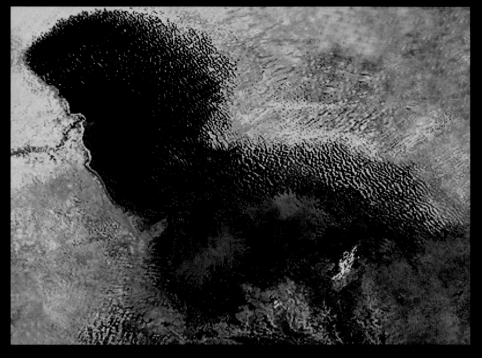

Lake Chad, once one of the African continent's largest bodies of fresh water, has dramatically decreased in size due to climate change and human demand for water. Once a great lake, close in surface area to North America's Lake Erie, Lake Chad is now a ghost of its former self. According to a study by University of Wisconsin-Madison researchers, working with NASA's Earth Observing System program, the lake is now one-twentieth of the size it was 35 years ago. Found at the intersection of four different countries in West Africa (Chad, Niger, Nigeria, and Cameroon), Lake Chad has been the source of water for massive irrigation projects. In addition, the region has suffered from an increasingly dry climate, experiencing a significant decline in rainfall since the early 1960s. The most dramatic decrease in the size of the lake is shown in the 15 years between January 1973 and January 1987 (left and below left). Beginning in 1983 the amount of water used for irrigation began to increase. Ultimately, between 1983 and 1994, the amount of water diverted for purposes of irrigation quadrupled from the amount used in the previous 25 years. The red colour denotes vegetation on the lake bed and the ripples on the western edge of the lake denote sand dunes formed by the wind. The final picture (right) is a composite of Landsat 7 images from November 2000 to February 2001 showing the present stage of Lake Chad. The small patch of blue that is now the lake stands in stark contrast to the wide swathe of the old lake bed (shown in green, indicating vegetation).

PART TWO: THE WORLD MODELLED

The planet is constantly being monitored from space, and the data that is sent back is used in a tremendous variety of ways. Much can be obtained from being able to view the world from far enough away to see the big picture, but the information collected by modern satellites amounts to a great deal more than just visual data. Temperature, moisture, magnetism, relief and many other apects of the Earth are measured and turned into graphic illustrations which often bear little resemblance to the world as the human eye would see it, but nevertheless reveal hitherto hidden aspects of our environment, and in many cases create striking and beautiful images. There are numerous examples of this principle in action throughout this next section, and it's fascinating to see our world depicted in such different ways. Often what we're looking at is imagery that has been achieved through the measurement of selected wavelengths or by highlighting something, such as heat, in a visual way to make it easier to interpret.

Satellites may be designed to carry out one specific mission, and will have instruments on board that have been designed solely to collect data relating to that specific goal. The TOPEX/Poseidon mission that originally launched in 1992 for example was designed to make precise measurements of the ocean surface with an instrument called an Altimeter (which can measure the altitude of an object or surface with respect to a fixed level, like sea level). The satellite enjoyed a 13-year career, roughly twice as long as the average satellite, and in that time provided the longest and most complete observation of surface circulation in the deep ocean. The craft was watching in 1997 when the largest El Nino in 100 years changed weather patterns around the world, and it allowed scientists to achieve their first global perspective on this and other short term climate events, such as La Nina. Its most important achievement, however, was to determine the patterns of ocean circulation: how heat stored in the ocean moves from one place to another. Since the ocean holds most of the Earth's heat, ocean circulation is a driving force of climate. With sister craft, Jason, which was launched in 2001 scientists will be able to make ever more detailed measurements of ocean surface topography and study critical issues such as sea level rise.

Another dramatic example of NASA utilizing the latest technology to translate data into remarkable images comes in the form of three-dimensional imagery. These are pictures that are artificially modelled using a combination of data. Often they have an uncannily realistic feel to them, almost like a surface-based photograph of a magical landscape. NASA can combine data from a source such as the Shuttle Radar Topography Mission (SRTM) – which obtained elevation data on a near-global scale to generate the most complete high-resolution digital topographic database of Earth – with conventional imaging data obtained from a satellite such as Landsat.

One set of information is 'draped' over the other to create a scene that can accurately reflect the terrain on the ground, and a false sky may even be added to complete the illusion of reality. Once complete, the image can be studied to yield valuable information about the region being highlighted.

Meanwhile the MODIS (Moderate-resolution Imaging Spectroradiometer) instrument that can be found on board two of NASA's most high-profile satellites, Terra and Aqua, sees every point of the planet every one to two days, and has proved to be ideal for monitoring large-scale changes in the biosphere that will yield new insights into the workings of the global carbon cycle. While no current satellite sensor can directly measure carbon dioxide concentrations in the atmosphere, MODIS can measure the photosynthetic activity of land and marine plants (phytoplankton) to yield better estimates of how much of the greenhouse gas is being absorbed and used in plant productivity. Coupled with the sensor's surface temperature measurements, MODIS' measurements of the biosphere are helping scientists to track the sources and the sinks of carbon dioxide in response to current climate changes.

MODIS also monitors changes on the land surface, mapping the aerial extent of snow and ice brought by winter storms and frigid temperatures. The sensor observes the 'green wave' that sweeps across continents as winter gives way to spring and vegetation blooms in response, and it also sees where and when disasters such as volcanic eruptions, floods, severe storms, droughts and wildfires start, and gives warning for those in the path to get out of the way. MODIS' bands are particularly sensitive to fires: they can distinguish flaming from smouldering burns and can provide better estimates of the amount of aerosols and gases that fires will release into the atmosphere.

One might not imagine that cold scientific data could yield images that were of much interest outside the laboratory, but as this chapter shows, these pictures are not only fascinating in terms of the information that they graphically reveal but are often majestic images in their own right. The satellites that collect the data each carry a unique selection of instruments and have a very specialized job to do, and it's important to realize that the data being sent back comes in all shapes and sizes and is not necessarily designed to be representative. What is clear is that the information that is now being obtained on a regular basis from Earth's orbit is adding enormously to our understanding of our environment and giving us the most comprehensive view yet of our planet. In the years to come the data we receive will become ever more important in terms of how it helps us to manage the issues facing human life on Earth, and scientific research can't help but be the major beneficiary of this flood of information arriving from hundreds of miles above our heads.

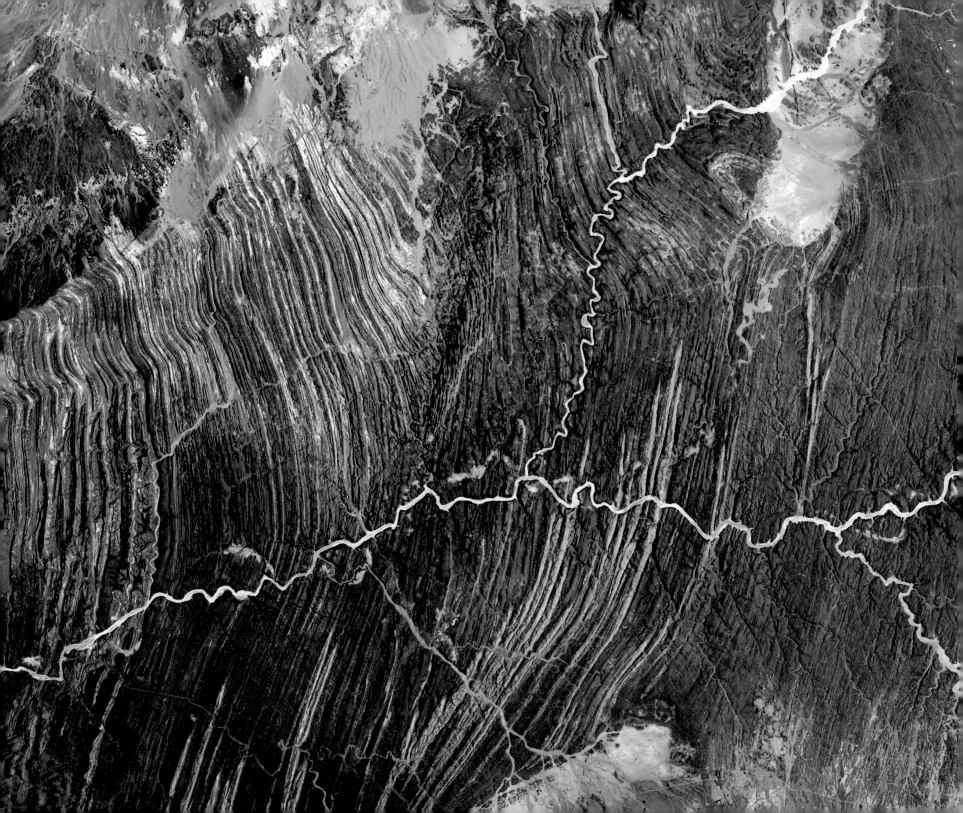

INTERPRETING
THE EARTH

PREVIOUS PAGE:

Elusive, but ecologically vital, Namibia's Ugab River only flows above ground for a few days each year. The subterranean waters underlying this ephemeral river, however, are shallow enough in places to fill hollows and to sustain a wildlife population that includes the rare desert elephant. In this image, the river passes through nearly vertical layers of thinly bedded limestone, sandstone and siltstone.

Lake Tahoe, along the California-Nevada border, is one of the clearest lakes in the world. Since 1965 scientists have been monitoring the water's clarity, and have discovered a 50 per cent reduction in the last 35 years. This is attributed to increased algal growth, more sediment washed in from the surrounding areas, and urban growth and development. The ASTER image, on the left, was acquired on November 7, 2000, and covers an area of 23 x 38km (14 x 23½ miles). The colours show vegetation in red. The image on the right was created from ASTER band 1, and is colour coded to show the bottom of the lake around the shoreline. Where the data is black, the bottom cannot be seen. This data can be used to determine spatial variations in clarity which complement the point clarity measurements made from boats. Continued monitoring of Lake Tahoe with ASTER data in the future will assist scientists to understand the changes in water clarity.

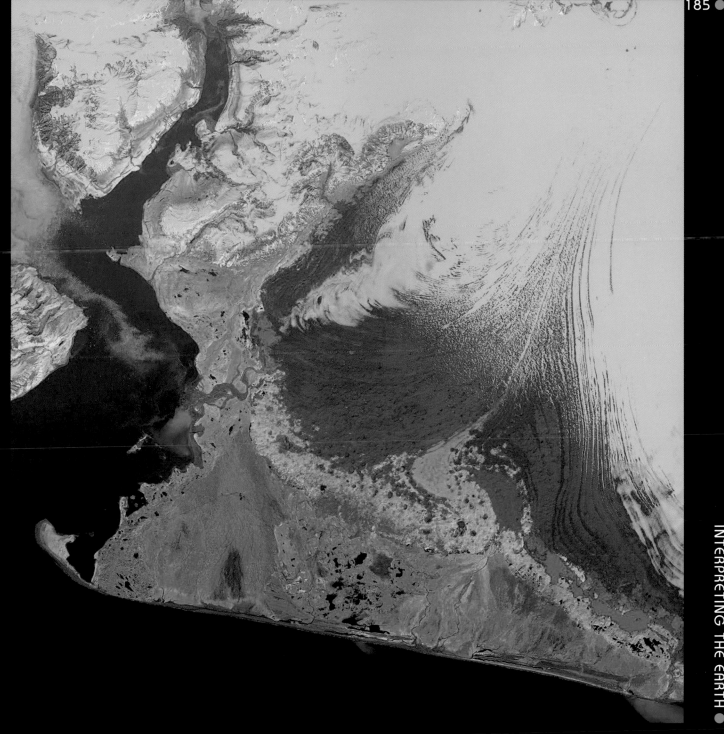

This ASTER image was acquired on June 8, 2001, and covers an area of 55 x 40km (34 x 24¾ miles) over the southwest part of the Malaspina Glacier and Icy Bay in Alaska. The composite of infrared and visible bands results in the snow and ice appearing light blue, dense vegetation is yellow-orange and green, and less vegetated, gravelly areas are in orange. According to experts, the Malaspina Glacier is thinning. Its terminal moraine protects it from contact with the open ocean; without the moraine, or if the sea level rises sufficiently to reconnect the glacier with the ocean, the glacier would start calving and retreat significantly. ASTER data is being used to help monitor the size and movement of some 15,000 tidal and piedmont glaciers in Alaska. Evidence derived from ASTER and many other satellite and ground-based measurements suggests that only a few dozen Alaskan glaciers are advancing. The overwhelming majority of them are in retreat.

INTERPRETING THE EARTH ●

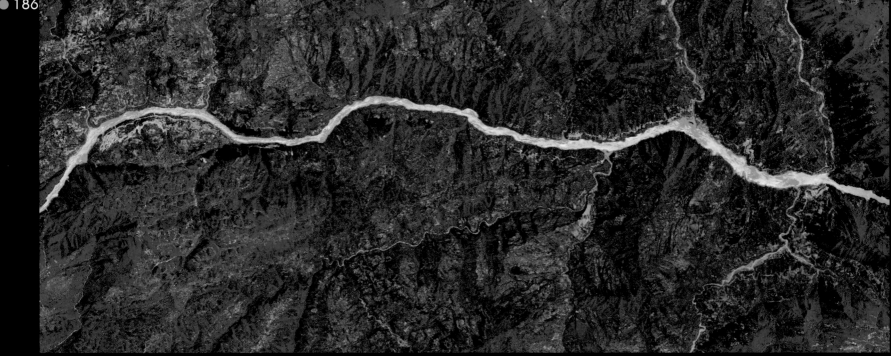

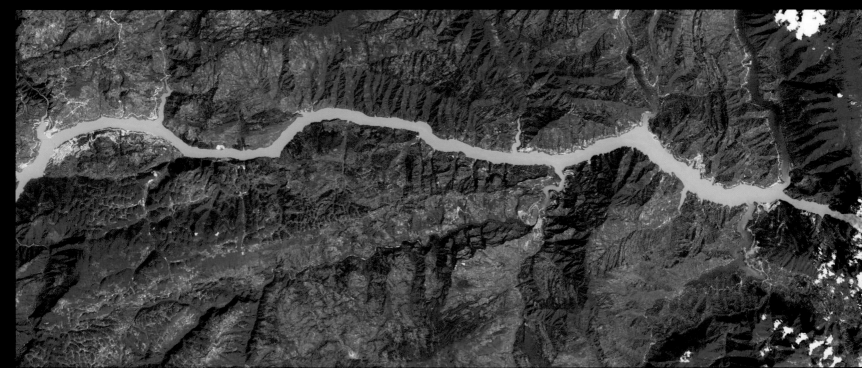

In these ASTER false-colour images, red represents vegetated land surface, while blue-green represents exposed land surfaces, clearly showing up the substantial changes caused by the damming of the Yangtze River in China just west of the Three Gorges Dam. When the reservoir is filled in 2012, water will rise to a height of 175m (574ft), and extend 600km (373 miles). The reservoir will submerge two of the three world-famous gorges, along with many important cultural and archaeological sites. Scientists fear the dam may change the Sea of Japan's salt content, thereby impacting on the region's climate. The dam is being built to control the flooding of the Yangtze, which has killed thousands of people in the past. The top image was acquired on May 20, 2001 during the dam's construction and before the reservoir was filled. The bottom image from March 25, 2003 shows the partial filling of the reservoir, including numerous side canyons.

The western-most part of the Ganges Delta is seen in this 55 x 72km (34 x 44 miles) ASTER sub-scene acquired on March 29, 2000. The Hugli River branches off from the Ganges River 300km (186½ miles) to the north, and flows by the city of Kolkata (Calcutta) before emptying into the Bay of Bengal. High sediment load is evident by the light-blue colours in the water, particularly downstream from off-shore islands. The deep red colours of some of these islands are mangrove swamps.

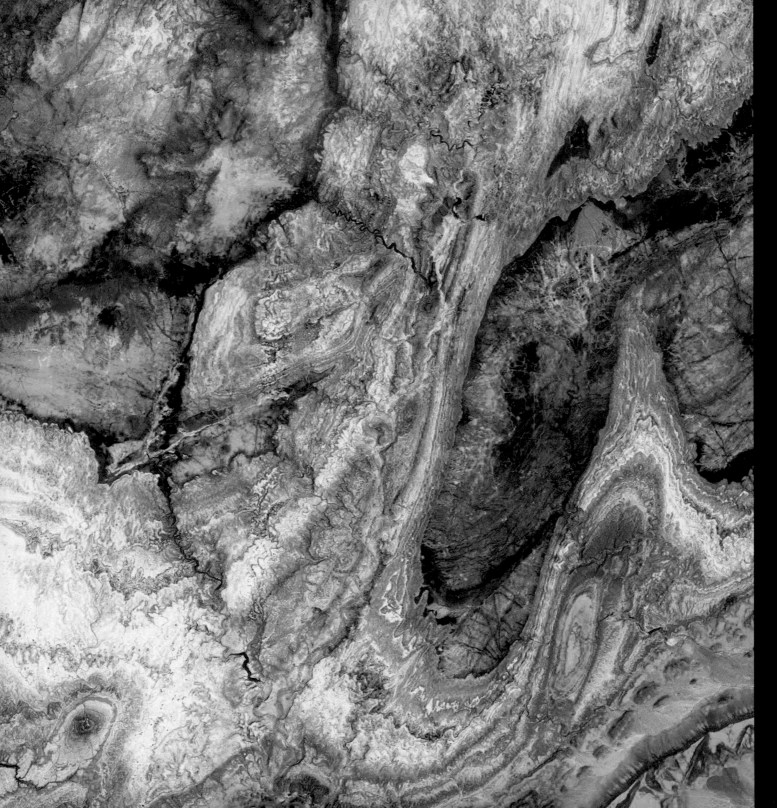

The Anti-Atlas Mountains of Morocco formed as a result of the collision of the African and Eurasian tectonic plates about 80 million years ago. This collision destroyed the Tethys Ocean; the limestone, sandstone, claystone, and gypsum layers that formed the ocean bed were folded and crumpled to create the Atlas and Anti-Atlas Mountains. In this ASTER image, short wavelength infrared bands are combined to dramatically highlight the different rock types, and illustrate the complex folding. The yellowish, orange and green areas are limestones, sandstones and gypsum; the dark blue and green areas are underlying granitic rocks. The ability to map geology using ASTER data is enhanced by the multiple SWIR bands, which are sensitive to differences in rock mineralogy.

This ASTER sub-image was acquired on April 3, 2000 and covers an area of 10.5 x 12km (6½ x 7½ miles) centred on Jerusalem. The data was processed to create a simulated natural-colour image, with green vegetation and orange tile roofs. The old city is the lighter blue area in the centre right of the image, surrounded by a 400-year-old wall built by the Ottoman Turks. Easily visible are the Dome of the Rock and the Al Aksa Mosque on the eastern side of the old city. Jerusalem is the source of three major religions – Judaism, Christianity, and Islam – and is considered holy by all three.

This ASTER image of Lake Garda in northern Italy was acquired on July 29, 2000 and covers an area of 30 x 57km (18½ x 35½ miles). This false-colour image includes near infrared, red, and green wavelengths of light showing the vegetation in red and developed areas around the shoreline in grey. The right-hand image has the land area masked out, and a harsh contrast stretch was applied to the lake values to display variations in sediment load. Also visible are hundreds of boats and their wakes, criss-crossing the lake.

● PART TWO: THE WORLD MODELLED

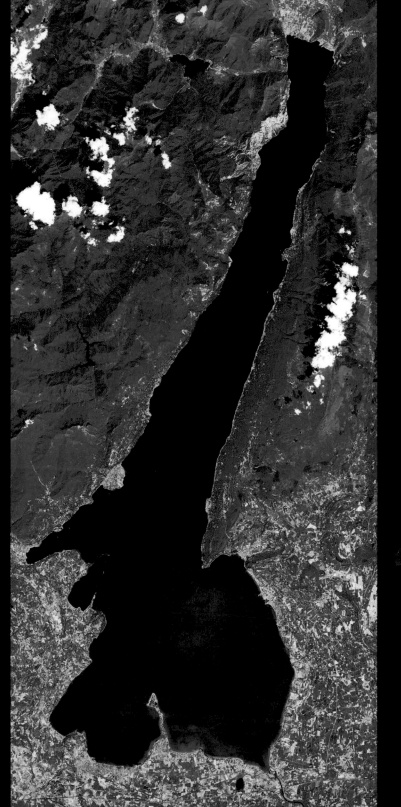
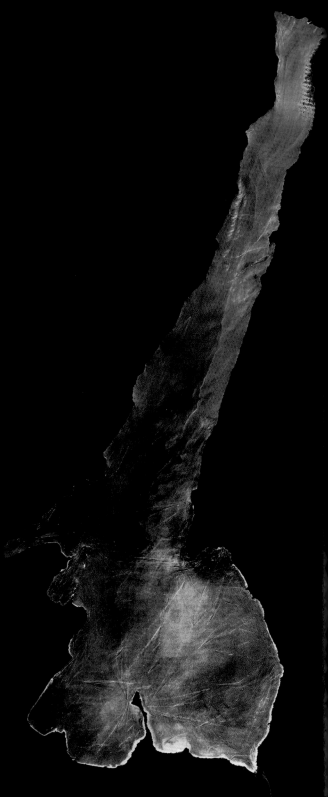

Wave patterns in the Bay of Bengal on the west coast of India are seen in this 18 x 15km (11 x 9 mile) ASTER sub-scene, acquired on March 29, 2000. The visible and near-infrared bands highlight surface waves due to specular reflection of sunlight off the wave faces. Two opposing wave trains interfere in the right half of the image, producing the complex pattern seen there.

This image of the world was generated with data from the Shuttle Radar Topography Mission (SRTM). The SRTM Project has recently released a new global data set called SRTM30, where the original one arcsecond of latitude and longitude resolution (about 30m/98ft, at the equator) was reduced to 30 arcseconds (about 928m/3,045ft). This image was created from that data set and shows the world between 60 degrees south and 60 degrees north latitude, covering 80 per cent of the Earth's land mass. The image is in the Mercator Projection, commonly used for maps of the world. Two visualization methods were combined to produce the image: shading and colour coding of topographic height. The shade image was derived by computing topographic slope in the northwest-southeast direction, so that the northwest slopes appear bright and the southeast slopes appear dark. Colour coding is directly related to topographic height, with green at the lower elevations, rising through yellow and beige, to white at the highest elevations.

These ASTER images cover 30 x 37km (18½ x 23 miles) in the Atacama Desert, Chile and both were acquired on April 23, 2000. The Escondida copper, silver and gold open-pit mine is at an elevation of 3,050m (10,000ft), and came on stream in 1990. Current capacity is 127,000 tons per day of ore; in 1999 production totalled 827,000 tons of copper, 150,000 ounces of gold and 3.53 million ounces of silver. Primary concentration of the ore is done on-site; the concentrate is then sent to the coast for further processing through a 170km (105 mile) long pipe. The left-hand image is a conventional 3-2-1 RGB composite, while the image on the right displays shortwave infrared bands 4-6-8 and highlights the different rock types present on the surface as well as the changes caused by mining.

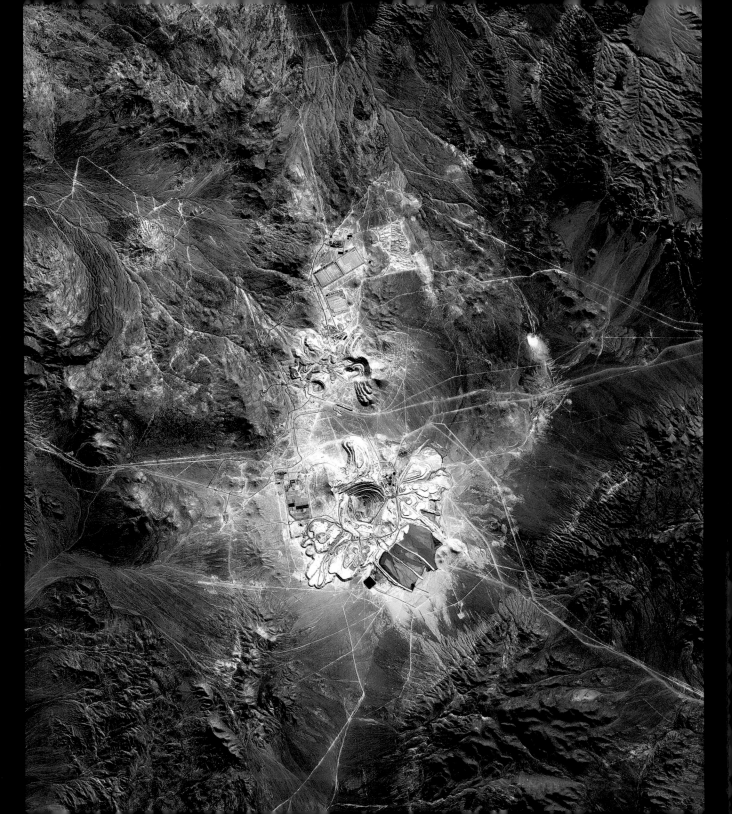

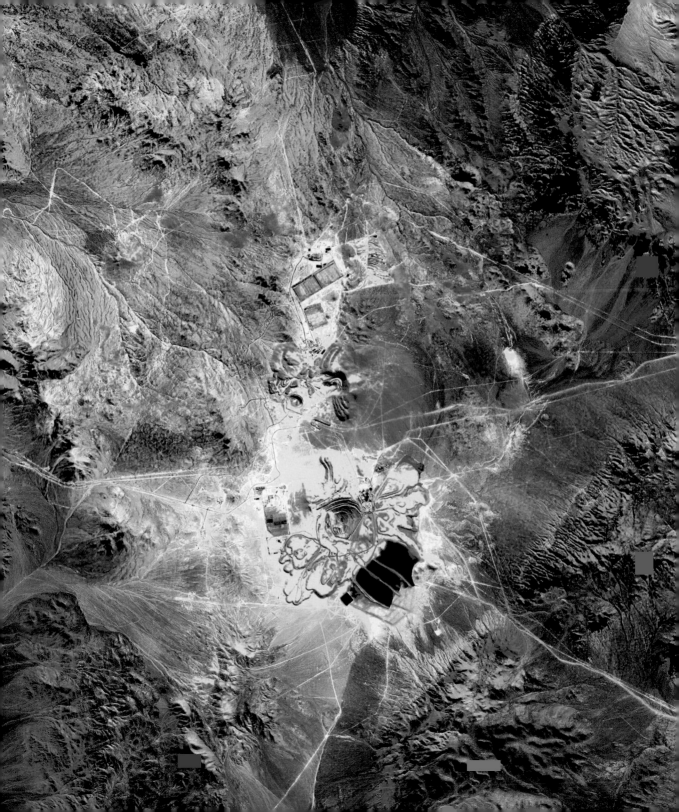

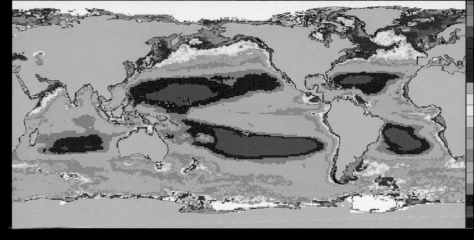

Vegetation burning in the Southern Hemisphere peaks during the dry season months between July and September. Burning of vegetation biomass releases various particles and trace gases into the atmosphere, including carbon monoxide (CO). The emissions from fires in South America and South Equatorial Africa significantly contribute to the global CO burden during this season, as is evident in the false-colour images shown left. This pair of images compares the CO concentrations measured in the lower troposphere for February (bottom) and September (top) 2004. While the Northern Hemisphere clearly dominates the CO budget in February, when biomass burning in the Southern Hemisphere is low, the fire season in the Southern Hemisphere becomes an important component to the global CO budget in September. The data was produced with the Measurements of Pollution in the Troposphere (MOPITT) instrument launched onboard NASA's Terra satellite in December 1999. The images show the averaged CO concentrations in parts per billion (ppb) at 3km (700 millibars) altitude for February 17–27, 2004, and September 17–27, 2004, respectively. High CO levels are indicated in red, while blue shades represent low CO concentrations. Missing data either due to clouds or due to high surface altitude (e.g. over the Andes or the Himalaya) is coloured in grey.

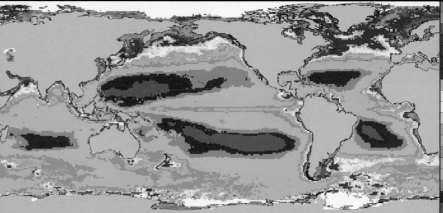

One of the ways that satellite technology can contribute to the knowledge of scientists is by measuring changes on the planet's surface over a number of years. These charts show, top, the levels of chlorophyll detectable in the world's oceans in 1998, while the middle image shows the same data collected in 2003. By comparing the two sets of results in the third data box, scientists have shown that phytoplankton amounts have increased globally by more than four per cent during this period, research that suggests there may be changes occurring in the biology of the oceans, especially in the coast regions.

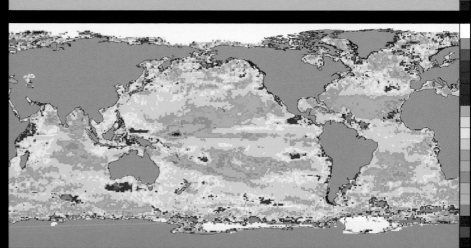

This satellite data was produced at a time when large fires were burning in western Canada and the north western United States, producing a significant amount of air pollution, as indicated by the elevated levels of carbon monoxide over the region. This false-colour image shows the concentrations of carbon monoxide at an altitude of roughly 3km (700 millibars) in the atmosphere. These data were taken by the MOPITT

instrument aboard NASA's Terra satellite for the period 1–7 August, 2003. The colours represent the mixing ratios of carbon monoxide in the air, given in parts per billion by volume; blue for the lowest concentrations rising through yellow to red for the highest. The grey areas in the image show where no data was collected, either due to persistent cloud cover or gaps between satellite viewing swathes.

The joint NASA-German Aerospace Centre Gravity Recovery and Climate Experiment (GRACE) mission released this image, which is the most accurate map yet of Earth's gravity field. The colours represent slight differences or anomalies in the Earth's gravitational pull, the red areas exerting a slightly greater effect and the blue areas a weaker one. Created from 111 days of selected GRACE data to help calibrate and validate the mission's instruments, this preliminary model improved knowledge of the gravity field so much that it was released to oceanographers in advance of the scheduled start of routine GRACE science operations. The data is expected to significantly improve scientists' ability to understand ocean circulation, which strongly influences weather and climate.

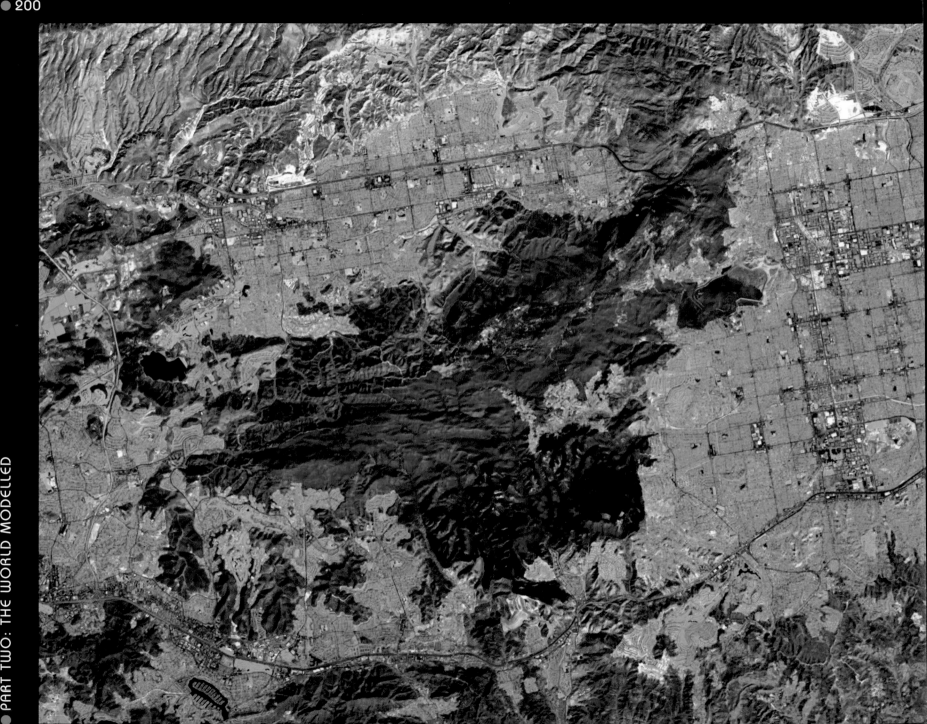

This area northwest of Los Angeles, California, shows the scars of a huge brushfire that raged from September 28, 2005. The ASTER image, acquired on October 6 by which time the fire was largely contained, displays the fire-damaged areas in red in sharp contrast to the vegetation in green.

This ASTER image was acquired on January 28, 2002 over Goma and Nyiragongo volcano. A river of molten rock poured from the Nyiragongo volcano in Congo on January 18, 2002, a day after it erupted, killing dozens, swallowing buildings and forcing hundreds of thousands to flee the town of Goma. The image covers an area of 21 x 24km (13 x 15 miles) and combines a thermal band in red which shows up the devastating lava flow and two infrared bands in green and blue. The flow continued into Lake Kivu. One of Africa's most notable volcanoes, Nyiragongo contained an active lava lake in its deep summit crater that drained catastrophically through its outer flanks in 1977. Extremely fluid, fast-moving lava flows draining from the summit lava lake killed 50 to 100 people, and several villages were destroyed.

Large plumes of smoke rising from devastating wildfires burning near Los Angeles and San Diego on Sunday, October 26, 2003, are highlighted in this set of images from the MISR. These images include a natural colour view from MISR's nadir camera (left) and an automated stereo height retrieval (right). The tops of the smoke plumes range in altitude from 500–3,000m (1,640–9,843ft), and the stereo retrieval clearly differentiates the smoke (in shades of blue and green) from patches of high-altitude cirrus (red). Plumes are apparent from fires burning near the California-Mexico border, San Diego, Camp Pendleton, the foothills of the San Bernardino Mountains, and in and around Simi Valley. The majority of the smoke is coming from the fires near San Diego (central, large plume) and the San Bernardino Mountains (to the northwest). The MISR observes the daylit Earth continuously and every nine days views the entire globe between 82 degrees north and 82 degrees south latitude.

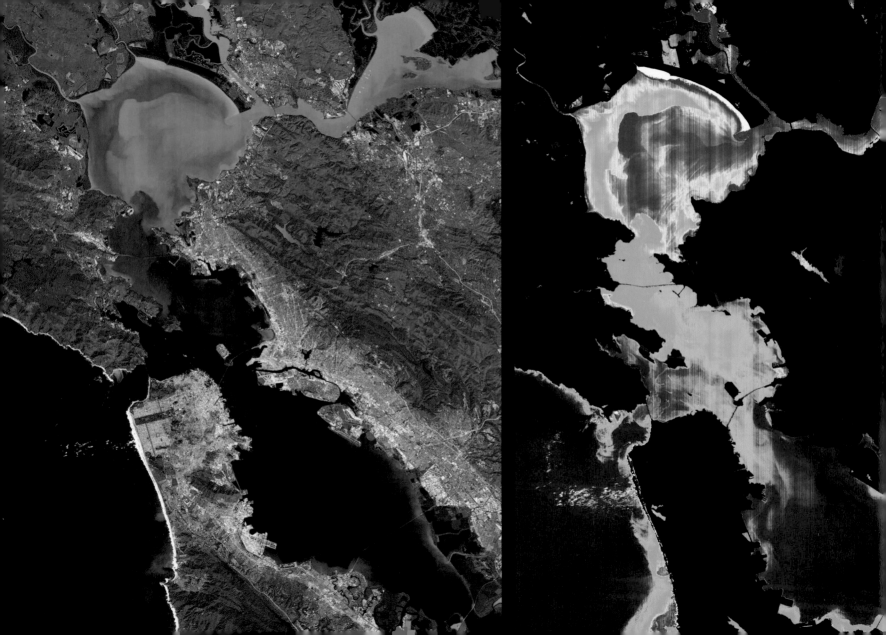

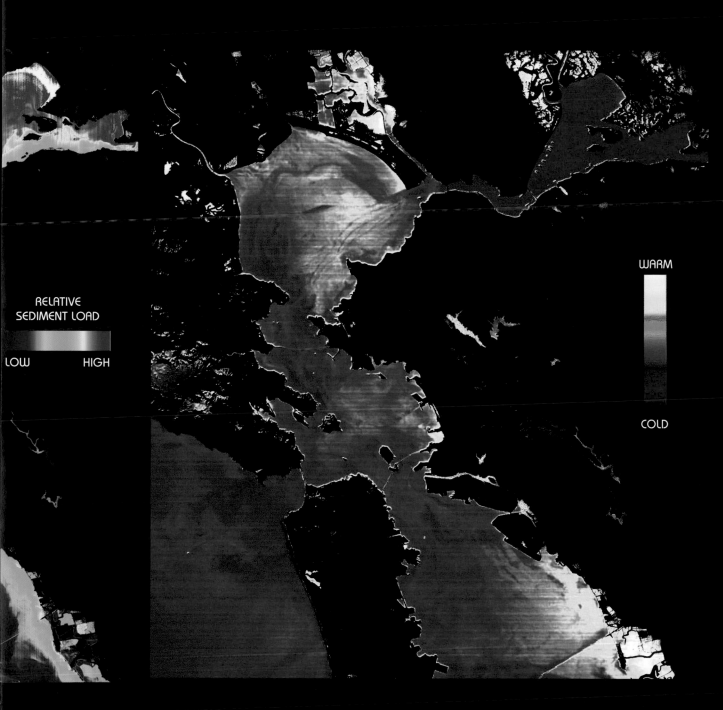

RELATIVE
SEDIMENT LOAD

LOW HIGH

WARM

COLD

LEFT: The image on the far left of the San Francisco Bay region was acquired on March 3, 2000, and covers an area 60 x 75km (37 x 47 miles) in three bands of the reflected visible and infrared wavelength region. The combination of bands portrays vegetation in red, and urban areas in grey. Sediment in the bays and ocean shows up as lighter shades of blue. Strong surf can be seen as a white fringe along the shoreline. A rip tide extends westward into the ocean. In the lower right corner, the wetlands appear as large dark blue and brown polygons. The high spatial resolution of ASTER allows fine detail to be observed. MIDDLE: this temperature image was created from a thermal infrared band by blacking out the land, and assigning colours to the relative temperature values: White is warmest, followed by yellow, orange, red, and blue. LEFT: this colour coded suspended sediment image was created by blacking out the land, and assigning colours to the relative brightnesses in the water. High values were coloured white, then red, yellow, green, blue.

INTERPRETING THE EARTH
●

On April 28, 2001 a category F5 tornado cut an east-west path through La Plata, Maryland, killing five and injuring more than 100. These two images acquired by the ASTER instrument on Terra show a 6 x 17.8km (3¾ x 11 mile) area centred on the town. The top image was acquired on May 12, 2001, and the bottom on May 3, 2002. The ASTER bands 3-2-1 used for the image portray vegetation in red, and bare fields and urban areas in blue-green. The dark turquoise swathe cutting across the 2002 image is the track of the tornado, where the vegetation was ripped up and removed.

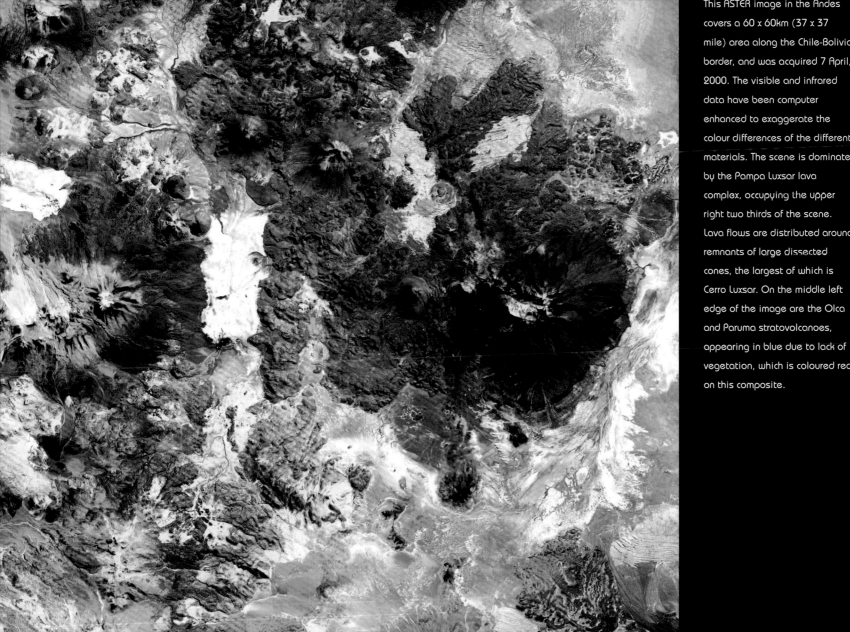

This ASTER image in the Andes covers a 60 x 60km (37 x 37 mile) area along the Chile-Bolivia border, and was acquired 7 April, 2000. The visible and infrared data have been computer enhanced to exaggerate the colour differences of the different materials. The scene is dominated by the Pampa Luxsar lava complex, occupying the upper right two thirds of the scene. Lava flows are distributed around remnants of large dissected cones, the largest of which is Cerro Luxsar. On the middle left edge of the image are the Olca and Paruma stratovolcanoes, appearing in blue due to lack of vegetation, which is coloured red on this composite.

Fractional Turf Grass Area

0.0 1.0

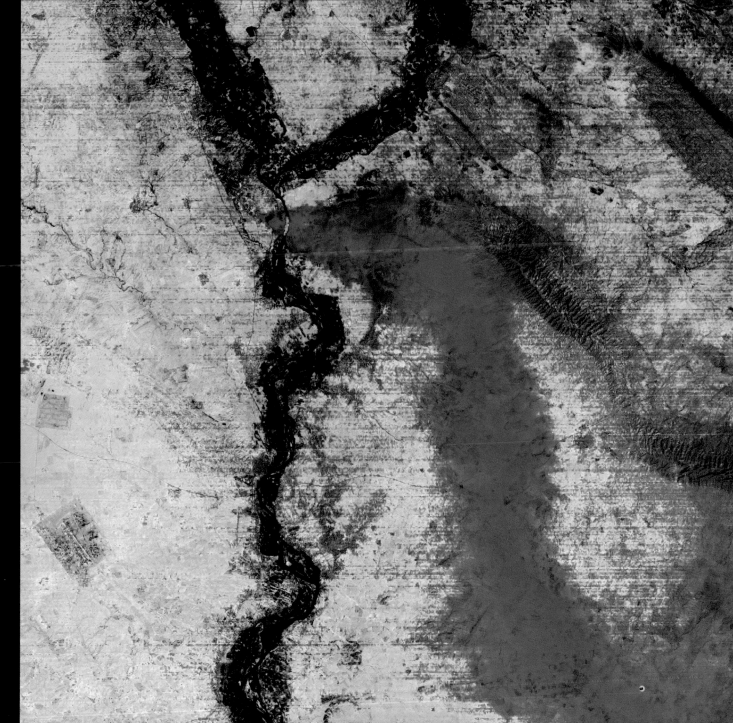

As people convert natural landscapes to human-tailored ones, the cycling of water and carbon changes dramatically. Among the human-tailored landscapes that influence carbon and water cycles in America are lawns. This map shows satellite-derived estimates of the fractional lawn area in shades of green. Areas where a large fraction of the land surface is lawn-covered are deep green; locations where the lawns cover a very small fraction of the land surface are light green or white. Scientists estimate that more surface area is devoted to lawns than to any other single irrigated crop in the country.

NASA's ASTER instrument photographed a fire at an industrial sulphur plant in Iraq south of Mosul, producing a noxious cloud of sulphur-containing gases. According to reports, the blaze created a significant environmental and health hazard, and several people died as a result of the fumes. ASTER's TIR bands are highlighting the presence of SO2 in purple

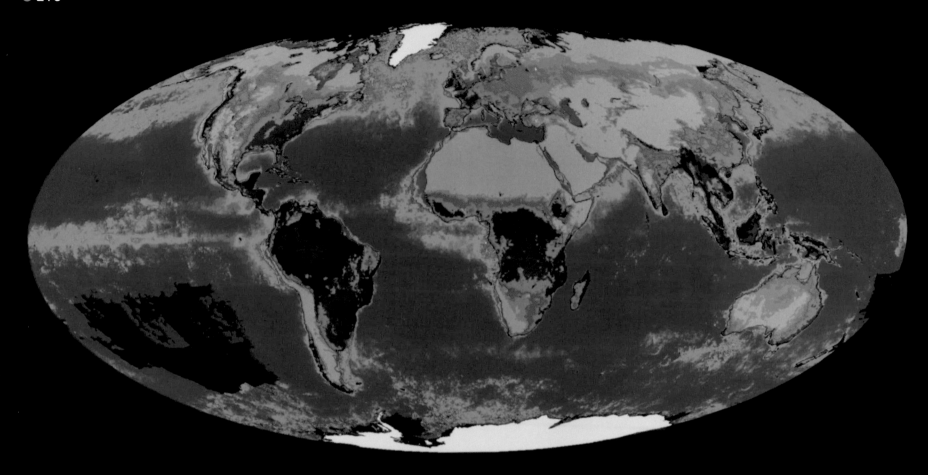

This image of the global biosphere, which was produced by combining data from two different satellite sensors, shows for the first time the productive potential of the Earth's vegetative biomass. The ocean image is a composite of all data collected during the 20-month period from November 1978 through to June 1980 by the Coastal Zone Colour Scanner (CZCS) flown on NASA's Nimbus-7 satellite, managed by the Goddard Space Flight Centre. The CZCS data shows concentrations of marine phytoplankton pigment. Phytoplanktons, the microscopic plants that grow in the sunlight regions of the ocean, form the base of the marine food web. Red and orange colours indicate areas of high plankton concentrations. Yellow and green represent areas of moderate concentration. One of the most notable features in this image is the clear delineation of the equator through increased plant abundance, and the differences between the equatorial Atlantic, Indian, and Pacific Oceans. The land-vegetation image is a composite of three years of data from the AVHRR on the NOAA-7 satellite, which measured land-surface radiation in the visible and near-infrared bands to estimate chlorophyll and leaf potential for chlorophyll production. The lighter shades of green highlight tropical and subtropical forests, temperate forests and farmlands, and some drier regions such as savannas and pampas. The yellow shades in the US Midwest show lower potential, while the darker yellow shades of Northern Hemisphere forests and the dry Australian Outback rank lower.

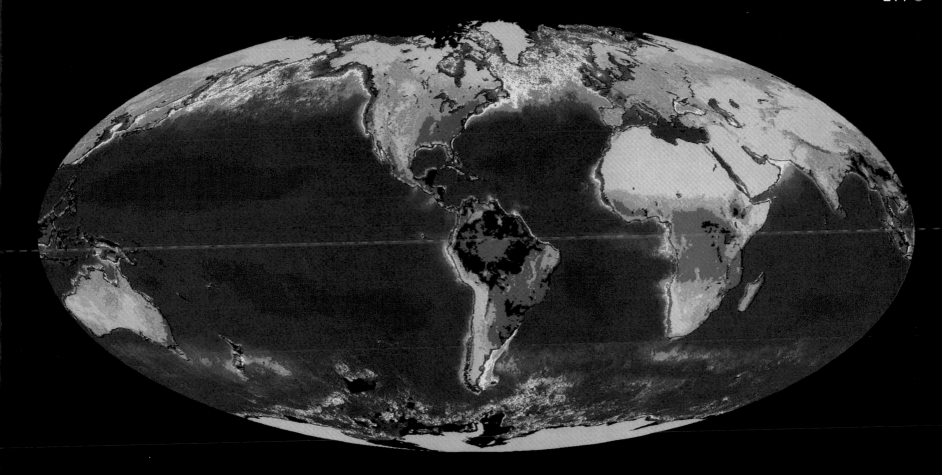

This image is comprised of data from the AVHRR onboard the NOAA POES, which is mapping global vegetation cover. The vegetation covering the continents was recorded by the AVHRR aboard NOAA-7, NOAA-8, and NOAA-11. Dense vegetation is represented by shades of purple and green; sparse vegetation by shades of brown. The vegetation 'index,' an indicator of vegetation cover, is calculated by comparing reflected infrared light to reflected visible light for a specific area of land. NOAA's two operational polar orbiting satellites scan the entire earth once every six hours from altitudes of about 850km (529 miles). The data collected by the AVHRR sensor is held in the archives of the United States Geological Survey's EROS Data Centre. The objective of the AVHRR instrument was to

provide radiance data for investigation of clouds, land-water boundaries, snow and ice extent, ice or snow melt inception, day and night cloud distribution, temperatures of radiating surfaces, and sea surface temperature.

KEY:

Tropical forests, very productive temperate forests
Temperate forests and moist savanna
Dry savanna, mixed forests, grassland
Coniferous forests, grasslands
Semi-arid steppes and tundra
Barren regions (deserts, ice)

INTERPRETING THE EARTH ●

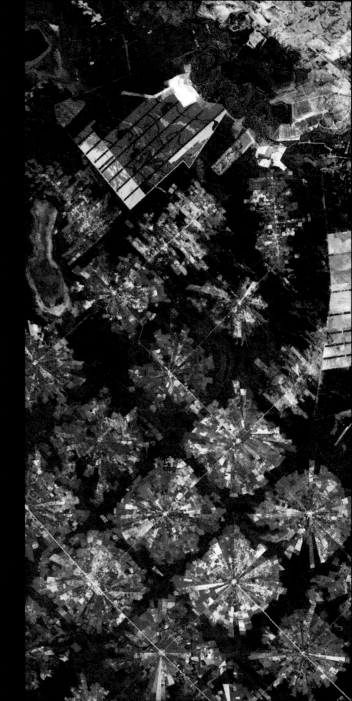

These images from 1986 (Landsat) and 2001 (ASTER) show an area of tropical dry forest lying east of Santa Cruz de la Sierra, Bolivia. The vegetation shows as red demonstrating the extensive deforestation that has taken place in the intervening years due to the resettlement of people from the Altiplano (the Andean high plains) and a large agricultural development effort (the Tierras Baja project). Soybean production began in earnest in the early 1970s following a substantial increase in the crop's world price. The pie or radial patterned fields are part of the San Javier resettlement scheme. At the centre of each unit is a small community and the rectangular, light coloured areas are fields of soybeans cultivated for export.

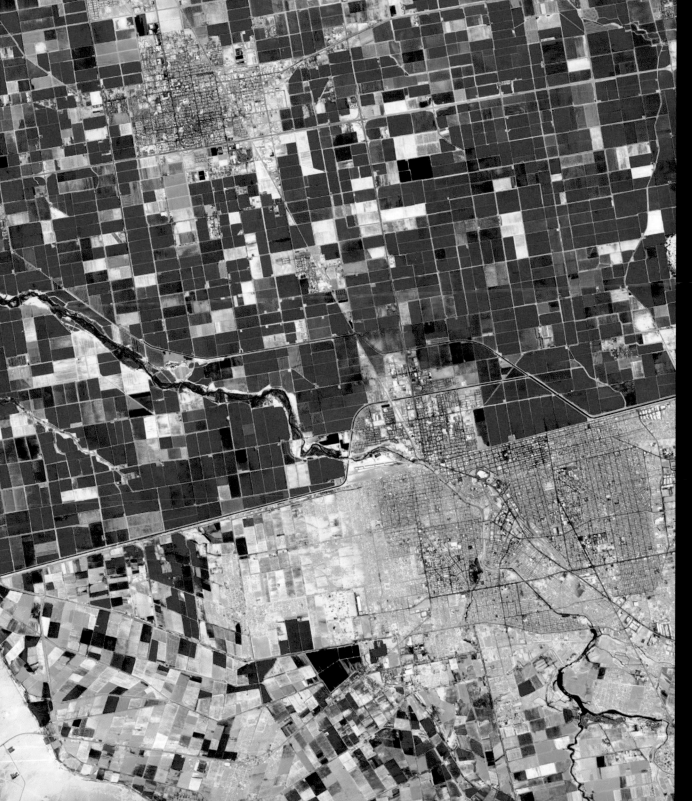

With vegetation recording as red, this 2000 image of the US-Mexico border in California, shows the dramatic difference in land use each side of the border. with the lush, regularly gridded agricultural fields of the US, and the more barren fields of Mexico. The Imperial Valley of California is one of the major fruit and vegetable producers for the US, watered by canals fed from the Colorado River. The town of Mexicali-Calexico can be seen spaning the border in the middle of the image and El Centro, California is in the upper left.

INTERPRETING THE EARTH

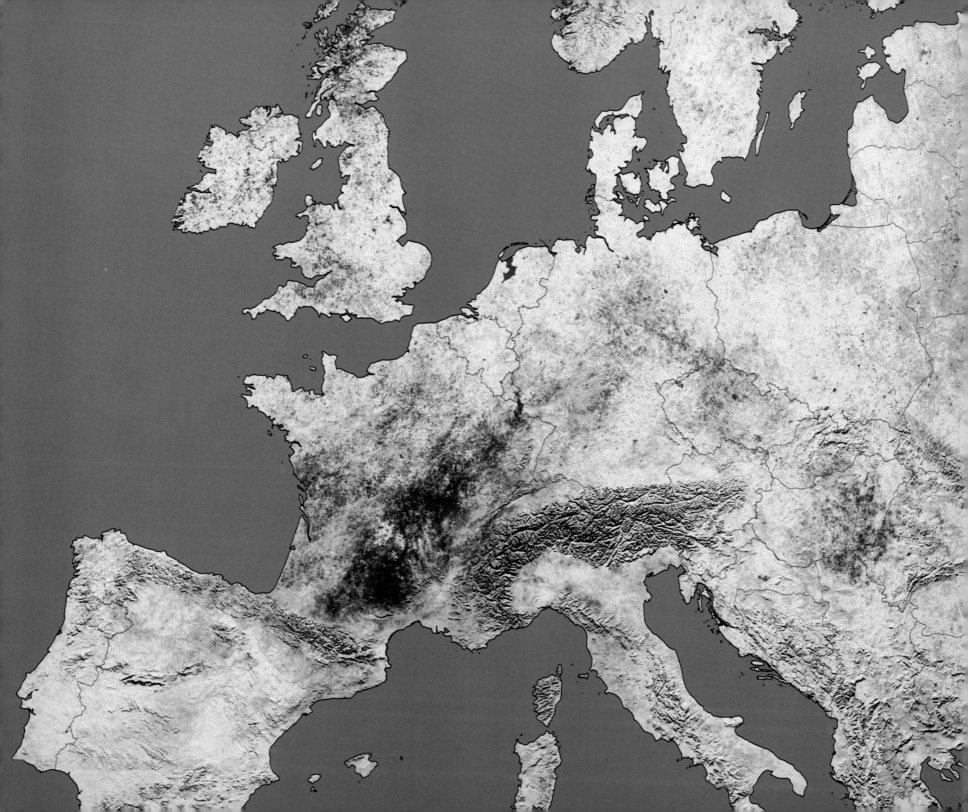

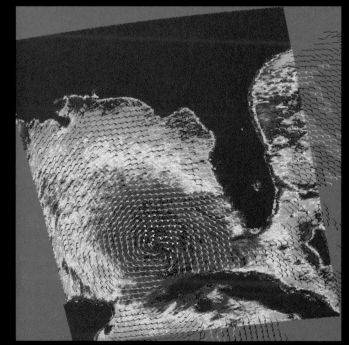

PREVIOUS PAGE:

in 2003, Europe was experiencing a historic heat wave that was responsible for at least 3000 deaths in France alone. Compared to July 2001, temperatures in July 2003 were sizzling. This image shows the differences in day time land surface temperatures collected in the two years by the MODIS instrument on NASA's Terra satellite. A blanket of deep red across southern and eastern France shows where temperatures were 10°C (18°F) hotter in 2003 than 2001, white areas show where temperatures were similar, and blue shows where they were cooler. The heat wave stretched north to southern England and Scotland.

NASA's TRMM spacecraft took a look under Hurricane Rita's clouds on September 19, 2005. Spikes in the rain structure known as 'hot towers' indicate storm intensity: these refer to tall cumulonimbus clouds, and they are seen as one of the mechanisms by which the intensity of a tropical cyclone is maintained. The existence of 18km (11 mile) towers in the eye wall alerted researchers that this storm was going to intensify rapidly. Within 48 hours, the storm was a very strong category 4 hurricane.

This visualization, taken while Hurricane Rita was at its height, shows the sea surface temperature from September 17–21 2005, when temperatures in the Gulf of Mexico remained one to two degrees warmer than the 28°C (82°F) minimum needed to sustain a hurricane. Every area shown here in yellow, orange or red represents a temperature of 28°C (82°F) or above. The temperature data was obtained from the AMSR-E instrument on the Aqua satellite, while the cloud images of Hurricane Rita were taken by the Imager on the GOES-12 satellite.

At 6:05am on September 21, 2005, Hurricane Rita's winds were observed by NASA's QuikSCAT satellite. This image depicts wind speed in colour and wind direction with small barbs, while white barbs point to areas of heavy rain. The highest wind speeds, shown in purple, surround the centre of the storm. The scatterometer on the satellite sends pulses of microwave energy down to the ocean surface, and measures the energy that bounces back. The energy changes, depending on wind speed and direction, giving scientists a way to monitor wind around the world.

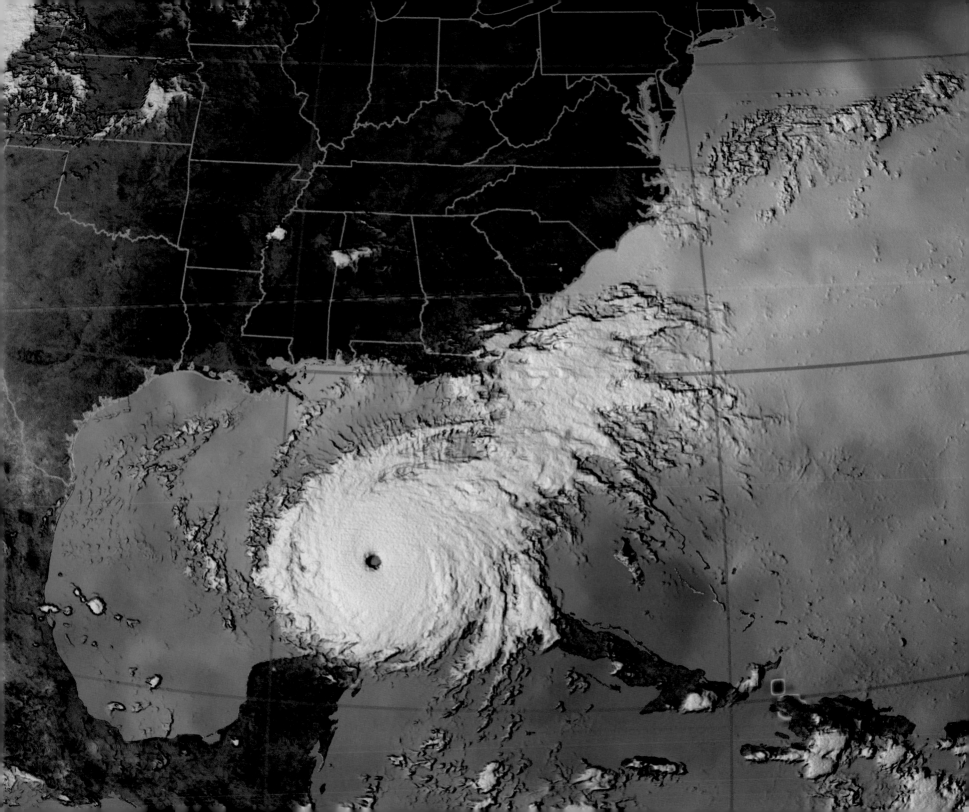

NASA's MISR sensor acquired this sequence of images for Hurricane Wilma in October 2005. Each pair in the sequence has a photo-like view of the storm on the left and a matching colour-coded image of cloud-top height data on the right. Cloud-top heights range from 0km (0 miles) (purple) to 18km

(11 miles) (red) in altitude. Areas where heights could not be determined are shown in dark grey.

The pair on the left shows Wilma on October 18. The central pair shows the eye of the storm on October 21. Hurricane Wilma surged from tropical storm to Category 5

hurricane status in record time, but the storm weakened considerably after battering the Yucatan Peninsula and the Caribbean. The right-hand pair displays the eastern edges of a weakened Wilma just starting to reach southern Florida on the morning of October 23.

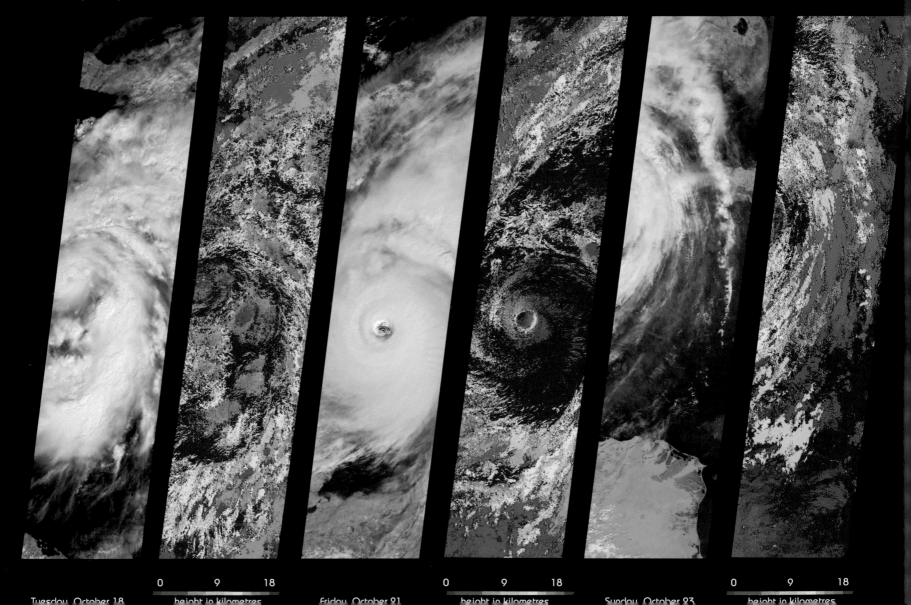

0	9	18

Tuesday, October 18 height in kilometres

0	9	18

Friday, October 21 height in kilometres

0	9	18

Sunday, October 23 height in kilometres

The Tropical Rainfall Measuring Mission (TRMM) overflew the very core of intensifying Typhoon Etau in the western Pacific. This remarkable TRMM image is constructed in three parts: the white background shows the counter clockwise spiral of the storm's clouds, as imaged by the Visible and Infrared Scanner (VIRS). Superimposed on top of the clouds (wide outer swathe) is the rain intensity, as detected by passive microwave energy using the TRMM Microwave Radiometer. The innermost swathe shows the rain intensity as measured by the TRMM Precipitation Radar. Reds indicated the heaviest rain regions, with rain rates on the order of several inches per hour. Typhoon Etau appears as a very symmetric storm – like a giant, slowly spinning pinwheel – with a well defined, nearly closed eye. During the time of this image the storm had achieved Typhoon 2 intensity. In one sweep, the TRMM satellite was able to capture the detailed cloud structure, as well as the entire rainfall pattern contained within the clouds. TRMM is shared between NASA and the Japanese space agency NASDA.

CLIMATE DATA

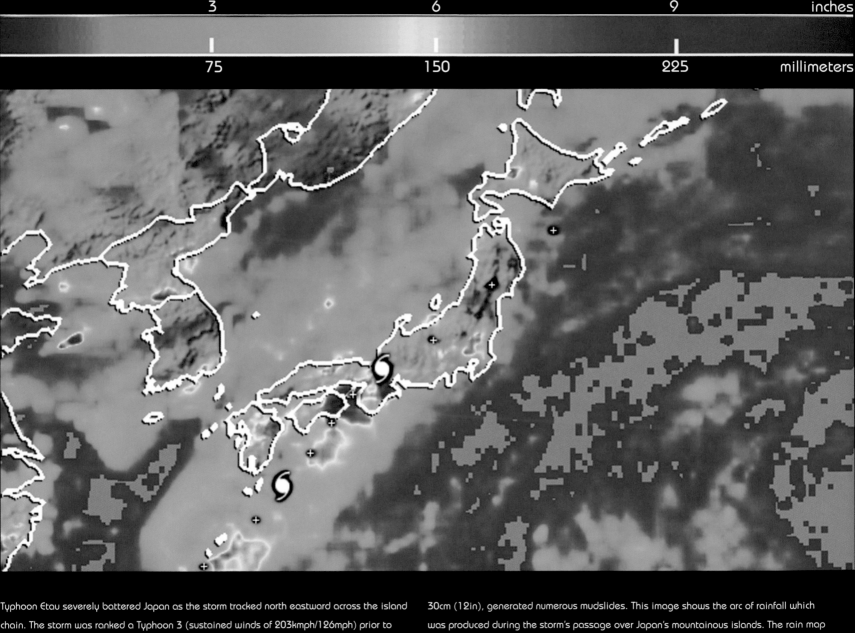

Typhoon Etau severely battered Japan as the storm tracked north eastward across the island chain. The storm was ranked a Typhoon 3 (sustained winds of 203kmph/126mph) prior to landfall, with reports of gusts to 241kph (150mph) and ocean waves in excess of 9m (30ft). The typhoon produced numerous casualties, disrupted power facilities and shut down Al Nippon, the national airline of Japan. Locally torrential rains, with reports exceeding 30cm (12in), generated numerous mudslides. This image shows the arc of rainfall which was produced during the storm's passage over Japan's mountainous islands. The rain map was produced using the TRMM-based Multi-Satellite Precipitation Analysis product at the Goddard Space Flight Centre. Local rainfall amounts approaching 30cm (12in) (dark red colours) are shown in the analysis.

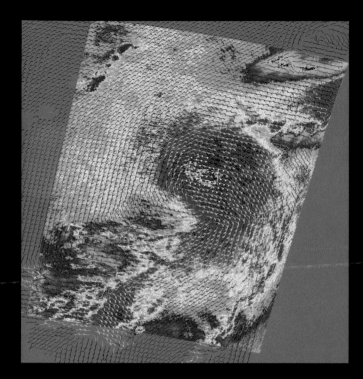

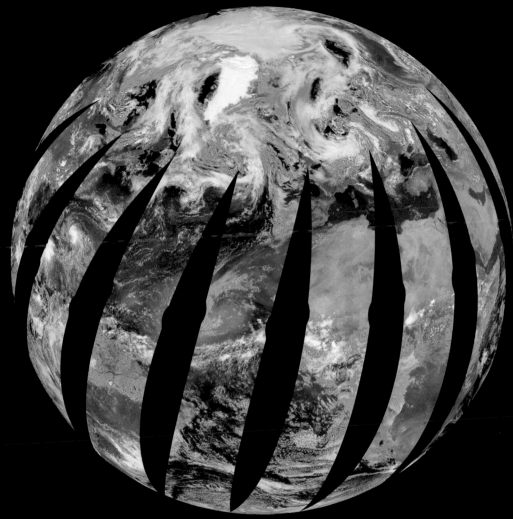

NASA's QuikSCAT satellite captured this image of Typhoon Nesat on June 6, 2005, at 8:41 UTC. At that time, Nesat had winds of 213kph (132mph) with gusts to 259kph (161mph), making it the equivalent of a Category 4 hurricane. The storm was moving north towards Japan over the Philippine Sea. This image shows the near-surface winds generated by the storm 10m (33ft) above the ocean. The highest wind speeds, shown in dark purple and light pink, circle the centre of the storm with barbs showing the direction of the winds. White barbs near the centre of the storm indicate areas of heavy rain. The scatterometer records wind speeds by sending pulses of microwave energy down to the ocean surface, and measuring the energy that bounces back. The energy changes depending on wind speed and direction. Determining accurate wind speeds inside a typhoon such as Nesat can be challenging because the unusually heavy rain found in a cyclone distorts the microwave pulses. As a result, the wind speeds shown here are lower than wind speeds recorded by the Joint Typhoon Warning Centre. Instead, the scatterometer provides a clear picture of the relative wind speeds within the storm and also shows the wind direction.

Floridians looking for a break from hurricane season in late July 2005 were in for a change, though it wasn't necessarily what they wanted: Saharan dust. By July 19, a massive dust storm crossed the Atlantic towards southern Florida. This image, captured by the SeaWiFS instrument, is reconstructed to represent the three-dimensinal globe. In the far upper left is North America. In the centre of the picture, intermixed with clouds, is the swirling dust storm. How damaging a dust cloud is depends on its dilution. Diluted clouds do little more than leave a thin coat of dust on cars and add colour to sunsets. Thicker clouds spell trouble for people with respiratory ailments. Saharan dust has decimated some species of Caribbean coral, yet without regular dustings, the Caribbean Islands would be barren rock – vegetation arose there thanks to dust from across the Atlantic. Saharan dust has also played a role in the development of the Amazon Rainforest.

What makes a hurricane? First, warm water – at least 28°C (82°F). In late June in the Northern Hemisphere, the tropical ocean waters reach their warmest. In this image, orange and red indicate where the ocean is 28°C (82°F) and warmer. This composite image is a false-colour map of sea surface temperature for the month of May 2003.

The next ingredient is a disturbance of generally easterly waves off Africa, comprised of winds resulting from the clash between the hot air from over the Sahara Desert and the cooler air over the Gulf of Guinea. These waves provide the initial energy and spin required for a hurricane to develop.

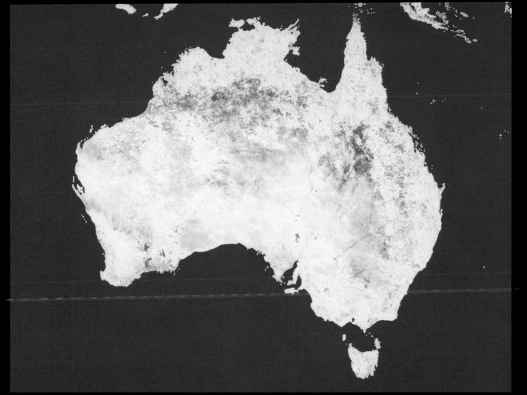

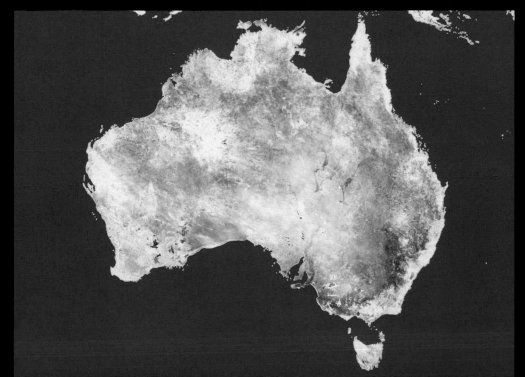

The impact of a long drought in Australia on vegetation is clearly visible in these vegetation anomaly images. Where vegetation, both crops and native plants, is less dense than average, the images are brown. Regions that are more densely vegetated than average are green. Between January, top, and May, bottom, vegetation has become progressively drier than average as drought has spread across the country. Covered with a streak of dark brown, the southeast corner of the country is most severely affected in the lower image. Most of this land falls in New South Wales, where as much as 91 per cent of the state has been drought declared. The patch of green in the southwest corner of the country is in Western Australia, where crops were, at this time, doing well. These images are a composite of data collected by the SPOT Vegetation satellite and were generated at NASA Goddard Space Flight Centre by the GIMMS Group under analysis agreement with the USDA Foreign Agricultural Service.

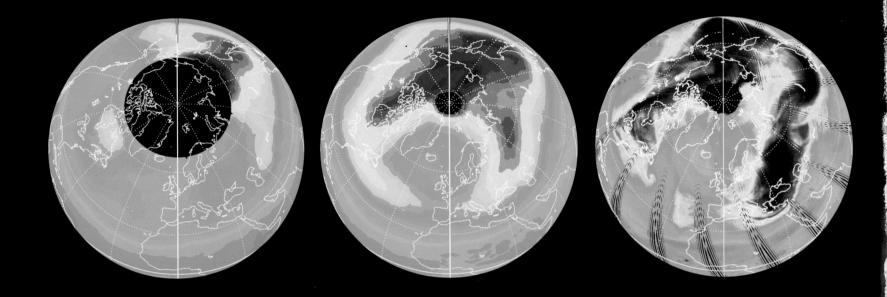

The winter of 2004–05 saw the second highest chemical ozone destruction ever observed over the Arctic. Polar ozone is destroyed when chlorine, cold temperatures, and sunlight mix in the atmosphere 8–50km (5–30 miles) above the Earth's surface. Since ozone shields the Earth from ultraviolet light, the high-energy light that causes sunburns and is associated with skin cancers, low ozone levels could threaten human health. Ultraviolet levels remained near normal through the winter, however, because unusual weather conditions brought ozone from the Earth's ozone-rich mid-latitudes to the pole to fill in the gaps left by the extreme ozone depletion. These images show the fluctuations in ozone during the Arctic winter of 2005. The two images on the left show the average total column ozone over the Arctic during the months of January and March, 2005, and the right-hand image shows total column ozone on a single day, March 11, 2005. The images are based on data collected by the Ozone Monitoring Instrument (OMI) aboard NASA's Aura satellite. During this time period, the Microwave Limb Sounder, another instrument on the Aura satellite, measured 50 per cent ozone loss, the second-highest level ever observed behind the 60 per cent loss measured in 1999–2000. Despite this, the lowest total column ozone values in polar regions are slightly higher in March than in January, on average, as evidenced by the broad splashes of red that represent high ozone levels. Stratospheric winds carried the ozone north into the Arctic, compensating for the significant chemical loss, so that no blue or purple holes representing low ozone levels appear in the March image. Black circles over the North Pole show where OMI did not collect data. On a single day, March 11, 2005, ozone was distributed far more unevenly, with dark red; almost black areas of high ozone over the Aleutian Islands, Asia, and Europe, and a pale blue thin spot over Iceland and Greenland. This reveals that even though ozone values appeared to be near normal on average throughout March, some regions experienced much lower ozone levels – and therefore, a greater exposure to UV light – on an individual day.

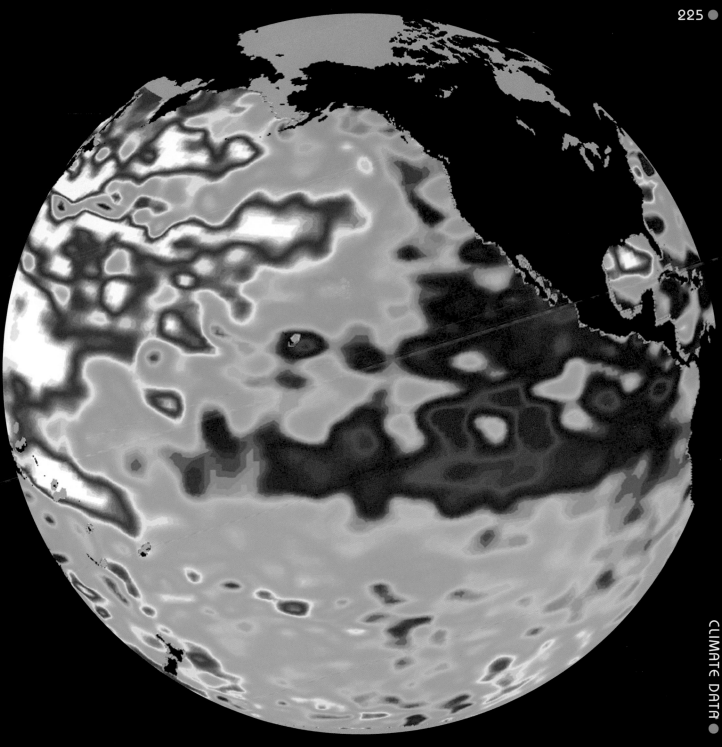

This image shows a horseshoe of higher than average (warm) water in western and central Pacific Ocean (red and white), and lower than average (cool) blue and purple water in the eastern and tropical Pacific Ocean. The cooler and drier conditions in Southern California over the last few years appear to be a direct result of a long-term ocean pattern known as the Pacific Decadal Oscillation (PDO). An important climate controller, the PDO is a basin-wide oceanic pattern similar to El Niño and La Niña but much larger. The PDO lasts many decades rather than just a few months like El Niño and La Niña. The climatic fingerprints of the PDO are most visible in the North Pacific and North America, with secondary influences coming from the tropics. The long-term nature of the PDO makes it useful for forecasting, as its effects persist for so long. Since mid-1992, NASA has been able to provide space-based, synoptic views of the entire Pacific Ocean's shifts in heat content with the Topex/Poseidon mission and its follow-up mission, Jason (which began in 2001). Before these satellites were available, monitoring oceanic climate signals in near-real time was virtually impossible.

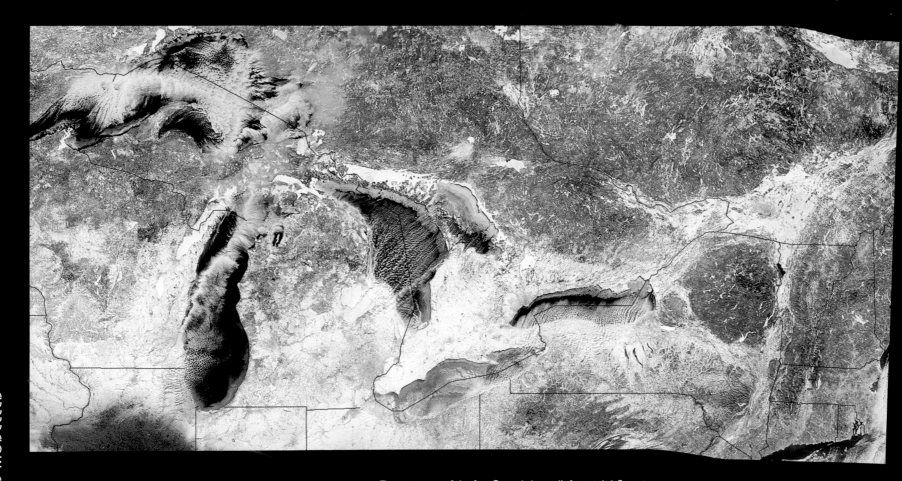

These images of the five Great Lakes – (left to right) Superior, Michigan, Huron, Erie, and Ontario – show ice beginning to build up around the shores of each of the lakes, with snow on the ground across virtually the entire scene. Both images were made from observations from MODIS on NASA's Terra satellite on January 27, 2005. The image on the left uses MODIS observations that simulate a digital photograph, while the image on the right adds infrared observations that help sort out all the 'white'. Snow and ice become electric blue, while clouds remain white. Open water appears blue or nearly black, and vegetation is bright green. Both Georgian Bay and Lake Erie have a considerable amount of ice.

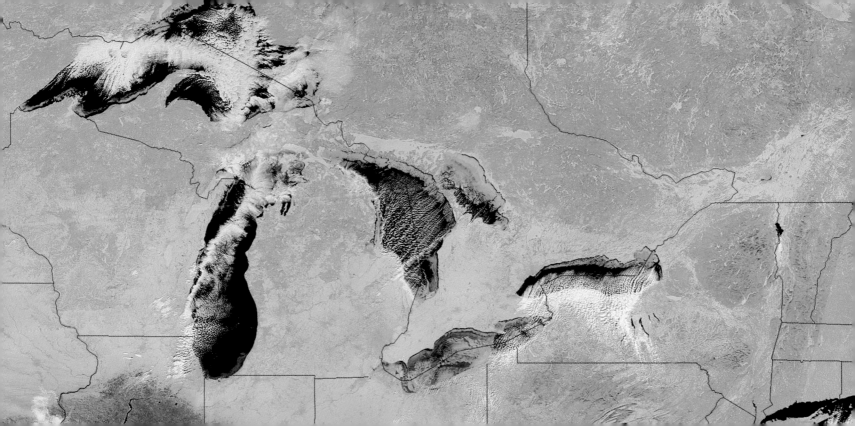

The dark blue icy finger of the Malvinas Current reaches north into the warm tub of South Atlantic Ocean in this sea surface temperature image. The current is an offshoot of the Circumpolar Current, the band of ocean water that circles Antarctica, and it carries frigid water north along the coast of South America until it encounters water pouring out of the Rio de la Plata between Argentina and Uruguay. Here, the cold Antarctic waters also meet the Brazil current carrying warm subtropical waters south, and the 20-degree boundary between the two currents forms a stark line.

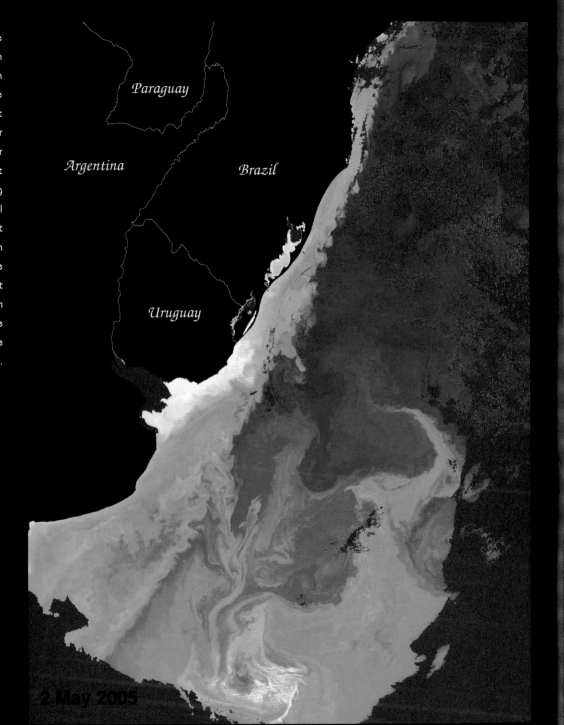

Paraguay

Argentina

Brazil

Uruguay

2 May 2005

This image, also produced by MODIS on the same day, reveals the correlation between sea surface temperature and plant life. The cold, deep current stirs nutrients from the ocean depths and brings them to the surface, where plants thrive on them. By contrast, the warm current is shallow, and so the waters tend to be nutrient poor. The effect of the two currents on plant life is starkly clear where the two meet near the Rio de la Plata. This image records chlorophyll concentrations, and here it can be seen that the Malvinas Current is rich with plant life. The pattern of warm pink formed by the Brazil current in the image opposite matches the lifeless dark blue bulge where few plants are growing in the centre of the lower image. Nutrient-rich waters such as those fed by the Malvinas Current also tend to support a diverse ecosystem. The tiny plants that grow on the surface of the ocean feed other ocean life. Off the coast of South America, fish teem in the waters of the Malvinas Current, and commercial fishing is an important industry in Argentina and Uruguay.

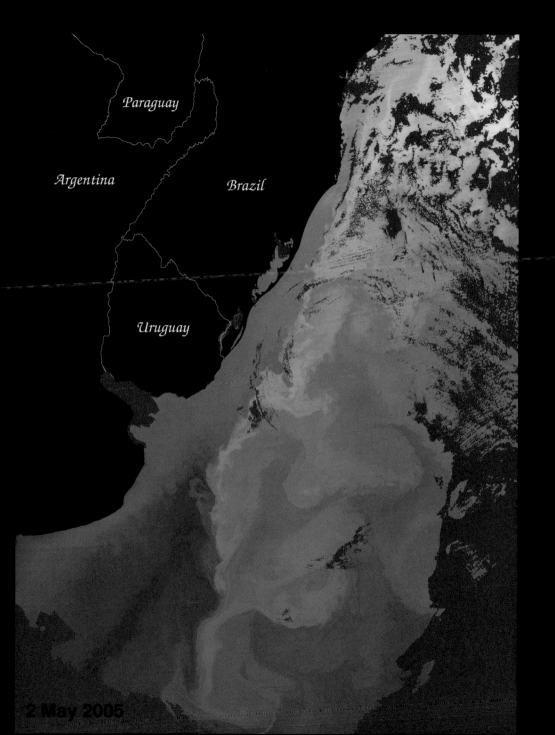

Paraguay

Argentina

Brazil

Uruguay

2 May 2005

CLIMATE DATA ●

A pre-monsoon heatwave left India, Pakistan, Nepal, and Bangladesh baking for much of June 2005. The heatwave, which started at the end of May, claimed more than 200 lives in India alone, according to news reports, and also caused deaths in Pakistan, Bangladesh, and Nepal.

The SeaWinds scatterometer on NASA's QuikSCAT satellite makes global radar measurements 24 hours a day, both in clear sky and through clouds. The radar data over the oceans provide scientists and weather forecasters with information on surface wind speed and direction. Scientists also use the radar measurements directly to learn about changes in vegetation and ice extent over land and Polar regions. This false-colour image is based entirely on SeaWinds measurements obtained over oceans, land, and Polar regions. Over the ocean, colours indicate wind speed, with orange as the fastest wind speeds and blue as the slowest, while white streamlines indicate the wind direction. The land image was made from four days of SeaWinds data. The lightest green areas correspond to the highest radar backscatter, so the Amazon and Congo rainforests are bright compared to the dark Sahara desert. The image of Greenland and the north polar ice cap was generated from data acquired by SeaWinds on a single day. In the polar region portion of the image, white corresponds to the largest radar return, while purple is the lowest. The variations in colour in Greenland and the polar ice cap reveal information about the ice and snow conditions.

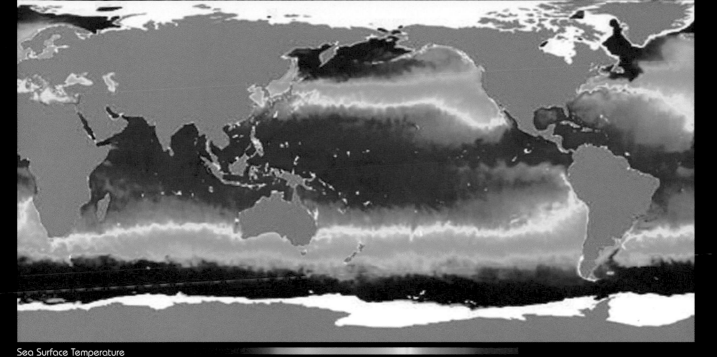

Sea Surface Temperature

Cool Warm

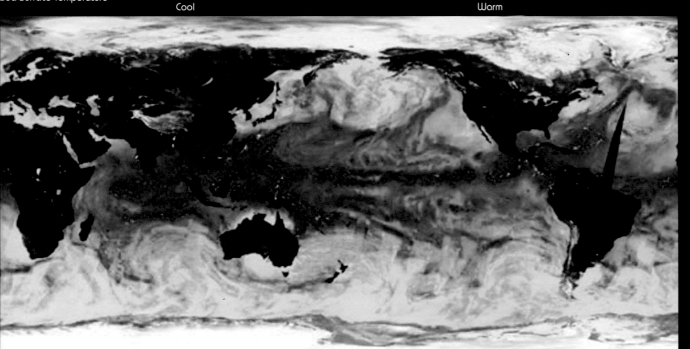

Brightness Temperature

The National Space Development Agency of Japan's (NASDA) Advanced Microwave Scanning Radiometer for the Earth Observing System (AMSR-E), onboard NASA's Aqua spacecraft, began sending high-quality data on June 1, 2002. The AMSR-E has delivered impressive pictures of the planet's sea surface temperature from the 6.9 Ghz vertical polarization channel (top left) and brightness temperatures (bottom left) from the 89.0 Ghz vertical and horizontal polarization channels and the 23.8 Ghz vertical polarization channel, averaged over the 3-day period June 2–4, 2002. The sea surface temperature image is indicative of the high level of detail the microwave imager is capable of providing, even in the presence of substantial cloud cover. In the brightness temperature image, ice and snow cover is shown in white and yellow, desert areas in shades of green, other land areas in dark colours, and oceans in shades of blue.

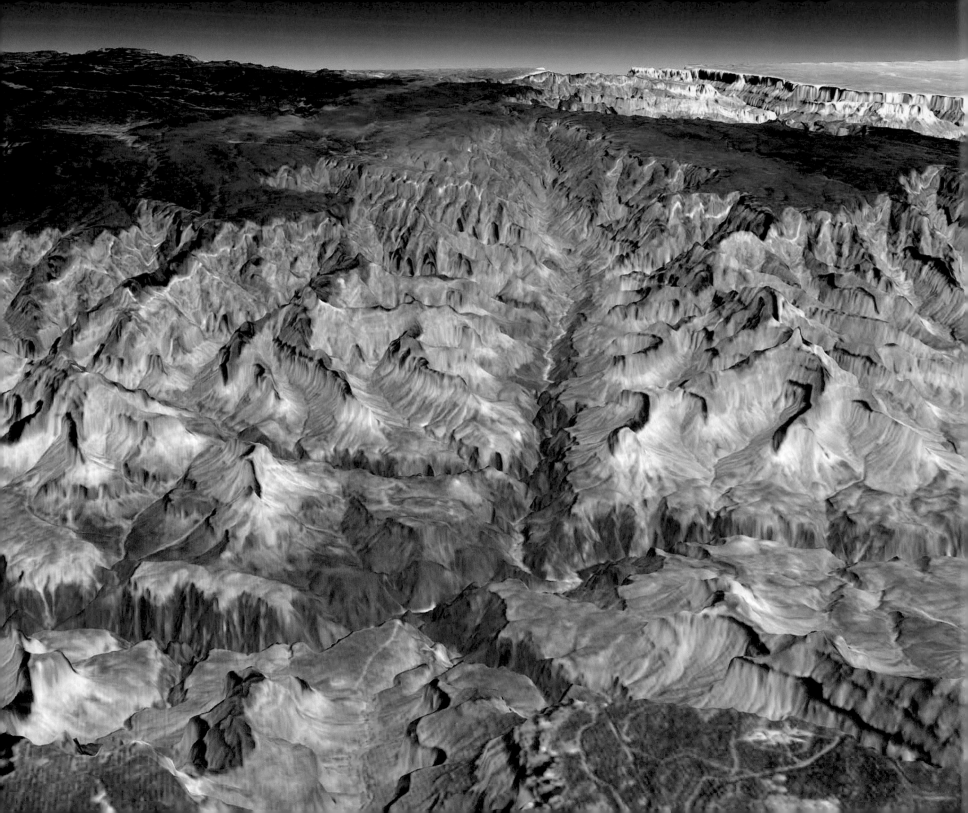

3-D PROJECTIONS

PREVIOUS PAGE:

This simulated true-colour perspective view over the Grand Canyon was created from ASTER data acquired on May 12, 2000. The Grand Canyon Village is in the lower foreground; the Bright Angel Trail crosses the Tonto Platform, before dropping down to the Colorado Village and then to the Phantom Ranch (green area across the river). Bright Angel Canyon and the North Rim dominate the view. At the top centre of the image the dark blue area with light blue haze is an active forest fire.

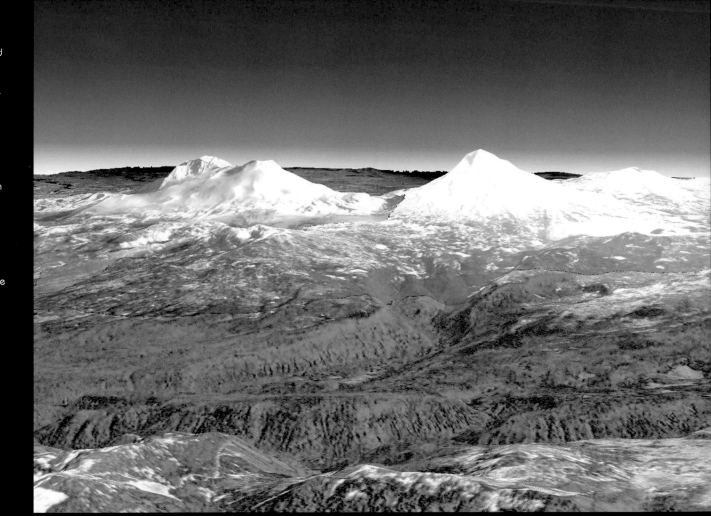

The ground near one of the long-dormant Three Sisters volcanoes in the Cascade Mountains of west-central Oregon has risen approximately 10cm (4in) in a 10 x 20km (6 x 12 mile) parcel since 1996, meaning that magma or underground lava is slowly flowing into the area, according to a research team from the US Geological Survey. The Three Sisters area – which contains five volcanoes – is only about 274km (170 miles) from Mount St Helens, which erupted in 1980. Both are part of the Cascades Range, a line of 27 volcanoes stretching from British

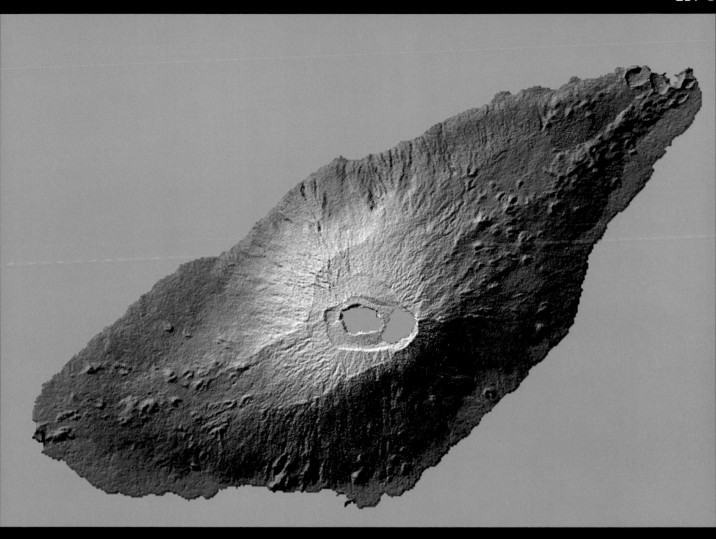

In late November 2005, Aoba (locally called Mt Manaro) Volcano on Ambae Island in the South Pacific began rumbling, threatening a dangerous eruption. About 5,000 people, half the island's population, were evacuated in early December when the volcano started spewing clouds of steam and toxic gases as molten material entered Lake Voui, which fills the volcano's crater. Aoba Volcano is the dominant feature in this shaded-relief image of Ambae Island, part of the Vanuatu archipelago, which includes more than 80 islands in the South Pacific located about three-quarters of the way from Hawaii to Australia. The November/December eruption involved a vent at the centre of Lake Voui (at left), which was formed approximately 425 years ago after an explosive eruption. Two visualization methods were combined to produce the image: shading and colour coding of topographic height. The shading indicates direction of the slopes; northwest slopes appear bright, while southeast slopes appear dark. Colour coding shows height, with green at the lower elevations, rising through yellow and tan, to white at the highest elevations.

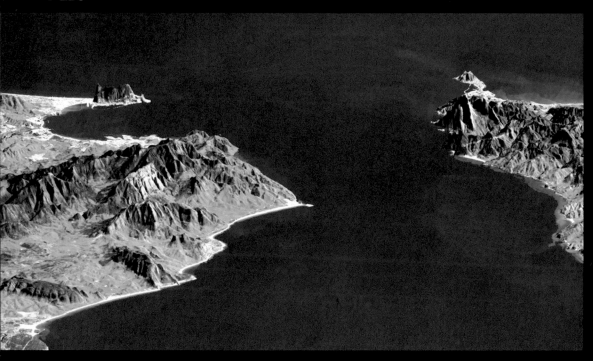

This perspective view shows the Strait of Gibraltar, which is the entrance to the Mediterranean Sea from the Atlantic Ocean. Spain is on the left. Morocco is on the right. The Rock of Gibraltar is the peninsula in the back left. This image was generated from a Landsat satellite image draped over an elevation model produced by the Shuttle Radar Topography Mission (SRTM). The view looks eastward with a three-times vertical exaggeration to enhance topographic expression. Natural colours of the scene (green vegetation, blue water, brown soil, white beaches) are enhanced by image processing. The scene includes some infrared reflectance (as green) to highlight the vegetation pattern and shading of the elevation model to further highlight the topographic features.

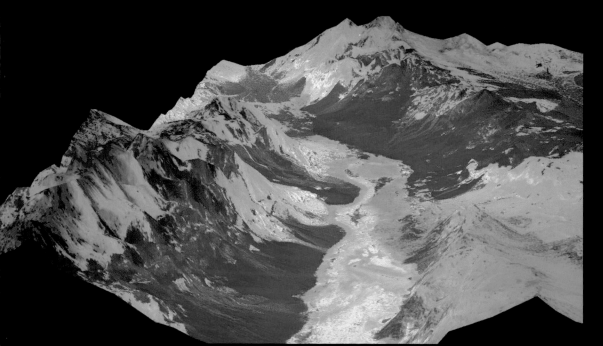

This 3-D perspective view looking north over Death Valley, California, was produced by draping ASTER nighttime thermal infrared data over topographic data from the US Geological Survey. The ASTER data was acquired on April 7, 2000 and covers an area of 60 x 80km (37 x 50 miles). The data has been enhanced to exaggerate the colour variations in different types of surface materials. Salt deposits on the floor of Death Valley appear in yellow, green, purple, and pink, indicating the presence of carbonate, sulfate, and chloride minerals. The Panamint Mountains to the west, and the Black Mountains to the east, are made up of sedimentary limestones, sandstones, shales, and metamorphic rocks. The bright red areas are dominated by the mineral quartz, such as is found in sandstones; green areas are limestones. In the lower centre part of the image is Badwater, the lowest point in North America.

Athens in southeastern Greece, is the capital and largest city in the country. This perspective view was made from an image acquired on April 29, 2004, which was draped over a DEM created from the same ASTER scene.

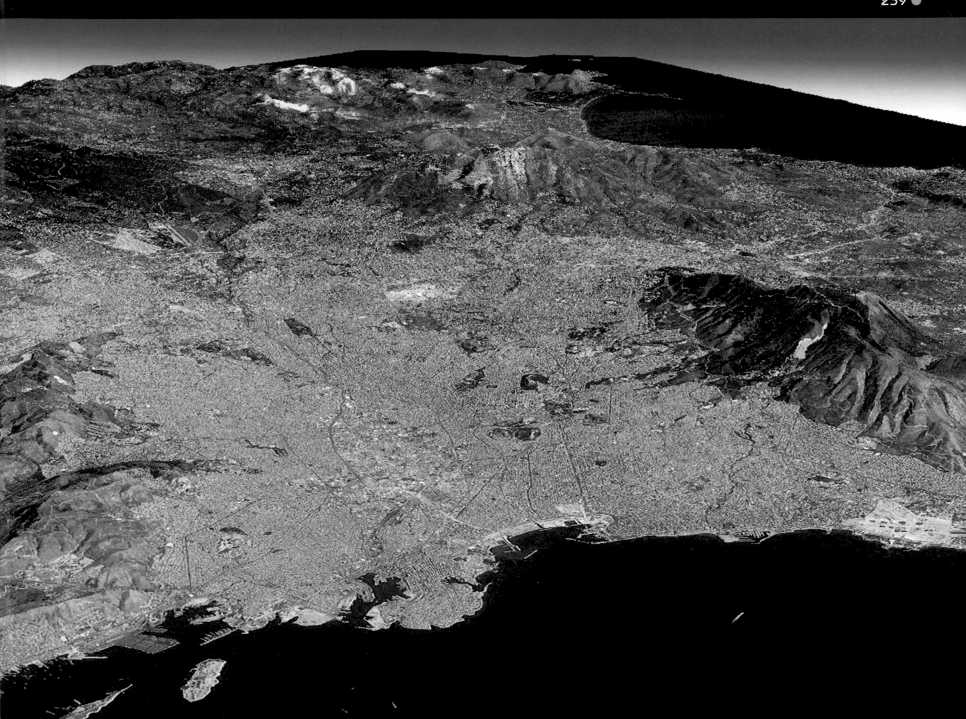

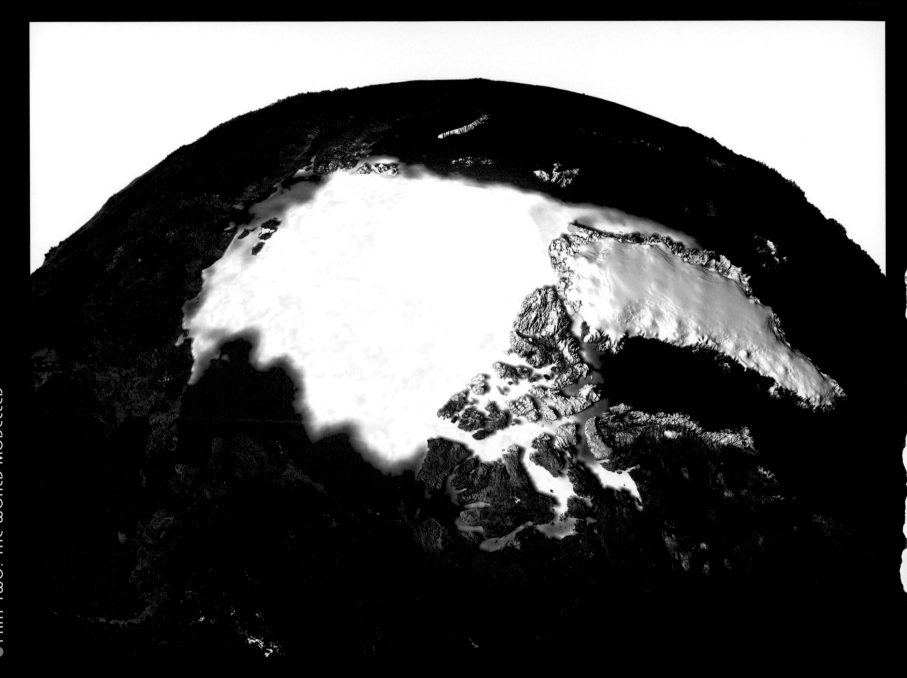

According to a new NASA study, Arctic perennial sea ice has been decreasing at a rate of nine per cent per decade since the 1970s. The changes in Arctic ice may be a harbinger of global climate change, with most of the recent global warming occurring over the last decade, with the largest temperature increase occurring over North America. Researchers suspect the loss of Arctic sea ice may be caused by changing atmospheric pressure patterns over the Arctic that move sea ice around, and by warming Arctic temperatures that result from the buildup of greenhouse gases in the atmosphere. These images show a comparison of composites over the Arctic Circle, acquired in 1979 (left) and 2003 (right) by the DMSP Special Sensor Microwave Imager (SSMI). The first image shows the minimum sea ice concentration for the year 1979, and the second image shows the minimum sea ice concentration in 2003.

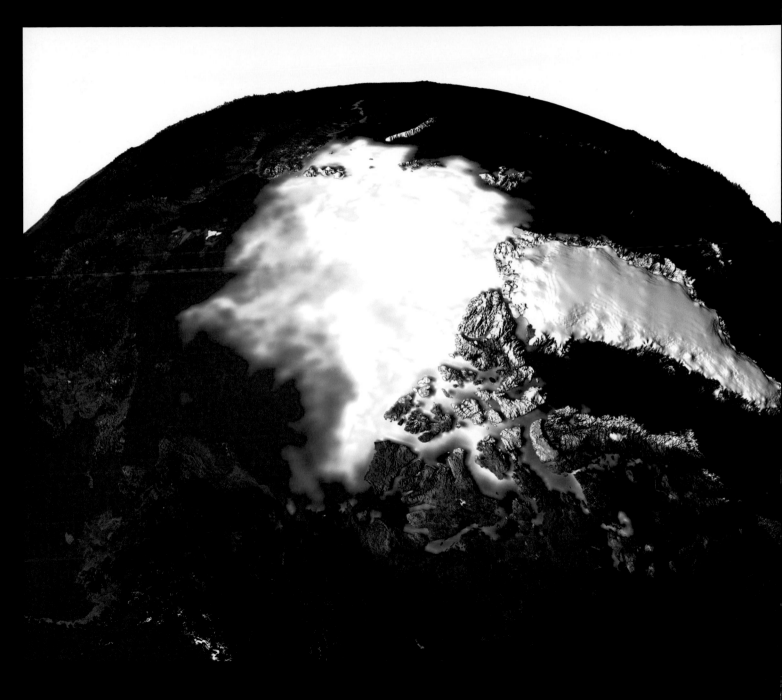

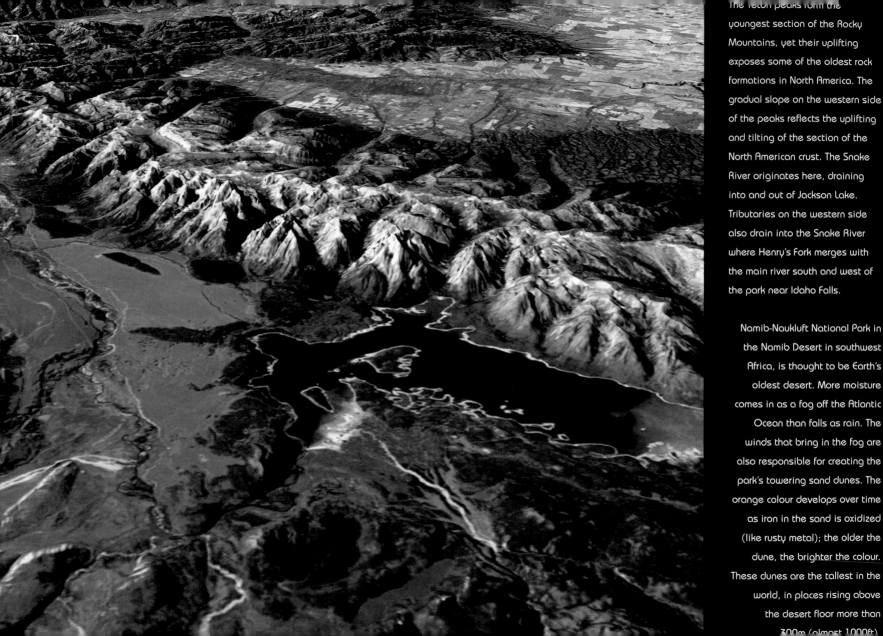

The Teton peaks form the youngest section of the Rocky Mountains, yet their uplifting exposes some of the oldest rock formations in North America. The gradual slope on the western side of the peaks reflects the uplifting and tilting of the section of the North American crust. The Snake River originates here, draining into and out of Jackson Lake. Tributaries on the western side also drain into the Snake River where Henry's Fork merges with the main river south and west of the park near Idaho Falls.

Namib-Naukluft National Park in the Namib Desert in southwest Africa, is thought to be Earth's oldest desert. More moisture comes in as a fog off the Atlantic Ocean than falls as rain. The winds that bring in the fog are also responsible for creating the park's towering sand dunes. The orange colour develops over time as iron in the sand is oxidized (like rusty metal); the older the dune, the brighter the colour. These dunes are the tallest in the world, in places rising above the desert floor more than 300m (almost 1000ft).

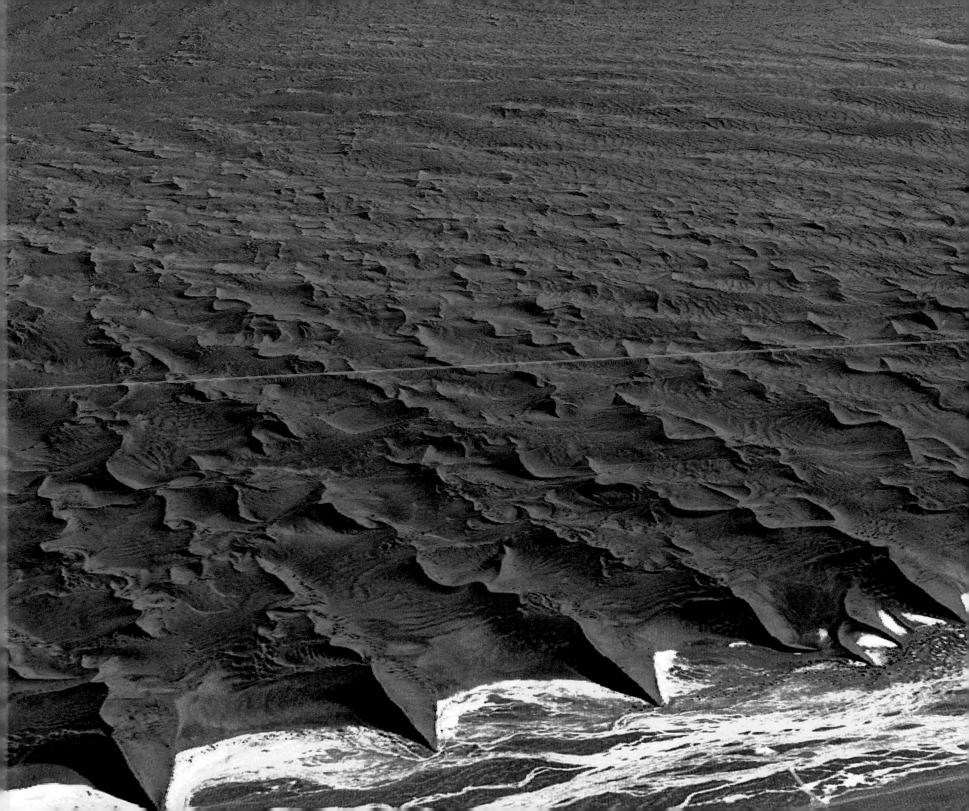

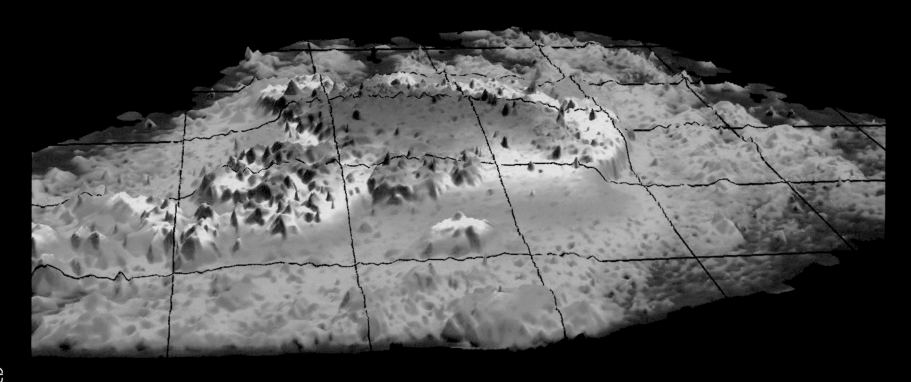

Johnson's Reef on the northwest shore of St John Island in the US Virgin Islands forms colourful peaks in this lidar image recorded by NASA's Experimental Advanced Airborne Research Lidar (EAARL) in June 2003. The coral reef is part of the Virgin Islands National Park. Reef managers could use such a complete picture of the shape of the reef as a standard when tracking reef health, growth or damage. This EAARL image provides a much-needed overview. Each grid in the image covers 100 sq m (330 sq ft) of the reef. The red peaks are sections of the reef just 1m (3ft) below the surface of the water. The dark blue troughs are 10m (33ft) below the surface. With much of the reef just below the surface of the water, using a boat to map the reef was impossible. Remote sensing from the air was a necessity. Lidar works just like radar, but bounces a laser off objects to ascertain their distance instead of radio waves. After being flown over the reef in a small airplane, EAARL returned a topographic map that is accurate to within 10 vertical cm (4in) and 40 horizontal cm (16in).

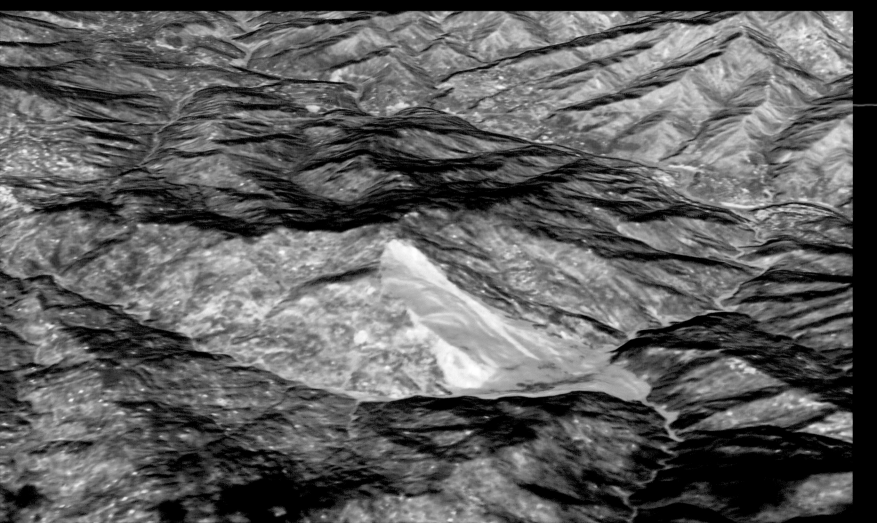

The massive earthquake that shattered Pakistan on October 8, 2005, was centered on the steep mountains of Kashmir. Communities already hard to reach because of the treacherous mountain topography were cut off entirely when landslides slumped over roads. The ASTER instrument on NASA's Terra satellite captured this image of one such landslide on October 11, 2005, which consisted of a large wedge of tan soil stretching more than 2km (1.2 miles) in length and over 1km (0.6 miles) in width. All vegetation, red in this image, is gone in the grey landslide region. A number of smaller landslides are also visible, mostly along the main river and other valleys. The large landslide was southeast of the earthquake's epicenter between Muzaffarabad, Pakistan, and Uri, India, in the Pir Punjal range of Kashmir.

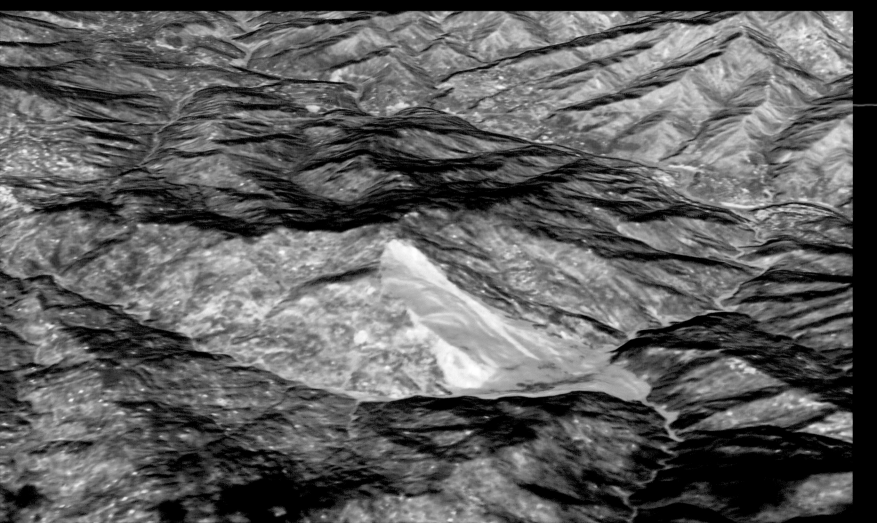

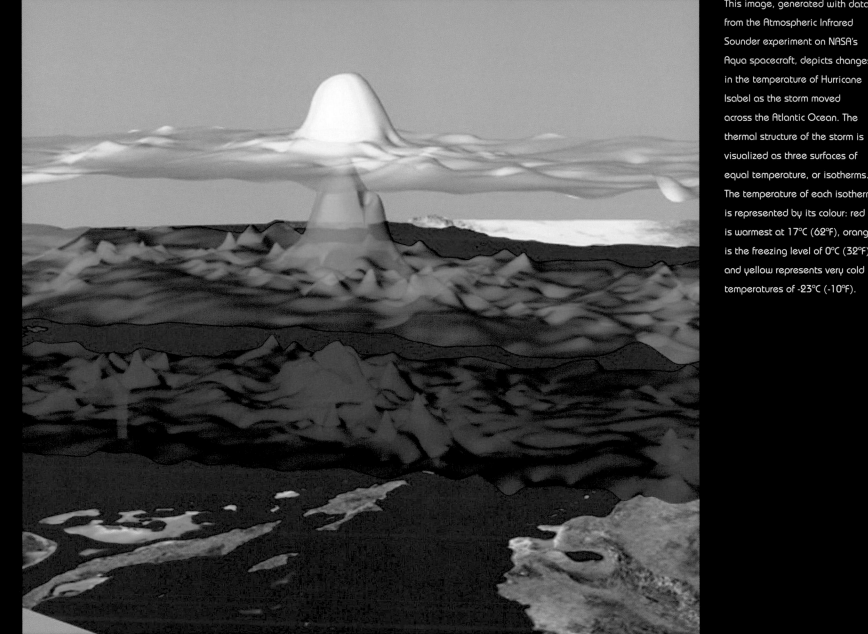

This image, generated with data from the Atmospheric Infrared Sounder experiment on NASA's Aqua spacecraft, depicts changes in the temperature of Hurricane Isabel as the storm moved across the Atlantic Ocean. The thermal structure of the storm is visualized as three surfaces of equal temperature, or isotherms. The temperature of each isotherm is represented by its colour: red is warmest at 17°C (62°F), orange is the freezing level of 0°C (32°F), and yellow represents very cold temperatures of -23°C (-10°F).

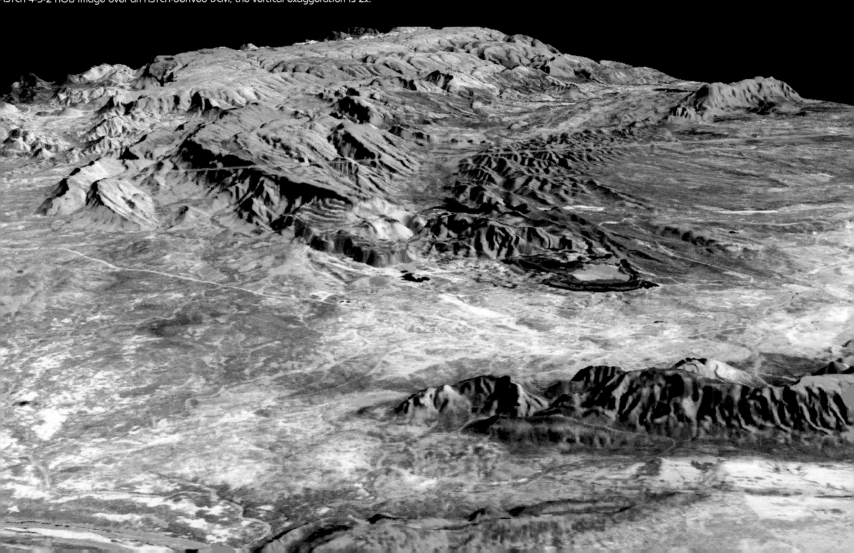

The Argyle open-pit diamond mine, located in the Kimberley region in the far north east of Western Australia, is the world's largest single producer of diamonds. The region is remote, rugged and hot, with temperatures of over 40°C (104°F) during the wet season from October to March. The deposit was discovered in 1979 following some 12 years of exploration by various companies in the area. This 3-D perspective view was created by draping an ASTER 4-3-2 RGB image over an ASTER-derived DEM; the vertical exaggeration is 2x.

This image shows Miquelon and Saint Pierre Islands, located south of Newfoundland, Canada. This 3-D perspective view is one of several still photographs taken from a simulated flyover of the islands. It shows how elevation data collected by the SRTM can be used to enhance other satellite images. Colour and natural shading were provided by a Landsat 7 image taken on September 7, 1999. The Landsat image was then draped over the SRTM data, with terrain perspective and shading being provided by the SRTM. The vertical scale has been increased six times to make it easier to see the small features, and this also makes the sea cliffs around the edges of the islands look larger.

This perspective view shows the western part of the city of Pasadena, California, looking north towards the San Gabriel Mountains. Portions of the cities of Altadena and La Canada-Flintridge are also shown. The image was created from three datasets: SRTM supplied the elevation data; Landsat data from November 11, 1986 provided the land surface colour (not the sky) and US Geological Survey digital aerial photography provided the image detail. This image shows the power of combining data from different sources to create planning tools to study problems that affect large urban areas. In addition to the well-known earthquake hazards, Southern California is affected by a natural cycle of fire and mudflows. Wildfires strip the mountains of vegetation, increasing the hazards from flooding and mudflows for several years afterwards. Data such as that shown on this image can be used to predict both how wildfires will spread over the terrain and also how mudflows will be channelled down the canyons.

Honolulu, on the island of Oahu, is a large and growing urban area with limited space and water resources. Features of interest in this scene include downtown Honolulu (right), Honolulu harbour (right), Pearl Harbour (centre), and offshore reef patterns (foreground). Clouds commonly hang above ridges and peaks of the Hawaiian Islands, and in this image appear draped on the mountains. The clouds are actually about 1000m (3300ft) above sea level. This perspective view was created by draping a Landsat 7 satellite image over an SRTM elevation model, with topography being exaggerated about six times vertically.

Tropical storm Keith originated in the Caribbean and reached hurricane Category 3 intensity on October 1, 2000. Making landfall on Mexico's Yucatan Peninsula and north eastern Belize on October 2, it packed winds as high as 217kph (135mph). This image was taken on October 2, shortly after the storm made landfall, and it was created using data from the Microwave Imager (TMI) aboard NASA's TRMM. That sensor has the ability to peer within a storm and detect rainfall, seen here as red and green blobs. The red blobs show higher rainfall rates (up to 5cm/2in per hour), and greens show lower rainfall rates (2.5cm/1in per hour).

The 1,200km (800 mile) San Andreas is the longest fault in California and one of the longest in North America. This perspective view of a portion of the fault was generated using data from the SRTM and an enhanced, true-colour Landsat satellite image. The view shown looks southeast as it cuts along the base of the mountains in the Temblor Range near Bakersfield, and the fault is the distinctively linear feature to the right of the mountains. Left of the range is the agriculturally rich San Joaquin Valley, while in the background is the snow-capped peak of Mount Pinos. Topographic heights in this image have been exaggerated two times.

bold page numbers refer to captions

ADEOS II 9
Afar Depression **24**
Africa
 Lake Chad decline (Landsat 7) **178**
 Lake Natron (Terra/ASTER) **33**
 Namib-Naukluft National Park **242**
 Orange River (Landsat 7/ETM+) **36**
 solar eclipse (Aqua/MODIS) **141**
 Victoria Falls/Zambezi (ISS) **122**
 see also individual countries
Alps **139**
Ambae Island: Aoba Volcano **237**
Amsterdam Island, Indian Ocean (Terra/
 MODIS) **132**
Andes (ASTER) **207**
Antarctica
 B-15A iceberg **54**, (MODIS) **70**,
 (Terra/MODIS) **71**
 Erebus Ice Tongue (ASTER) **72**
 megadune formations **74**
Aqua 8, **181**
Arabian Sea
 oilfield (Endeavour/SIR-C/X-SAR) **64**
 Pakistan/India coast **63**
 sunglint pattern **51**
Aral Sea **57**, (MODIS) **174**
Arctic (Aura/OMI) **224**, (SSMI) **241**
Argentina
 ocean coast (SeaWifS) **65**
 Rosario/Paraná River (ISS) **96**
ASTER 8
Athens (ASTER) **238**
Atlantic Ocean **56**, **58**, (MODIS) **228–9**
Australia
 Argyle diamond mine (ASTER) **247**
 Ayers Rock (QuickBird) **124**
 drought effect (SPOT/GIMMS) **223**
 Great Barrier Reef (MISR) **62**
 Shoemaker Impact Structure **38**
 Simpson Desert (ISS) **84**
 Stirling Range National Park (Landsat

7/ETM+) **37**
 Sydney Harbour (QuickBird) **127**

Bahamas, Andros Island (Terra/MODIS)
 154
Bangladesh (Terra/MODIS) **147**
Bhutan Himalayas (ASTER) **22**
Bolivia (Landsat/ASTER) **212**
Brazil
 forest fires (Terra/MODIS) **166**
 Lençóis Maranhenses National Park
 (ISS) **44**
 Rio Negro–Amazon junction (ASTER)
 34

Cambodia: Angkor ruins **114**
Canada
 Chapman Glacier (ASTER) **14**
 Ellesmere Island National Park (Terra/
 ASTER) **75**
 Hudson Bay ice (Terra/MODIS) **76**
 Miquelon/Saint Pierre Islands
 (Landsat/SRTM) **248**
 Okanagan Mountain Park fire (ASTER)
 169
 Quebec: wildfires (Landsat) **164**
Chile, Atacama Desert (ASTER) **194**
China (Aqua/MODIS) **171**
 Beijing pollution (Terra/MODIS) **171**
 Forbidden City (QuickBird) **125**
 Hong Kong (ASTER) **116**
 Songhua River **39**
 Taklimakan Desert **22**
 Yangtze River (ASTER) **38**, **187**
Congo: Gama/Nyiragongo volcano
 (ASTER) **201**

Denmark/Sweden, Oresund Bridge
 (ASTER) **119**
Dubai, UAE **112**

Earth
 Blue Marble: Next Generation **18**,

130–1
 first TV image (TIROS-I) **14**
 full disk (Terra/MODIS) **18**, (GOES/
 SeaWifS/POES) **19**
 gravity field (GRACE) **199**
 hurricane conditions **223**
 Mercator projection (SATM) **192**
 ocean chlorophyll **197**
 radar data (SeaWinds/QuikSCAT)
 232
 temperatures (Aqua/AMSR-E) **233**
 vegetation cover (NOAA-7/-8/-11/
 AVHRR) **211**
 vegetative biomass (Nimbus-7/CZCS;
 NOAA-7/AVHRR) **210**
Egypt
 Cairo (ASTER) **108**
 Giza plateau (IKONOS) **123**
 Lake Nasser (ISS) **104**
El Salvador: volcanoes (Terra/ASTER)
 162
Europe: heat wave (Terra/MODIS) **216**

French Polynesia
 Marquises Islands **53**
 Rangiroa Atoll (Landsat 7/ETM+) **61**

Galapagos Islands, Sierra Negra
 Volcano (Terra/ASTER/MODIS) **160**,
 161
Germany
 Berlin (ASTER) **95**
 North Rhine Westphalia (ASTER) **121**
Greenland
 Greenland Ice Sheet **77**
 Qassiarsuk (Landsat 7/ETM+) **28**
Gulf Stream **50**, (SeaWifS) **61**

Hamoun wetlands, Central Asia (Terra/
 MODIS) **144**
Hawaii, Oahu (ASTER) **111**
Honolulu (Landsat 7/SRTM) **248**
Howland Island, north Pacific **59**

hurricanes
 Alma (Terra/MODIS) **130**
 Andrew (GOES-7) **148**
 Isabel (Aqua/AIS) **246**
 Ivan (Ikonos) **152**
 Katrina (Ikonos) **153**
 Keith (TRMM/TMI) **250**
 Rita (Aqua/MODIS) **146**, **149**,
 (TRMM/QuikSCAT) **216**, (Aqua/
 GOES-12) **216**
 Wilma (Terra/GOES/MODIS) **150**,
 (MISR) **218**

ICESat 8
India
 Bay of Bengal (ASTER) **191**
 Ganges Delta (ASTER) **187**
 Kolkata (Calcutta) (ASTER) **93**
 Rann of Kutch (Aqua/MODIS) **143**
Indian Ocean (Terra/Aqua/MODIS) **135**
Indonesia, Jakarta (Landsat MSS/
 Thematic Mapper/ASTER) **106**
International Space Station (ISS) 9
Iran, Kavir (Desert) National Park
 (Landsat 7/ETM+) **80**
Iraq
 Al Qaqaa: bunkers (Quickbird) **124**
 Baghdad (ASTER) **117**
 sulphur plant fire (ASTER) **209**
Istanbul (ASTER) **104**
Italy
 Lake Garda (ASTER) **190**
 Rome (ASTER) **101**
 Strait of Messina (Terra/ASTER) **21**
 Venice (Terra/ASTER) **100**

Japan
 Honshu island (Aqua/MODIS) **52**
 Kansai International Airport (ASTER)
 117
 Tokyo (ASTER) **95**
 Typhoon Etau (TRMM) **220**
Jason 1 8

Jersey 106
Jerusalem (ASTER) 189

Kashmir (Terra/ASTER) 245
Kazakhstan
 Ural River 43, (ISS) 103
Kiribati: Maiana/Tarawa atolls (ISS) 60
Krakatau Volcano National Park (Landsat
 5) 30

Labrador Sea: sea ice (ISS) 66
Landsat 7 8
London (ASTER) 99

Madagascar, Bombetoka Bay (ASTER)
 26
Madrid (ASTER) 110
Maldives (ASTER) 48
Malta, islands of 40
Mediterranean Sea (Terra/MODIS) 144
Mexico
 Colima Volcano (ASTER) 159
 Cozumel (Landsat) 30
Mississippi River delta 26
MODIS instrument 8, 181
Montagu Island: Mount Belinda Volcano
 (Terra/ASTER) 162
Morocco: Anti-Atlas Mountains (ASTER)
 188

Namibia 87, 184
New Zealand
 Egmont National Park 29
 Farewell Spit (Terra/ASTER) 112
North America
 Algodones Dunefield (ISS) 85
 carbon monoxide (Terra/MOPITT) 198
 Great Lakes (Terra/MODIS) 226
 Niagara River 114
 Pacific Coast (SeaWifS) 49
 Rocky Mountains 242
 winter weather (OrbView-2/SeaWifS)
 138

Pacific ocean (Explorer VI) 14, (Terra/
 MODIS) 133
 Olaf/Nancy cyclones (Aqua/MODIS)
 135
 Pacific Decadal Oscillation (PDO)
 225
Pakistan (Aqua/MODIS) 74, (Landsat)
 158
Paris 99, (QuickBird) 126
Peru
 mouth of Amazon (MISR) 62
 Toquepala copper mine (ISS) 102
Portugal: fires (Terra/MODIS) 165

Quickbird satellite 9
QuikSCAT 8

Russia
 Putorana Plateau (Aqua/MODIS) 79
 West Siberian Plain (Landsat/ETM+)
 86

Scandinavia/Baltic (MISR) 21
SeaWifS 8
Siberia (Landsat 7) 32, (MSS/ETM+)
 156–7
South Africa (ISS) 108
 Johannesburg (ISS) 109
South Asia: heatwave (Terra/MODIS)
 230–1
South Georgia Island (ISS) 77
Southern Hemisphere: biomass burning
 (Terra/MOPITT) 197
Spitsbergen (Terra/ASTER) 73
Sri Lanka (Terra/MISR) 142
Strait of Gibraltar (Landsat/SRTM) 238
Sudan, White Nile (Aqua/Terra/MODIS)
 177
Switzerland, Aletsch Glacier (ASTER) 78

Tanzania, Olduvai Gorge (ASTER) 34
Terra 8, 181
TOPEX/Poseidon mission 180

TRMM 8
typhoons
 Etau (TRMM) 219, 220
 Nesat (QuikSCAT) 221

United States
 eastern US haze (Terra/MODIS) 173
 giant photo map (ERTS-1) 15
 map showing lawns 209
 Alabama: hurricane damage (Ikonos)
 152, 153g
 Alaska
 College Fjord glaciers 70
 Copper River 54
 dust storm (MODIS) 83
 forest fires (Terra/MODIS) 166
 Juneau 80
 Kodiak Island: volcanic ash 140
 Malaspina Glacier (ASTER) 185
 Arizona, Grand Canyon (ASTER) 236
 California
 Death Valley (ASTER) 238
 Golden Gate National Recreation
 Area (Landsat 7/ETM+) 102
 Lake Tahoe (ASTER) 184
 Palm Springs 90
 Pasadena (Landsat/SRTM) 248
 San Andreas fault (Landsat/SRTM)
 250
 San Gabriel Valley (ASTER) 40
 US/Mexico border 213
 wildfires (Terra/MODIS) 165,
 (MISR) 202
 see also Los Angeles
 Cape Cod National Seashore (ISS)
 59
 Colorado snow (Terra/MODIS) 136
 Florida
 Saharan dust (SeaWifS) 221
 Wilma damage (Terra/GOES/
 MODIS) 150
 Indiana/Kentucky: tornado (Landsat 5)
 154

Kansas, Finney County (ASTER) 96
Los Angeles
 general image (ASTER) 90
 Topanga fire (Terra/MODIS) 169,
 (ASTER) 201
Louisiana: flooding (MODIS) 146
Maryland
 Baltimore (ASTER) 112
 La Plata: tornado (Terra/ASTER)
 206
Missouri River (Landsat/ASTER) 176
Montana wildfires (Terra/MODIS)
 175
Nebraska: Sand Hills 25
Nevada
 Lake Mead (Landsat 7) 34
 Las Vegas 93
New Orleans (EO-1/Advanced Land
Imager) 100
New York
 Arthur Ashe Stadium (QuickBird)
 126
 New York City (Terra/ASTER) 91,
 (ISS) 91
Oregon: volcanoes (ASTER) 236
San Francisco Bay (ASTER) 205
Statue of Liberty (QuickBird) 124
Tucson, Davis-Monthan Air Force Base
 (QuickBird) 124
Utah
 Arches National Park (Landsat 7)
 102
 Navajo Mountain 43
 Salt Lake City/Wasatch Range
 (ISS) 118
Washington DC (ASTER) 90
Wyoming
 open-cast mining (ISS) 120
 Yellowstone National Park (ASTER)
 82
US Virgin Islands: Johnson's Reef
 (EAARL) 244

115, 116, 117(l and r), 119, 121, 159, 160, 162, 169, 176, 182, 184, 185, 186, 187, 188, 189, 190, 191, 194–5, 201, 204–5, 206, 207, 209, 213, 234, 236, 238(b), 239

NASA/GSFC/MITI/ERSDAC/JAROS and US/Japan ASTER Science Team 21(t), 29, 73, 75, 91(l), 92, 100(l), 101, 212, 243, 247

NASA/ Liam Gumley, Space Scence and Engineering Center, University of Wisconsin-Madison 56

NASA/F Hasler, M Jentoft-Nilsen, H Pierce, K Palaniappan and M Manyin 148

NASA/JPL 58, 64, 216(b), 232

NASA/JPL/Agency for Aerospace Programs (Netherlands)/Finnish Meteorological Institute 224

NASA/JPL and NGA 237

NASA/JPL/NIMA 248(t and b), 249, 251

NASA JPL, University of Texas Center for Space Research, and GeoForschungsZentrum Potsdam 199

NASA/Norman Kuring, MODIS Ocean Team, GSFC 50, 51(l), 228–9

NASA/Norman Kuring, MODIS Ocean Color Team 53

NASA Landsat Project Science Office and USGS EROS 155

NASA/MODIS Rapid Response Team, NASA GSFC 136–7, 141, 146, 147, 149, 167, 171, 172, 173, 226–7

NASA/Lawrence Ong, EO-1 Mission Science Office, NASA GSFC 100(r)

NASA/QuikSCAT Science Team at JPL 221(l)

NASA/Jeff Schmaltz MODIS Land Rapid Response Team at NASA/GSFC 51(r), 52, 70, 71, 76, 79, 83, 132, 135(r), 165(l), 168

NASA/Jeff Schmaltz MODIS Rapid Response Team and Robert Simmon, Earth Observatory 77(l)

NASA/Robert Simmon, based on Landsat data provided by Landsat 7 Science Team and the UMD Global Land Cover Facility 28

NASA/Robert Simmon, based on Landsat 7 ETM+ data provided by the UMD Global Land Cover Facility 30

NASA/M Justin Wilkinson (Lockheed Martin/Earth Observations Laboratory, Johnson Space Center 102(r), 109

NCAR/University of Toronto MOPITT Teams 196, 198

Lori Perkins/NASA 216(t)

Hal Pierce, NASA GSFC 219

Hal Pierce, TRMM Project, NASA GSFC 220

Vincent J Realmuto/NASA JPL 246

Jeff Schmaltz, MODIS Land Rapid Response Team at NASA GSFC 55, 140

Scientific Visualizations Studio NASA GSFC 240–1

SRTM Team NASA/JPL 238(t)

SRTM Team NASA/JPL/NIMA 192–3

Reto Stockli, NASA Earth Observatory 16–17

Reto Stockli and Robert Simmon, NASA Earth Observatory, based on data provided by the MODIS Land Science Team 214

University of Maryland Global Land Cover Facility 31, 174

USGS Eros Data Center based on data provided by the Landsat Science Team 57

US/Japan ASTER Science Team 110

ACKNOWLEDGMENTS/WEBSITES

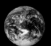

ACKNOWLEDGMENTS

Many thanks to all of those who have helped in the production of this book, including Dr Kamlesh Lulla and Stephen Nesbitt from NASA and Neil Baber and the team from David & Charles. This book is dedicated to Dr Noel Digby, who will always have a very special place in the heart of his family.

WEBSITES

The many and varied NASA websites offer an unrivalled resource for educationalists, researchers and those who are simply interested in discovering what is happening at the cutting edge of space research. Many sites have facilities for high-resolution imagery and research material to be downloaded free of charge, and others offer up-to-the-minute reports on the latest missions to allow schools and individuals to keep track of progress as the exploration of space continues apace. There are so many sites available that it is impossible to list them all here, but this is a selection of some of the best, and it's up to the individual to follow the links that are offered and to explore the variety of sites on offer for themselves.

http://spaceflight.nasa.gov
(Images and information from human space flight)

http://eol.jsc.nasa.gov
(Images of Earth taken from manned spacecraft and the International Space Station)

http://hubblesite.org/newscenter/ newsdesk/archive/ (Hubble Space Telescope images)

http://images.jsc.nasa.gov
(Collection of 9000 NASA Press Release photos)

http://grin.hq.nasa.gov/subject-science.html
(Great Images in NASA)

http://visibleearth.nasa.gov/
(Visible Earth website, pictures of Earth from Space)

http://marsrovers.nasa.gov/home/index.html
(Mars Exploration Rover Mission)

http://aqua.nasa.gov/
(Home page of the Aqua Satellite)

http://terra.nasa.gov/
(Home Page of the TERRA satellite)

http://www.nasa.gov/mission_pages/cassini/main/index.html
(Home page of the Cassini Mission)

http://spaceflight.nasa.gov/shuttle/index.html
(Space Shuttle Home Page)

http://www.nasa.gov/mission_pages/station/main/index.html
(International Space Station Home Page)

http://sohowww.nascom.nasa.gov/
(Home page of the SOHO project that studies the sun)